100 UNFORG

100 UNFORGETTABLE DRESSES

100 UNFORGETTABLE DRESSES

Hal Rubenstein

Foreword by Alber Elbaz

HARPER
DESIGN
An Imprint of HarperCollins Publishers

FOR MOLLY

I keep looking for the dress that's as lovely as she is.

CONTENTS

The Dresses

12

FOREWORD

As a designer, I know how the process of dressmaking starts, but I never know how it will end. It's a fascinating adventure but it's also a long, complicated one. Because a memorable dress has to do more than merely look amazing. It's not just three yards of fabric or a sketch of a front and a back. Into that dress you have to weave enough allure and mystery to excite and transform the most integral factor in making a dress unforgettable: the woman who is wearing it.

This book is a gallery of such dressmaking magic. As I look at these women and these unforgettable clothes, as I read the clever, devilish, and witty ways these fantasies came true, I feel as though I am looking at a very special family album, one that revels in the joy, happiness, and desire we inspire in others when we triumph in creating moments of memorable beauty.

There is nothing more frightening in fashion than being "of the moment" because it's a heightened state that doesn't last. But here are moments that will never fade, forever shining bright in our collective memory, each the result of enviable imagination, canny intuition, fortuitous timing, a little bit of luck, and the willingness to feel free and fearless. And as *100 Unforgettable Dresses* reveals, such fearlessness may be the secret of true beauty.

—Alber Elbaz
Designer and dressmaker

INTRODUCTION

Twenty years ago, I was sitting in my office at the *New York Times* when I heard the unmistakable clatter of Carrie Donovan's Bakelite Chanel bracelets approaching my doorway. It was rare for the newspaper's legendary deputy editor of style to venture up three floors from her comparatively plush domain to my spartan yet cluttered one-man-band warren, where I worked as the men's style editor of the august daily.

"My dear Hal, I have the most marvelous surprise for you!" declared Carrie in her emphatically musical, slightly adenoidal voice as she handed me an airline ticket to Milan to attend the opening of the fall 1991 women's ready-to-wear collections. Having just returned from that same city's fall men's presentations, I was confused. At the time, I didn't cover women's fashion, nor did I even care about it that much, and I told her so.

The doyenne lifted her eyebrows high above her trademark oversize black round-rim glasses and proclaimed with her trademark effusiveness, "That's ridiculous! Of course, you do! Everybody does! Besides, I don't like Milan, so you must go!" Further protests proved futile, as Donovan blew off each one with a hand wave that wiped my future clean. "I'm opening a door for you!" she insisted with Auntie Mame logic. "You will *adore* women's fashion! It's just *too divine*! So much more fun, full of imagination, details—oh, the details—it's so dramatic! Besides, women love clothes so much more than men, which is why what they wear makes such a difference." Then, waving

good-bye over her shoulder, her bracelets a-clatter, my self-appointed mentor walked away, singing out, "Bon voyage, my dear! I can't wait for a full report!"

Naturally, when it came to style, Carrie was absolutely right about everything. Women's fashion is a culturally pervasive, behavior-altering, trend-inducing, emotion-stirring, perpetually exhausting, psychologically daring, hopefully uplifting yet potentially scarring, and occasionally foolish but undeniably influential celebration of craftsmanship, showmanship, ego, and seduction that has us more riveted and more attuned to its output and our appearances than ever before.

It's not that past generations didn't take equal notice, but today we thrive on both the recognition of fashion's immediate ability to shape our self-images and our enlightened awareness of the way past examples of significant design affected the way women dressed, as well as how society perceived them.

100 Unforgettable Dresses celebrates this remarkable power by citing those gowns, minis, muumuus, shifts, shirtwaists, sheaths, costumes, and beaded extravaganzas that sparked unforgettable collective memories and are directly responsible for changing how women wanted to look. This is not a historical compendium so you can be better informed the next time you go to the museum. Instead, this is a book for all fashion enthusiasts, movie buffs, music fans, celebrity watchers, backstage story snoops, gossip lovers, die-hard shoppers, and pop culture mavens who guiltlessly admit they can't get enough of these indelible, once-in-a-lifetime moments.

It's amazing that one feathered dress helped shape the most memorable number of the screen's greatest dance team, Fred Astaire and Ginger Rogers. It's a rush to discover that a fabric developed for automobile upholstery became the source for Halston's most famous creation. And although many people may not remember what film she won her Best Actress Oscar for (*The Hours*), no red-carpet watcher can forget the immediate and stunning effect of a copper-tressed young Nicole Kidman in a commanding chartreuse chinoiserie Dior gown. Fashion's calendar of shows may be fixed years in advance, but its landmark events— such as Alexander McQueen revealing the final dress for one of his presentations as a hologram, or Jason Wu discovering Michelle Obama had selected his design for her inaugural-ball gown only by actually seeing her appear on television, or Marilyn Monroe entertaining President John F. Kennedy in a second skin of sequins—were all unexpected, serendipitous delights.

What movie lovers can ever take their eyes off of Audrey Hepburn in any film, let alone the panoramic tableau of black-and-white costumes in the Ascot scene in *My Fair Lady*? But the great designer Cecil Beaton did more than rely on Hepburn's beauty. With one design trick, he made sure you'd focus only on her. Yves Saint Laurent's trend-defining Mondrian dress was not a simple shift but a marvel of subtle infrastructure. Rita Hayworth's black gown in *Gilda* ignited every would-be siren's reliance on a strapless dress, but besides Hayworth's knowing how to dance or slither, there was something special that Jean Louis crafted inside her gown so she would not be

prone to hiking it up the way so many young stars tend to when they walk the red carpet.

Digging into fashion's past proved an intoxicating treasure hunt. Who was responsible for the Supremes' psychedelic glamour? Where did Valentino find his trademark red? How did several strategic safety pins make one beauty world famous overnight? Did you know that the most infamous red-carpet outfit ever worn didn't cause a single eye flutter when it was first shown on the Versace runway, that Bette Davis's classic hostess gown in *All About Eve* didn't really fit her properly, or that television's most uproarious movie parody costume barely made it onto the set of *The Carol Burnett Show*?

100 Unforgettable Dresses is a work of sheer selfishness because every entry either spurred me to smack my lips, roll my eyes, connect a dot, jolt to a delicious flashback, or flick on a light of recognition. Equally thrilling for a populist like me, these dresses prove that fashion doesn't merely live on a runway. It insinuates itself everywhere in our daily lives and then works its way into our daydreams. These one hundred selections shaped the way women dressed for proms, job interviews, and their own weddings. They set standards and broke them, established concepts of sexiness, hipness, and elegance. They are an essential element of certain red-letter days. And they disprove that beauty is restricted to the eye of the beholder, because it's really a group effort.

So, for Carrie Donovan, and for everyone else who thinks fashion is *too divine*, here is my full report.

—Hal Rubenstein

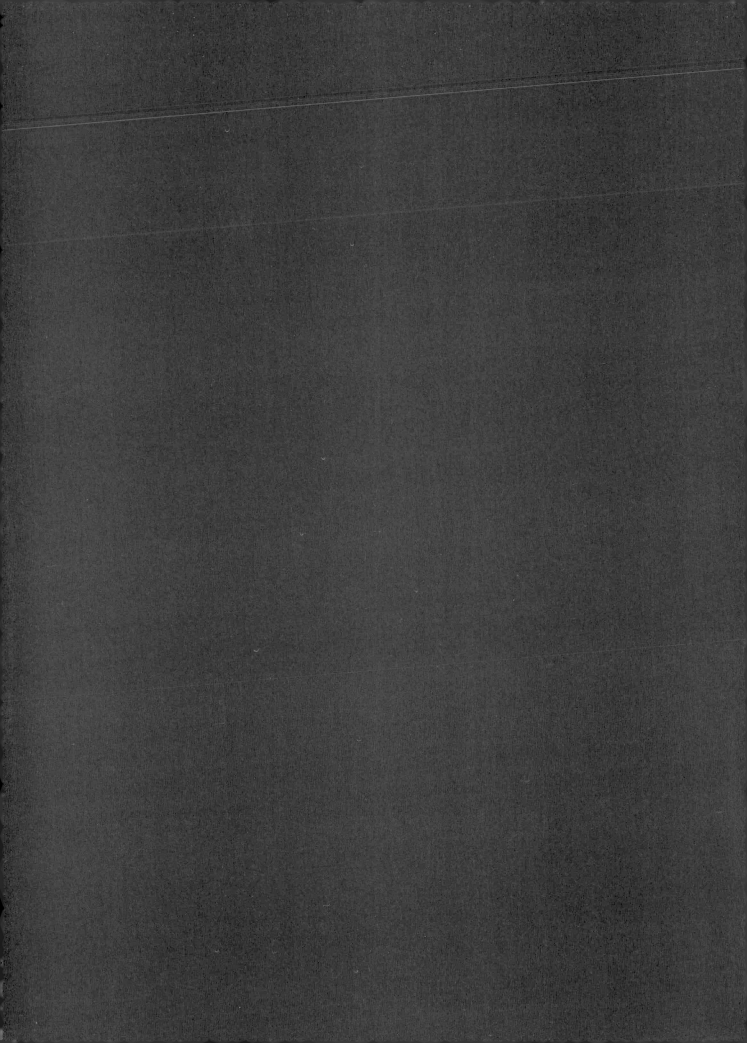

The Dresses

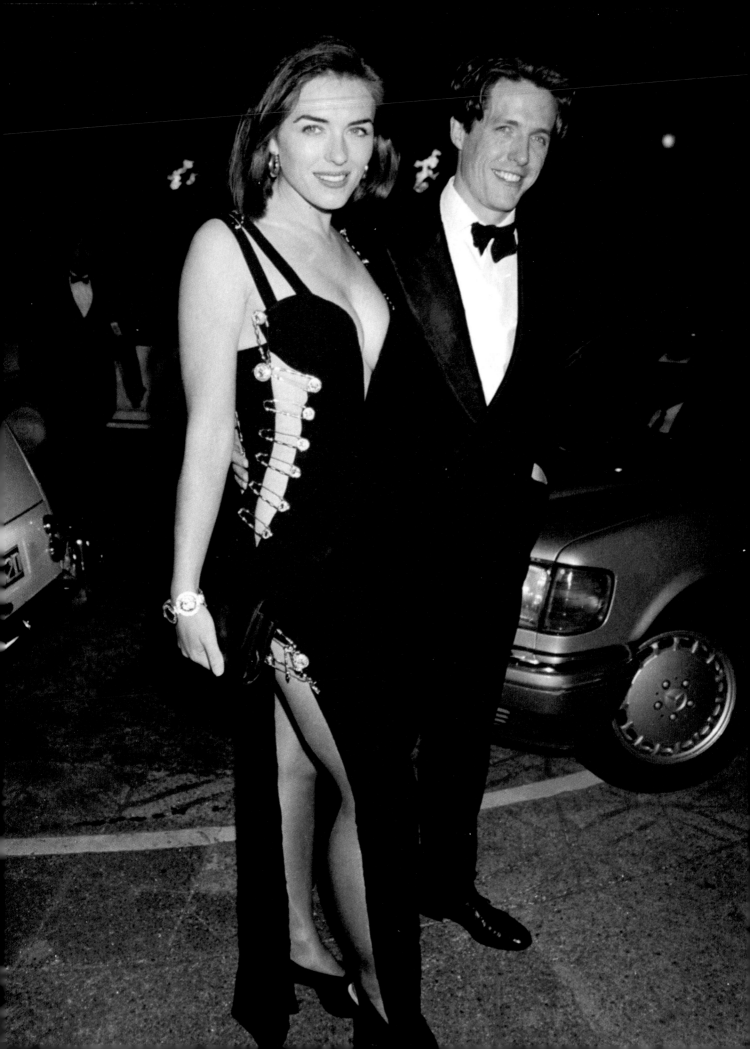

SAFETY-PIN GOWN

Gianni Versace · 1994

Quick, name five Elizabeth Hurley movies. All right, then, can you name three? The truth is not a single screen performance is responsible for branding Elizabeth Hurley into our collective memory. And yet, she is emblazoned there, thanks to her having stepped out one night in the sartorial equivalent of the shot heard 'round the world. All it took was one dress—"That Dress"—as it was tagged by the media the morning after Hurley's appearance at the world premiere of *Four Weddings and a Funeral* in London. Upending her usual tabloid-captioned capacity as Hugh Grant's girlfriend, Hurley stepped out of a limo and into the paparazzi's viewfinders. Suddenly, Grant, his soon-to-be-hit romantic comedy, his costars—in fact, every other rival—fell out of favor and focus. Instead, the twenty-nine-year-old sassy beauty and Gianni Versace's devilishly engineered safety-pin gown were instantly rendered inseparable, incredible, combustible, derisible, and ultimately, globally inescapable.

Hurley didn't pick the dress from endless racks of stylists' options herself, nor was it deliberately chosen for maximum shock effect (though there was no doubt she savored the outcome, and the lack of fallout, so to speak). Gianni Versace, whom Hurley knew through their mutual friend Elton John, had selected and shipped it off to Hurley fresh from his Milan Fashion Week runway. The premiere was just weeks after Versace had presented his spring 1994 collection, in which Hurley's chosen gown was but one in a series of similarly brilliantly precarious looks climaxing a deliciously, progressively taunting runway parade in which Medusa-headed safety pins (the Versace logo is a representation of Medusa) dominated. The show had started simply enough, with tailored daytime suits: the skirts closed with a single pin, invoking the innocence commonly associated with pleated plaid parochial-school uniforms. But as the show proceeded, the pins grew larger and more numerous, less designed to preserve virtue than to hold together the increasingly risqué slits and slashes strategically set into Versace's dresses and gowns.

Any devoted buyer or knowing critic was hardly surprised and, in fact, often relished the designer's sexual bravado at this point in his career. Nevertheless, virtually everyone at the show, from the front row to the last, was either wide-eyed or drop-jawed, if only in admiration for the collection's brilliant engineering. But Versace had repeatedly insisted that there was nothing inherently sexy about his clothes. "On a hanger, no dress is sexy," he said. "It's just fabric on a hanger. My clothes only come alive on the woman who knows how to be sexy in them." In a post-premiere-frenzy interview, where he went so far as to deny that there'd even been a fitting, Versace claimed he "knew Elizabeth would look simply *bellissima, perfetto* in that dress. Liz has this intelligent face attached to that very naughty body. So seeing a woman like her in this gown was a guarantee that everyone would go *pozzo* [nuts]."

As for the secret as to how the silk crepe gown's ravine-deep neckline, thigh-high slit, double-fastened straps, and open rib cage, secured by a half dozen pronged Medusas, managed to stay in place long enough for Hurley to become legendary overnight instead of arrested for indecent exposure, Versace insisted, "There was never any danger." Brushing aside all doubt with a flick of his wrist and a coy smile, he added, "That's why you call them *safety* pins, my dear."

MING-VASE
GOWN

Roberto Cavalli · 2005

In 2010 Roberto Cavalli celebrated his fortieth anniversary in fashion by presenting a collection of over forty looks, every one of them the equivalent of a finale gown, and for Cavalli, there is no finale without laser-cut pony skin, crystals cross-stitched into leather, gold leafing on python, feathers woven into chiffon, hand-painted floral lace, and brilliants trapped in a silk-net overlay—sometimes all in the same dress. The only thing Roberto Cavalli loves more than extravagance is women.

Roberto Cavalli is fashion's Guido Anselmi, Fellini's alter ego in $8\frac{1}{2}$, but with a thimble instead of a camera and none of the tormented angst. A show-off with a smile, Cavalli sees no point in making a gesture unless it's grand. He spent two million dollars on the anniversary party that followed his show; he owns both a yacht and a vintage Mercedes with iridescent paint jobs so intense they change from light pink at sunrise to teal at high noon to royal purple at sunset and to navy in moonlight. He got tired of waiting for a table at a favorite industry restaurant in Milan, so he designed and opened his own place in the middle of a Milanese park, with soaring glass walls and a bar stocked with rows of Roberto Cavalli Vodka. He seeks technological innovation in fabric painting, leather tanning, and weaving techniques and has a weakness for exotic skins, but all of the above is on track with a man who started his career in 1971 by being the first designer to patchwork glove-soft leather into full-length jackets, now a common practice. "When you come from Florence," he says, "you can't help but breathe in art as if it's air. It affects your brain and makes you want to do incredible things." By the way, he made the jacket in a fit of inspiration, "to impress a woman I was seeing that night."

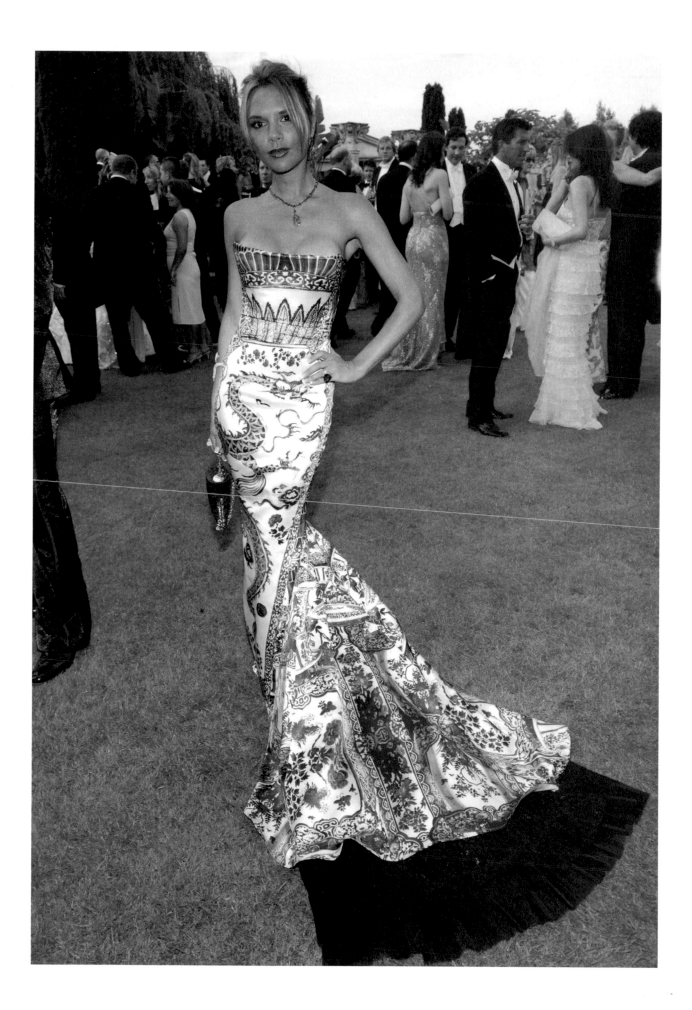

> **"** I really don't understand minimalism. It's so polite and boring. If you don't want anyone to notice you, you should stay home and grow your own vegetables. **"**
> —ROBERTO CAVALLI

Given all that, it's easy to imagine the designer fixating on a rare Ming vase that he had bought at an auction for one of his homes. "I kept staring at it, thinking, this is too beautiful to keep to myself." He took pictures of the vase and sent them to several textile factories, finally finding one willing to silk-screen the delicate intricacy of its multiblue-hued floral and dragon-framed landscape. (Cavalli loves serpents and things that slither. An embossed-glass snake encircles his eponymous frosted-bottled vodka.) The result is a gown that nearly approximates the shape and asymmetrical balance of his prized antique. "The only problem," says Cavalli, "is that it took so long to weave the manufacturer would only give me enough material to make one dress." To his own surprise, Cavalli resisted adding beading, embroidery, or crystals. "I wanted it pure. For me, this was restraint." The gown was the standout of his spring 2005 collection.

Not one for understatement either, Victoria Beckham begged Cavalli to let her wear it to her friend Elton John's annual White Tie & Tiara Ball in London. Cavalli was utterly tickled with the idea of someone whom most people perceive as being hard wearing a version of something so fragile. "The truth is, Victoria is funny and very sweet, and if anyone is ever going to have the last laugh, it's going to be her. She knows exactly what she is doing." Happily, she also happens to be sample size. Cavalli credits Beckham with making the dress even better than when it was first shown on the runway. After trying on the dress, "Victoria insisted on one change. In order to make it really appear more like the shape of a vase, she insisted I take the dress in at the bottom so tightly that she wouldn't be able to sit down. She wouldn't wear the dress otherwise. I did exactly what she asked me to do, and she stood the whole night."

YELLOW CHIFFON GOWN

Jean Dessès · c. 1955

There was a time when the term "vintage" was never applied to any garment less than fifty years old. Then it was fudged to twenty-five. Now the word is meaningless, used to cite anything that isn't current, a euphemism for turning something old and something borrowed into something special. A true vintage dress on a red carpet is as rare as a film about middle-aged romance. So when a rare sighting of authentic vintage does come along, it really is a treat.

The Egyptian-born, Paris-based clothing designer Jean Dessès first made his name in jersey, then became famous for his work in chiffon in the 1950s. His canary-yellow gown, worn by Renée Zellweger to the Oscars in 2001, dates back to about 1955 (four years shy of an official vintage "diploma," but in light of what passes for vintage, it's downright ancestral) and represents one of the actress's most winning trips down the red carpet and one of the designer's most successful experiments in finding ways to drape and gather chiffon without increasing volume or weight.

What is striking about the dress is not only how contemporary it looks but the way the bust is so perfectly fitted and that the silhouette appears so lean despite the fact that, from the sternum, two arcs of curtain-draped chiffon sweep down the front, then around to the back to form a modest train—all without adding bulk.

In addition to that elegantly innovative engineering, Zellweger offset the vintage aura by wearing her hair down and loose, making the total effect sexy, carefree, and modern. By contrast, whoever got zipped into this dress first, most likely wore her hair in a French twist or in a prim Grace Kelly–esque pageboy for a more temple-goddess effect. Wearing the Dessès was one of the few times Zellweger broke from her unofficial public appearance alliance with Carolina Herrera, but even Herrera would have to forgive her having strayed, since Renée looked as smashing at thirty-two as the dress did at nearly fifty.

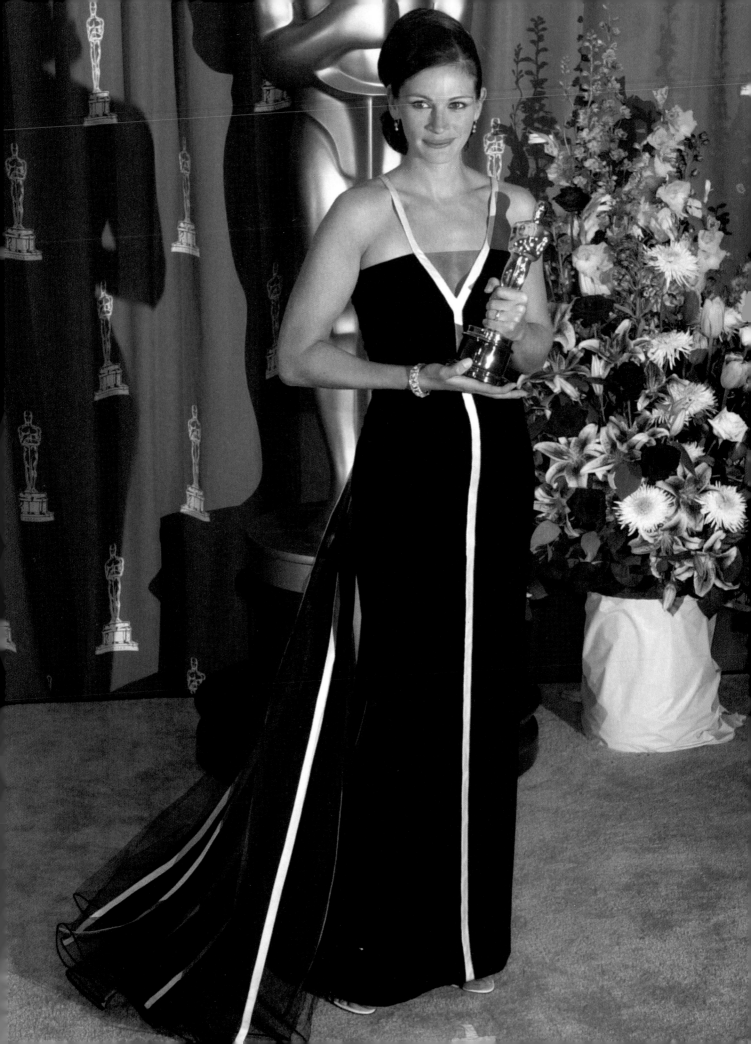

BLACK GOWN WITH WHITE STRIPES

Valentino · 1982

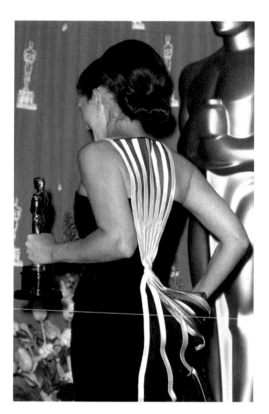

Julia Roberts has never been one to run to a stylist every time she has to go outside. She happily admits to not being a clotheshorse, not fretting over what she is going to wear to events. One of the reasons why she has favored tuxedoes for big nights out is because they are "easier." Yet, to accept her Best Actress Academy Award in 2001 for *Erin Brockovich*, she chose one of the most starkly sophisticated and enduringly populist gowns of all time. And in typical throwaway fashion, Roberts took no credit for the idea; she says her niece, actress Emma Roberts, chose it for her.

Pulled from the Valentino archives from his fall 1982 couture collection, stripped of ornamentation, the strapless black velvet is basic. But the gown is divided in half by a white satin stripe that goes straight up the torso, splitting into a V at the neckline to form a thin-strapped halter. However, once over the shoulder, the two straps join five other straps to form multiple chevrons that go down the back like a trellis. At the waist, the stripes multiply yet again, into over a dozen paths down the back of the full skirt with train. The stark geometry of the dress was made even more dramatic by Roberts's choice to wear her hair in an uncharacteristically formal series of knots atop her head.

Even prior to Roberts's appearance, the gown was always one of Valentino's best sellers, so much so that variations of it appeared in his collections for several seasons after its initial presentation. In fact, the reason publications have often pegged Roberts's gown incorrectly to 1992 is that Valentino presented an almost line-for-line copy of it that year. However, seeing the Oscar winner looking so elegant ensured that Valentino would let those lines go on and on, at least for a few years more.

BALL GOWN FOR *THE KING AND I*

Irene Sharaff · 1956

Naturally, credit must go to Rodgers and Hammerstein for the glorious score, as well as to the citizens of nineteenth-century Bohemia who thought it might be fun to dance a hop-step-close-step in 2/4 time. But if you love *The King and I*, each time the brass section slows to swell as Yul Brynner finally takes Deborah Kerr firmly by the hand to lead her around the highly polished vast floor of his epically large palace, you hold your breath in anticipation, knowing at the first downbeat on the kettle drum you are about to witness one of the most exuberant yet unaffected dance numbers in the history of film.

There is nothing amazing about the choreography in "Shall We Dance?" The dance is a basic polka, devoid of the dexterity with which it would be manically performed almost weekly on *The Lawrence Welk Show*, too banal a routine to be atop the leaderboard on *Dancing with the Stars*. Neither of the film's stars was a trained dancer. (Kerr didn't even do her own singing. Marni Nixon warbled for her.) And yet, "Shall We Dance?" is pure rapture. To begin with, Brynner is hot: those intense, searing eyes; the bare, shaved chest; that sonorous voice—not to mention the fact

that he was the first bald movie star to make women go flush. But rampant testosterone aside, it's Kerr's voluminous gown that gives the scene its sweep and grandeur. Made from pale lavender Oriental silk, the dress was similar to the one Sharaff created for Gertrude Lawrence for the stage version of the show. Yet, minus the confines of a Broadway stage and afforded the added bonus of a film being shot in CinemaScope, Sharaff increased the Victorian crinolines and added yards of imported Thai silk to the skirt, which necessitated replacing the cane hooping, authentic for the period, with a metal underskirt cage. However, because the large film set allowed the actors to dance the polka faster and more aggressively than onstage, the voluminous off-the-shoulder puffed sleeves of the original Broadway costume had to be reduced so as not to inflate. The dress weighed close to forty pounds, and Kerr had to wear foam rubber pads on her hips to prevent bruising. With the rest of her wardrobe of similar scale and weight, Kerr came away from *The King and I* twelve pounds lighter. Irene Sharaff wound up eight-and-a-half pounds heavier, thanks to the weight of her second Academy Award for Best Costume Design for the film.

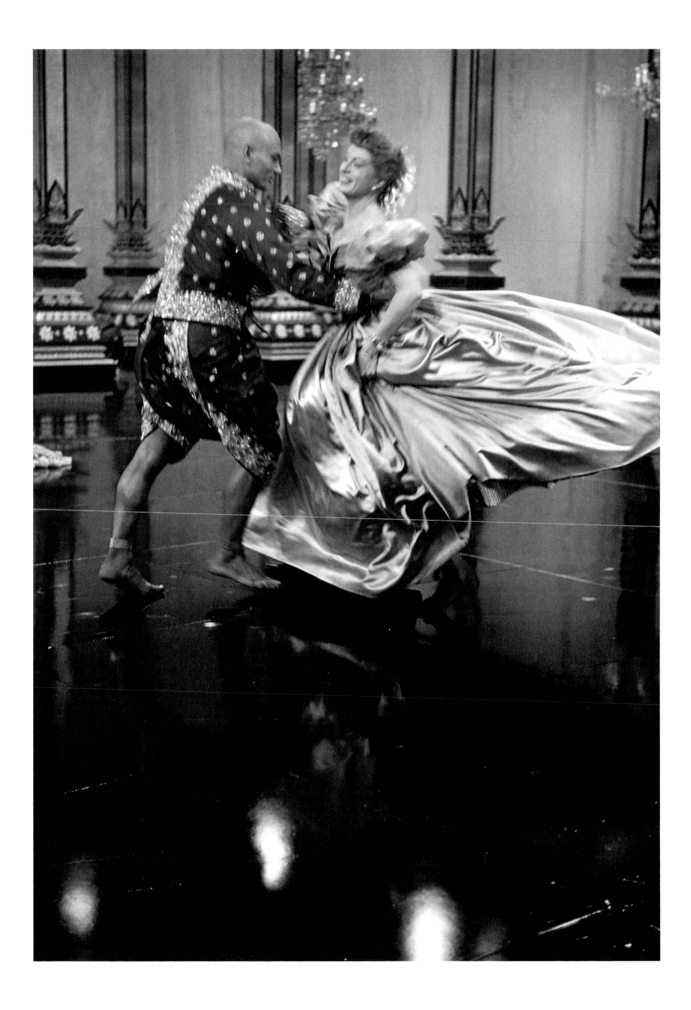

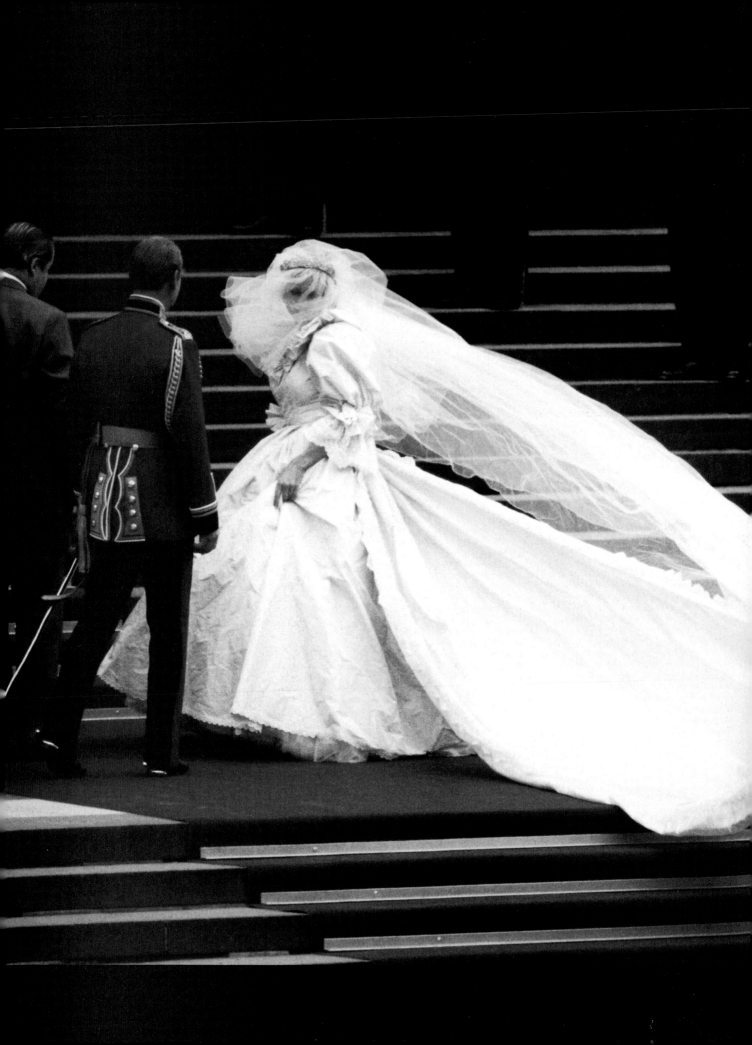

WEDDING GOWN FOR HER ROYAL HIGHNESS DIANA, PRINCESS OF WALES

David and Elizabeth Emanuel · 1981

Let's be honest. The gown is hideous, with mutton sleeves so high and wide you could hide a Smithfield ham in each; a flouncy "Poor little Pierrette, where's your Pierrot?" neckline; an inexplicably bloated bosom; that fire-retardant, theater-curtain-weight skirt—and to top it off, a head-flattening veil that goes yard for yard with a train that could supply half the infant population in Lancashire with communion dresses.

True, Princess Diana's bridal lollapalooza initially knocked us all out. Partially, it was the sheer volume of all that ivory silk, taffeta, and lace; the tens of thousands of hand-sewn seed pearls and sequins; plus the unexpected choice of the attractive young married designers, David and Elizabeth Emanuel, who had become a favorite source for the young betrothed Lady Diana Spencer soon after they had graduated from the Royal College of Art. Then there was the relentless torrent of images that proved that, no matter how far Diana walked, there was always more of that gown pulling up the rear. But above all, nearly a billion people watching the televised marriage ceremony were taken in by the vivid framing of the shrewdly marketed fairy tale. The royal wedding was a live-action version of a Disneyfied fable, complete with beribboned, dashing (if not particularly handsome) prince,

horse-drawn gilded carriage, and requisite princess clad in a big, poufy, never-to-fall soufflé of a gown.

Had the fairy tale continued, perhaps there would have been no reassessment. But as the union unraveled into an overwrought embarrassment, anyone who returned for a nostalgic review of Charles and Diana's wedding photographs couldn't help but reenvision the dress as a prescient marker. Unfortunately, that second glance came too late to save the bridal industry from more than a decade of fabric overkill. The Emanuels' gown became one of the most copied Big Day gowns in history. "It set wedding couture back at least ten years," bemoans a very successful bridal designer who is too well mannered to allow attribution, though not too shy to voice an opinion: "The amount of business lost by those of us who couldn't come up with our version of that top-of-the-wedding-cake look was devastating. Every time a future bride pulled out a picture of Di drowning in that dress I had to physically stop my finger from going down my throat." Another equally famous, slightly more philosophical bridal designer adds, "For all that fabric, there wasn't one square inch of sex appeal in that dress. You know why? Neither the dress nor the wedding ever focused on the bride. You know, maybe that was the problem all along."

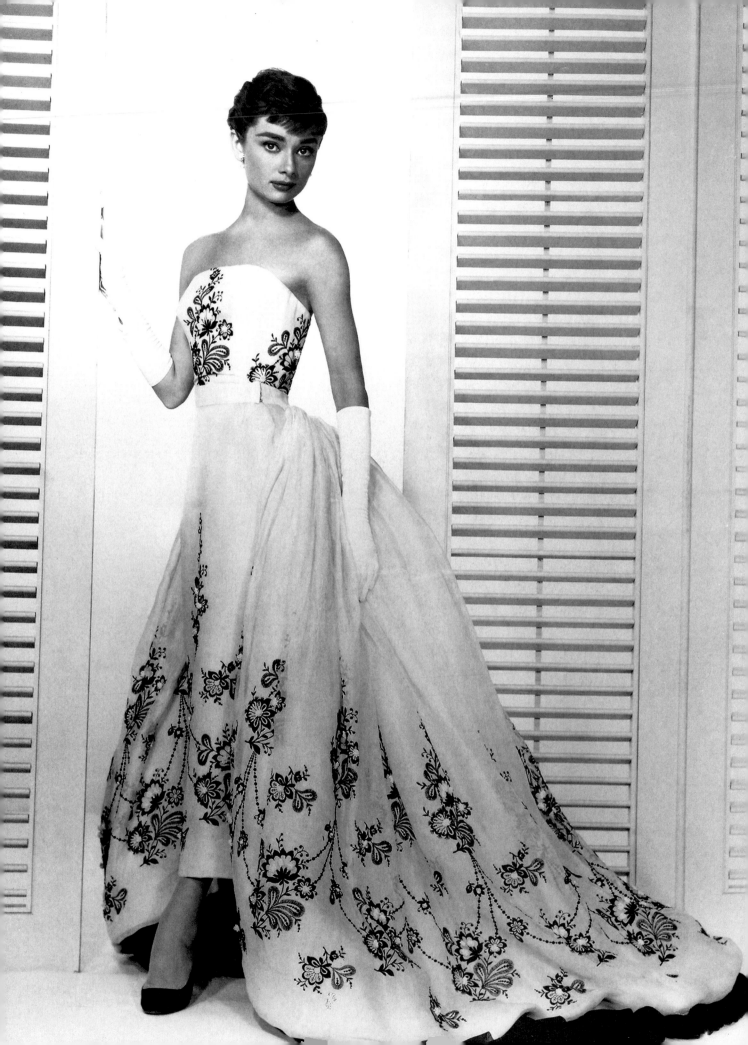

Audrey Hepburn

Whenever I'm asked about red-carpet glamour on one of those morning-after-awards segments on television, the same question always comes up: "You have the inside scoop. So tell us, who has great style now? Who's the next Audrey Hepburn?"

Well, you don't have to scoop very deeply. The answer's easy.

No one.

The list of female celebrities who wear or wore clothes beautifully, have been highly influential, or established distinctive profiles is easy to compile: from Marlene Dietrich to Grace Kelly, Jacqueline Kennedy Onassis to Ali MacGraw, Cate Blanchett to Nicole Kidman, and maybe a score more in between.

But as notable as all these women may be, Audrey Hepburn had something extra. Her unique screen persona—part tomboy, part princess, sometimes plucky, sometimes brittle, but always vulnerable—has already been chronicled in countless tomes. Her beauty was unassignable to a time or a place, so while she always looked different in her screen roles, she always looked exactly right. Not that she didn't seek outside help. In fact, Hepburn was watched over by a very special guardian angel.

It's not uncommon for stars to consult with costumers on wardrobe for their roles, just as Garbo did with Adrian, and Dietrich

with Travis Banton. But for forty years, Hubert de Givenchy was much more than a consultant to Hepburn, and she, more than a client to him. The designer regarded her not only as his friend and muse but also as his collaborator during the actual design process, which could explain why she always appeared so natural and comfortable on-screen. Hepburn never seemed to be in costume. It was as if she had gone through her own closet, pulled out what was right for the role, and brought it to the set in a tote. She also possessed an agility that kept her from appearing frozen in an inimitable but sometimes physically limiting silhouette. Even offscreen, she never looked as if someone had styled her.

In addition, though indisputably a legendary star, Hepburn lacked that layer of fixed iconography that Davis, Crawford, and Katharine Hepburn possessed that allowed them to rise above mediocre projects, although it often kept audiences from forgetting that persona when they were off-screen. The younger Hepburn could never climb out of a clunker, because her fame wasn't built on establishing

a presence that was bigger than any role. But when a film of hers did click, her self-effacement made us fall in love with Holly, Eliza, Rima, Sabrina, and Jo with the funny face. Sure, they were all Hepburn, but her magic was that each time we were smitten, she made us believe it was for the first time. The way she looked as she stole our hearts only hastened our infatuation.

While Coco Chanel is credited with making the little black dress a wardrobe staple, it was Hepburn who made the LBD popular again in the 1950s. In *Breakfast at Tiffany's* she wears a fitted, stunning black number to visit her ex-mobster friend, Mr. Sally Tomato, in jail, but her most fetching on-screen example, the dress that set off the unabated rage for the LBD, is the one—with its high bateau neckline, straight-fitted bodice, and umbrella skirt—she wears to meet Humphrey Bogart at the end of *Sabrina* (shown above). This dress was designed for her by Givenchy.

Though she'd won the Academy Award for Best Actress for her first film, *Roman Holiday*, *Sabrina* was only Hepburn's second

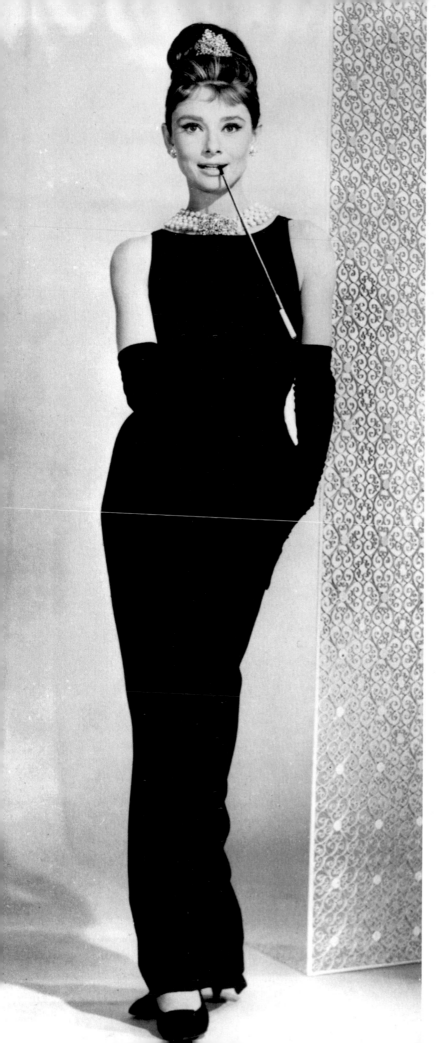

film, so when the twenty-four-year-old actress told her producers at Paramount Pictures that she wanted to work with the twenty-six-year-old French couturier, with whom she felt an immediate kinship, in creating Sabrina's post-Paris wardrobe, the executives reminded her that the film already had a costume designer, Edith Head, who at fifty-six had already won five Oscars for Costume Design (including one for *Roman Holiday*). If she was compelled to work with Givenchy (whom Hepburn had contacted at Cristóbal Balenciaga's recommendation after he had turned her down), that was fine by them, but Givenchy would get no credit and she'd have to pay for the clothes out of her own pocket. To their surprise, Hepburn agreed. Head, now limited to designing Sabrina's wardrobe at the beginning of the film, when the character was simply the overlooked chauffeur's sparrow-like daughter living over the multicar garage, seethed.

The budding Givenchy-Hepburn coalition also produced Sabrina's sensationally sensual yet regal strapless white organdy gown with embroidered black flowers on its tiered hem (see page 26). Not only does it turn the two brothers, played by Humphrey Bogart and William Holden, besotted with the "new" Sabrina, into combatants, but it became the dress the press always ran photographs of when citing Hepburn. Retailers were deluged with requests for copies of it, practically ensuring the film an Oscar nomination for Best Costume Design. But Head refused to share the nomination with Givenchy, justifying her demand that the studio submit only her name for award consideration because, although Givenchy had designed most of Sabrina's wardrobe, all the costumes were sewn and finished on the Paramount lot under Head's supervision. Head won her sixth Oscar for *Sabrina*—she would win two more over the course of her career—shamelessly omitting Givenchy in her acceptance speech.

Undeterred, Hepburn and Givenchy embarked upon a devoted lifelong friendship. With one notable and singular exception, *My Fair Lady*, Givenchy designed Hepburn's full wardrobes for all her major roles after *Sabrina*, among them these showstoppers:

the gorgeous ballerina-inspired wedding dress she wears to marry Fred Astaire at the end of *Funny Face* (although Head claimed to have designed it); the infamous black gown she wears in the *Breakfast at Tiffany's* opening sequence on Fifth Avenue (see page 29) (Givenchy finally got sole screen recognition, and since Pauline Trigère designed Patricia Neal's wardrobe, Head received credit only as "costume supervisor"); and, except for one look, the varied wardrobe that spanned five stages of marriage to Albert Finney in *Two for the Road*. The sole outsourcing occurs during the depiction of the crumbling marriage's final stage, when a sleek, Sassoon-like-coiffed Hepburn steps out of a Mercedes-Benz convertible in a sensational Mylar disk minidress by Paco Rabanne (this page, bottom). Though Coco Chanel dismissed Rabanne as "a metal worker," Rabanne rightly boasted that his jersey-backed-Rhodoïd and aluminum-ring-linked constructions acted like "the triggers on a revolver" because with each movement of the body, the dress resonated with intense shine and flashes of the illusion of nudity. It's the perfect dress for a disillusioned wife seeking revenge.

Hepburn's most notable transgression was when she put herself in the hands of Cecil Beaton for *My Fair Lady*. In creating both the sets and the costumes for stage and film productions of the story, he set Lerner and Loewe's brilliant yet slightly more romantic version of Shaw's *Pygmalion* against an elegant panorama of Edwardian London.

For Beaton's rendition of the Royal Ascot scene, he dressed one hundred and fifty women and one hundred men in black, in white, or in a combination of the two, an idea apparently derived from the all-black Ascot of 1910, when attendees were in mourning for Edward VII. Beaton's variations within his strictly set parameters are astounding, but his most ingenious feat is how he garbed and positioned Audrey Hepburn with singular

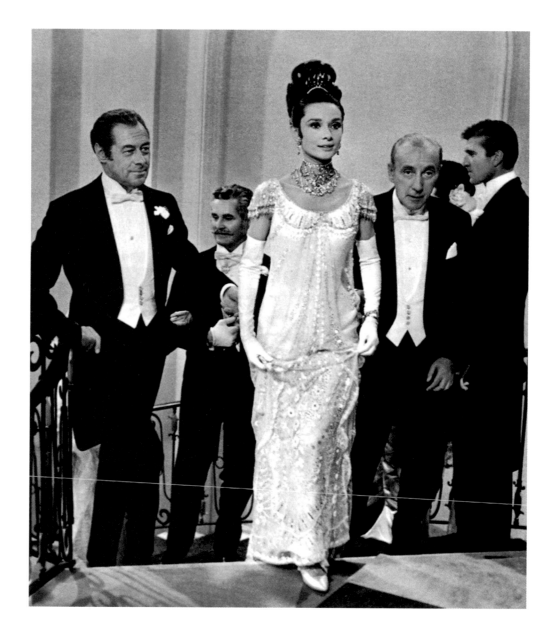

and stunning clarity. Granted, she was a rare beauty, and the brim of her hat is so large it could shade a picnic, but that's not how Beaton brought her front and center. As the camera pans across the two hundred and fifty extras (all of whom Beaton forbade to sit down during the entire shoot for fear of wrinkling their costumes), every sumptuously clad woman is wearing a dress that has an overskirt, a peplum, a bell sleeve, a cape, a shawl, a swallowtail, or a full skirt—something that adds volume. Hepburn's beribboned head-to-toe lace costume is the only gown that is sinuously formfitting from shoulder to sleeve, and from neck to knee (opposite page, top). Leaner is keener, so Hepburn stands out from the crowd.

But who would ever suspect that Beaton would pull an "Edith Head" with Eliza's big moment? He took full credit for her costume for the Embassy Ball (above), yet the one-of-a-kind dress was not his design, but found in an antiques shop and refitted and refurbished. Regardless of who the real designer was, our first view of Hepburn in this resplendently beaded and embroidered Empire-waist Edwardian lace gown topped by a crimson cape, her neck latticed in brilliants, her hair piled impossibly high, is heart-stopping. Hepburn was Eliza transformed, yet she was unmistakably herself, which can only be defined as utterly vibrant. That's why there is no one to equal Audrey Hepburn. Look what she could do with a hand-me-down.

"STARLETT" O'HARA DRESS

Bob Mackie · 1976

"Went with the Wind" is the knee-slappingest laugh-'till-you-cry, funnier-each-time-you-see it film parody ever broadcast in any medium. In case comedy is not your genre, please note that the competition is stiff, although almost all other worthy contenders—"Lovely Story," "Sunnyset Boulevard," and "From Here to Maternity"—also come from the same source.

The Carol Burnett Show was the last of television's landmark variety hours. A radiant yet warm comedienne with a Broadway belter's voice and a winning favorite-neighbor-down-the-block demeanor, Burnett bolstered her universal appeal by surrounding herself with a repertory company of enthusiastic, endlessly versatile, and eager-to-crack-one-another-up comedic character actors (Harvey Korman, Tim Conway, Vicki Lawrence, Lyle Waggoner) fueled by a seasoned, irony-loving round table of veteran comedy writers. While Burnett's merry band were riffing on movie melodrama, television commercials, Broadway musicals, or their continuing soap opera "As the Stomach Turns," designer Bob Mackie was creating every piece of clothing seen on the weekly program, even the dresses Burnett wore when taking questions from the audience or tugging her ear at the show's close. "I never knew anyone could make me look as glamorous," admitted the self-effacing star.

Over the course of eleven years, Mackie created thousands of costumes for the show, but even he admits his comic masterpiece was his hilarious alteration of Scarlett O'Hara's elegantly makeshift gown, which she whipped up from the green velvet curtains hanging in her crumbling, post–Civil War Tara to impress a returning Rhett Butler. "I actually had a copy of Vivien Leigh's original dress from *Gone with the Wind*, but when we tried it on Carol it just wasn't funny," recalls Mackie. "It took me a few days to realize that what we needed for Carol's 'Starlett' was a real set of drapes. So I called the studio's prop shop and asked for a set of antique green velvet curtains, complete with thick brass curtain rod, finials, and gold braided tassels, the gaudier the better. Carol, who was game for anything, screamed when she saw it. 'What are you going to do with all that?' she asked. 'Tie it round you, and leave the rod in,' I replied."

The challenge, however, wasn't making the dress. "We were really just dropping the whole thing over a cotton gown," says Mackie. "The problem was getting it on her. Carol had to make her entrance at the top of the stairs. But the sketch's sets were just flats. To get up to the top of the grand staircase Carol had to stand on a steep ladder. So the wardrobe mistress, who was maybe five feet tall and weighed no more than eighty pounds, and I had to get up on two separate ladders and tie these heavy drapes around her." As Carol descended, complete with tasseled tieback chapeau, the audience went wild.

Korman's Rhett then asked her where she had found such a magnificent gown. With consummate timing, Burnett waited until the hysteria had waned just enough and then recited the verbal cherry to cap Mackie's can-you-top-this visual.

"I saw it in a window and I had to have it," she said, and brought down the house again.

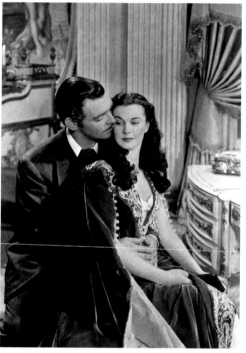

66 It provoked the
greatest blast
of laughter I'd
ever heard from
an audience.
And I've been
around forever. 99
—BOB MACKIE

DEBUTANTE DRESS FOR
A PLACE IN THE SUN

Edith Head · 1951

She was never merely pretty. Even at age twelve in *National Velvet*, she was blessed—or perhaps cursed—with an unsettling allure that owed nothing to childhood. At nineteen, the girl with the most beautiful face ever captured on film made her first appearance as an adult in *A Place in the Sun*, George Stevens's film adaptation of Theodore Dreiser's novel *An American Tragedy*. As spoiled heiress Angela Vickers, Elizabeth Taylor is the day-dream and night sweat of every young man with nothing but ambition, like George Eastman, the role played by Montgomery Clift.

For the scene where Clift kisses Taylor for the first time, Stevens asked costume designer Edith Head to create a dress for Taylor that would initially appear virginal in a long shot but prove irresistibly come-hither in close-up. What Head delivered was the ideal debutante dress echoing the style of the era, its strapless sweetheart bodice covered in five-petal white silk flowers. The full-length skirt was all tulle

with appliquéd flowers sewn on throughout. On most women who are only five foot two, the dress would have had a stunting effect. But according to studio records, Taylor's waist measured nineteen inches, so the severe diagonal geometry of the dress not only made her appear taller but even more buxom than the 36C cup she was.

During the early 1950s, this dress was the blueprint for virtually every prom dress sold. Though now commonplace, strapless dresses were not a style initially aimed at the young. But the big success of *A Place in the Sun* and the extraordinary electricity between Taylor and Clift—whom critic Andrew Sarris called "the most beautiful couple in the history of cinema"—helped turn a taboo into a trend. Watching George Eastman succumb to Angela Vickers's charms when the voluptuous and newly mature Taylor whispers to him, "Tell Mama. Tell Mama all," how many prom kings of that era wished their evenings had ended so memorably?

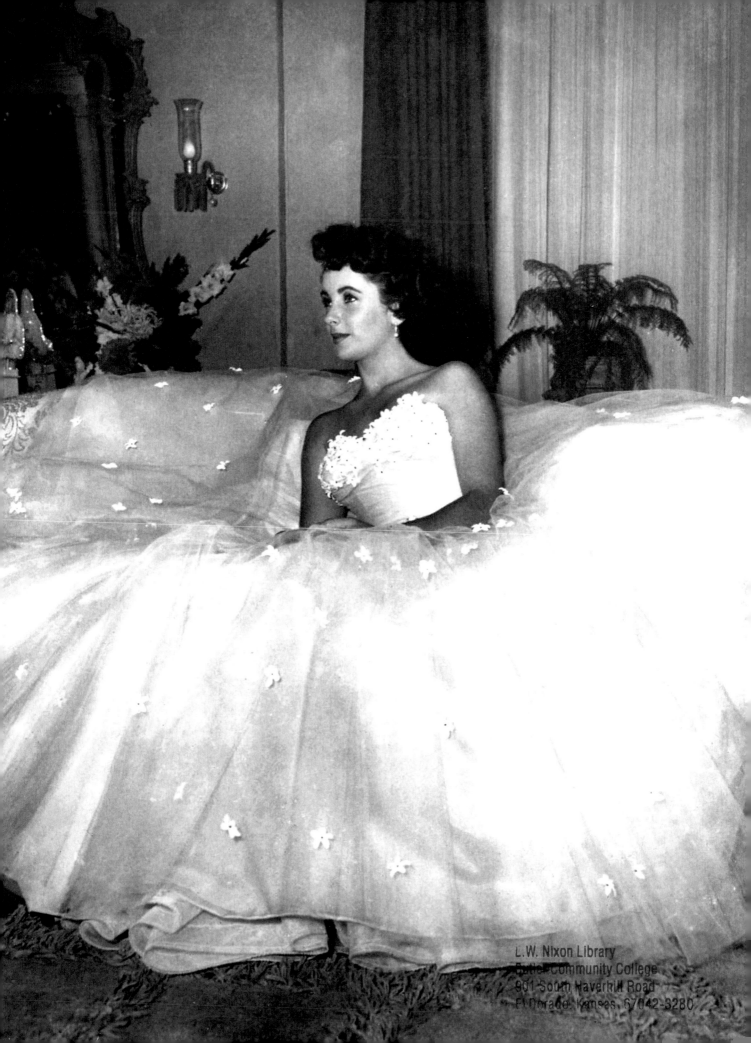

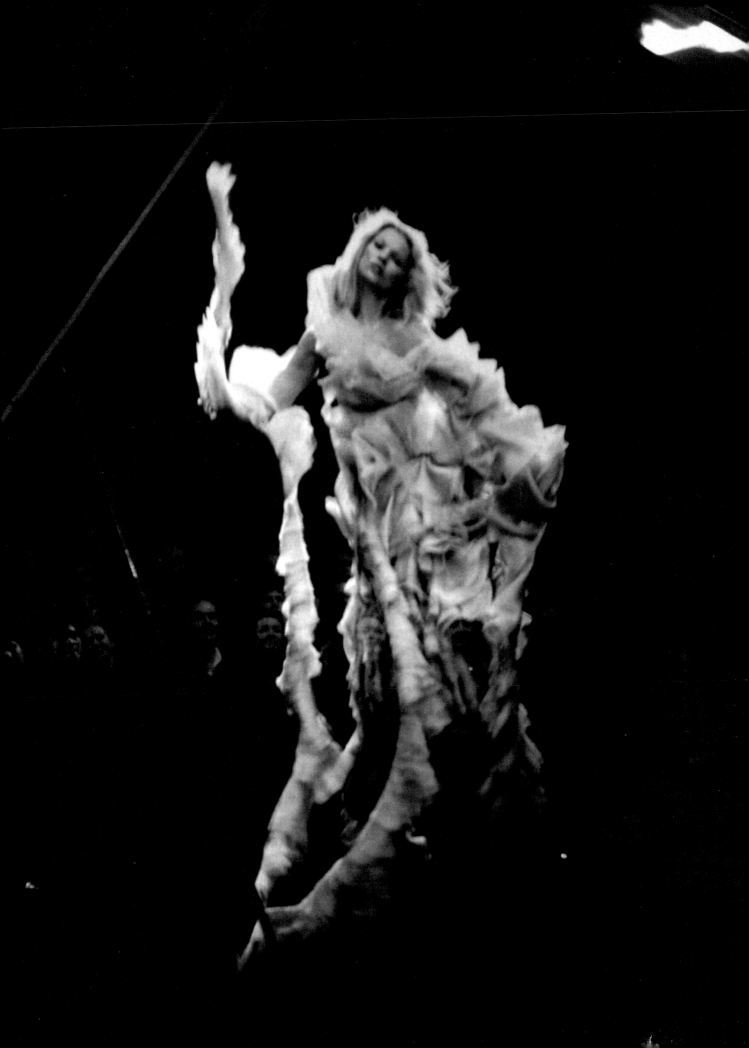

HOLOGRAM GOWN

Alexander McQueen · 2006

Though he freely admitted feeling truly alive only when he was preparing a show, Alexander McQueen thrilled us for years by conjuring elaborate, sometimes inconceivable, but often breathtakingly memorable presentations of his work that possessed the common thread of entrapping his models in inescapable situations. For his fall 2002 collection, some of his models, bound in leather harnesses and yokes, were chained to wolves they were taking for walks inside La Conciergerie, the Paris fortress where Marie Antoinette was imprisoned. For his fall 2003 presentation, McQueen sent a model through a glass wind tunnel, where she had to propel herself forward against fierce gales, the hand-painted fabric of her clothes flying dramatically. And for his spring 2004 collection, he trained twenty models to dance, then paired them with twenty ballroom professionals to engage in a mini–dance marathon based on the 1969 film *They Shoot Horses, Don't They?*, colliding and collapsing in fluid Depression era-inspired clothes.

But McQueen focused on only one dress to create the technological marvel that was the climax of his fall 2006 presentation. The show began quite straightforwardly, provided one could avoid staring at the formidable glass pyramid the models were walking around. In fact, in this collection, McQueen had distilled some of the loveliest elements of his past ones, highlighting his Savile Row training with precisely cut Edwardian waistcoats and jackets, some with wide, nearly portrait collars, others sporting the boldly beautiful tartans from his controversial fall 1995 "Highland Rape" collection (criticized by many for being misogynistic), now almost girlish with exquisitely wrought embroidery and Victorian petticoats. The only eccentricity came in the form of disquietingly ornate ornithological hats (his fall 2005 collection had been inspired by Hitchcock blondes, so the hats may have been a knowing homage to *The Birds*).

Near the end of the show, however, the intensity and volume of the gowns increased, becoming more dreamlike in their design, with endless folds and falls of ruffles. Then the lights went dark. A puff of smoke shot through the inside of the glass pyramid, twirling as if rising from a magic lamp until it mysteriously began to take on the form of Kate Moss, the model's curled long blond hair defying gravity as her arms swayed in cascades of organza ruffles on a white dress drenched in iridescent blue light so elusive you'd swear it couldn't be real. It was, in fact, a state-of-the-art hologram McQueen created in conjunction with video director Baillie Walsh.

Just before viewers thought they might be able to take it all in, the image vanished like a vision of Shangri-la. And yet, when the house lights came up, and the models entered in formation for their final circling walk, there, at the end of the line, was Kate Moss, as real as the incredible gown she was wearing, the same one that had transfixed the audience in a holographic haze.

Despite his penchant for shock effects, his drama-queen antics, and his fascination with new technology, McQueen was at his best when he exposed what he too often suppressed—his romanticism. Just as the dresses from both his dance-marathon collection and his heartbreakingly lovely final collection (presented soberly after his death, one dress of which is shown on Cate Blanchett on page 132) didn't need a conceit, the impact of Moss's gown was undoubtedly amplified by the hologram. The gown was ovation-worthy on its own. But what the pyramid revealed was a man for whom beauty came so easily yet one who never believed it would remain within his grasp unless he trapped it.

Alexander McQueen was a Barnum-worthy showman, a once-in-a-generation artist of possibly limitless scope and skill. He was more than those who love fashion could wish for. Sadly, that wasn't enough for him.

CHINOISERIE GOWN

John Galliano for Dior · 1997

While Giorgio Armani is solely entitled to bragging rights for laying the groundwork for the designer-celebrity hookup during the early 1980s, initially these were just-between-us liaisons conducted with a quiet grace. The intent was always promotional, but there was mitigating evidence of a loyalty factor. Anjelica Huston and Jodie Foster didn't just wear Armani—they *always* wore Armani.

But at some point fidelity vanished, the competition began, an unacknowledged but undeniable hierarchy of woo-worthy actresses was unofficially posted, and a spirit of seduction took over. Friendship was still a factor, but it became obvious that stars (and their now ever-present stylist go-betweens) were far more pliant when designers came bearing spectacular one-of-a-kind gifts.

And this Galliano gown for Dior is the dress that set off the frenzy.

Galliano's dress was unlike any other anyone had appeared in on a red carpet before—a streamlined explosion of shimmering chinoiserie, framed in many hours' worth of painstakingly hand-stitched silk floral embroidery, with a back latticed in crystals and beads so intricate it could have been created by a spider spinning its way out of a jewel box. This wasn't merely a sensational creation. This was haute couture–claiming turf. And it arrived on the perfect vessel, Mrs. Tom Cruise. Despite her presence in nearly a dozen films since meeting her husband on the set of *Days of Thunder*, Nicole Kidman had yet to star in a breakout hit, so playing wife to the most popular film star in the world—in addition to his being the cover boy for *People*'s "The 50 Most Beautiful People in the World 1997" issue— was still her most conspicuous role.

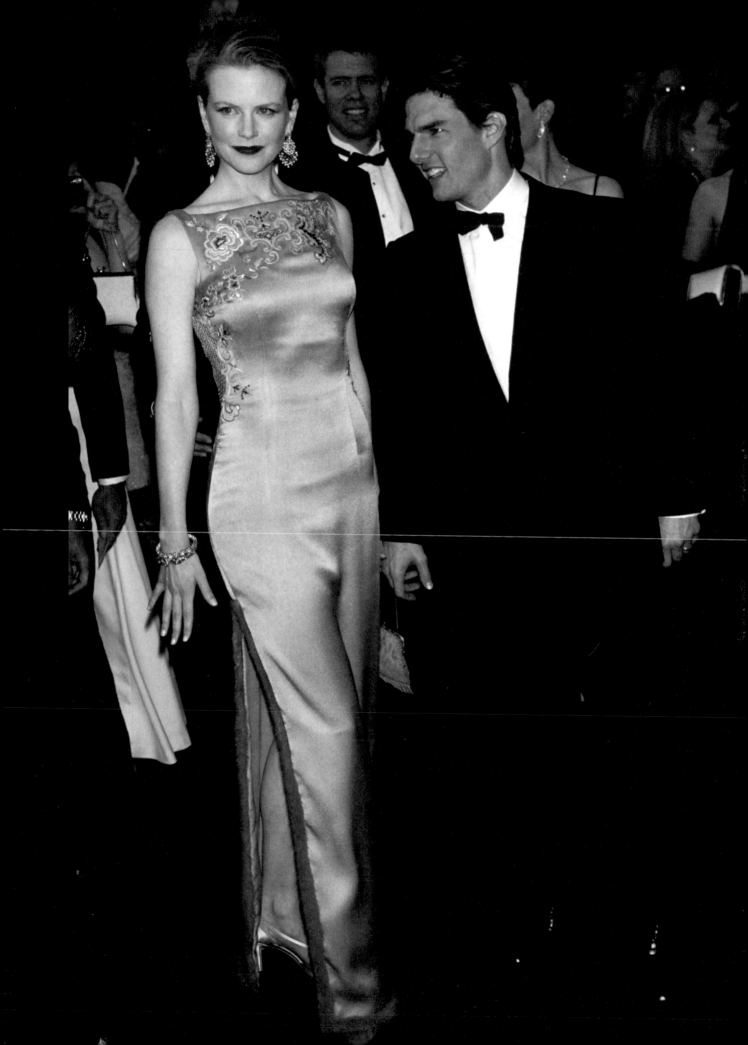

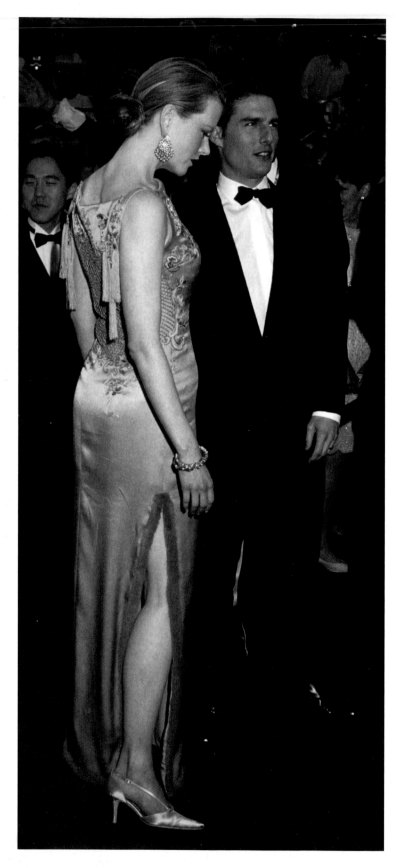

The Academy Awards changed all that. The electrifying combination of the actress's flame-haired beauty and Galliano's striking blink-twice chartreuse, as well as Kidman and stylist L'Wren Scott's trend-defying decision to shun traditional carats-heavy diamonds in favor of Martin Katz's Indian-inspired bejeweled golden disks, created a total look that was nearly the equivalent of Kidman's landing her first blockbuster film.

The dress was also a major hit for Dior's new designer. At the time, John Galliano had quickly become a fashion-industry crush due to his wit, idiosyncratic personal style, and sweepingly romantic talent, but he admits, "I was the new boy at the big house of Dior, and there were more than a few people who didn't think I could cut it. Because Nicole was willing to show the world she believed in me, I wanted everyone to see her step out from her husband's shadow." Television's talking heads, trained to respond to primary colors and pastels on movie damsels, bristled. But time has shown that this daring gamble added a new edge to the fashion competition at subsequent award shows. While ready-to-wear elegance is nothing to sneer at, haute couture has become Hollywood's new high bar, only partially because of its incomparable artisanry. Not only does a couture gown cost in the six figures, but shipping one can cost in the tens of thousands. So for a female star, being loaned Chanel, Dior, or Valentino haute couture affords her bragging rights that are almost as satisfying as a boffo opening weekend at the box office.

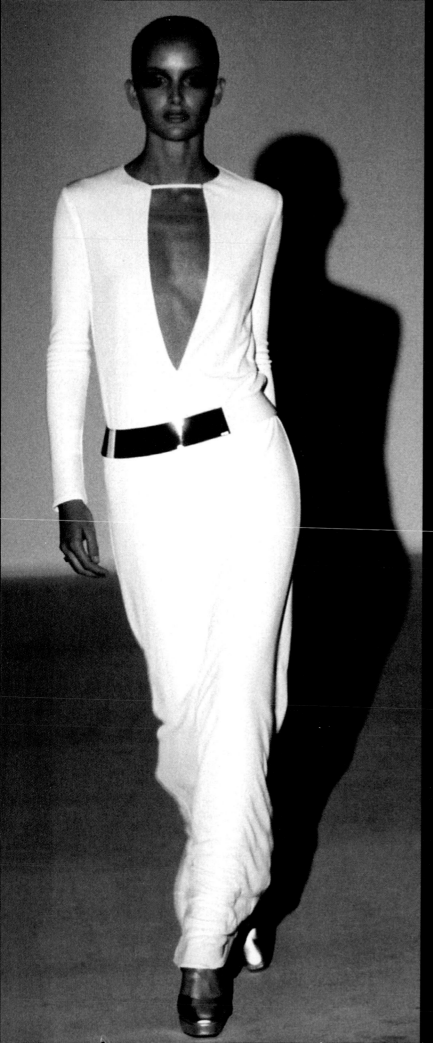

THE WHITE DRESS COLLECTION

Tom Ford · 1996

When he walked away from designing womenswear in 2004, legions of fashion editors, retailers, stylists, and photographers reacted as if they had lost the love of their life—and not all of the mourners were women. Had his talent been even minor, Tom Ford would be recognized as one of fashion's great seducers. Yet, as shrewdly aware of the power to activate pheromones as he is gleefully confident of his aesthetic, Ford revitalized the nearly stagnant and financially troubled century-old Gucci brand into a fashion powerhouse of the 1990s by assuming a Dionysian-like position as arbiter of the urbane yet overt come-on. Each season at Gucci he would take at least one of the house's classic signatures—horse bits, stirrups, the interlocking Gs, the inimitable red-and-green banding—and transform them into totems of seduction. The response was equal to Gucci offering free guzzles from Ford's fountain of youth in his backyard.

But for his spring 1996 collection, Ford chose to look outside Gucci's archives in order to make a revolutionary leap forward. Unhitching himself from the house's sartorial safety nets and symbolism, with a gracious nod to Halston, Rudi Gernreich, and Geoffrey Beene, Ford ventured as close to minimalism as he ever had before, sending out body-caressing white silk-knit jersey T-shirt gowns, each with unique strategic skin-baring cutouts: a keyhole at the breast, the absence of side panels along the torso, or a hole at the hip just large enough to hold a thin gold sculptural variation on the trademark GG. The reaction

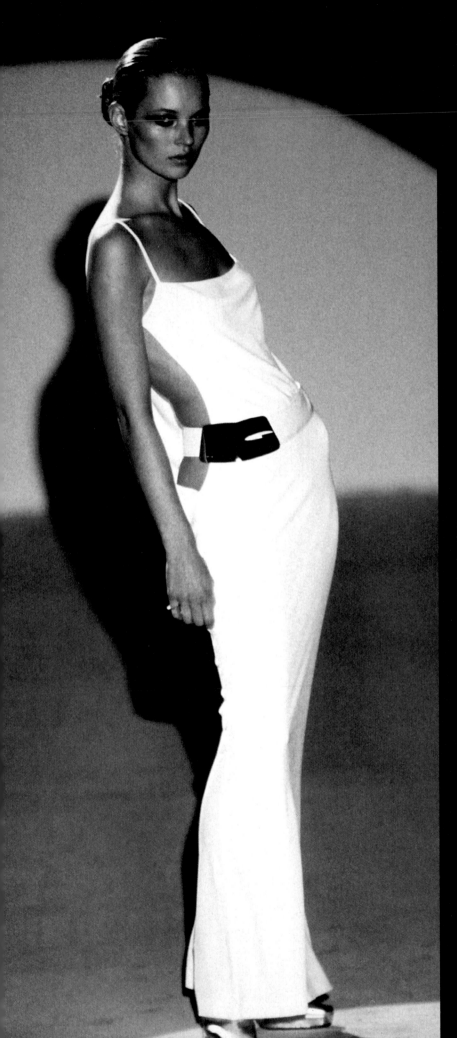

to the collection was immediate and rapturous because Ford, as insinuating as he was arrogant, was making two declarations. From now on, Gucci would be recognized first and foremost for its fashion, instead of as a venerated brand with an iconic logo and a go-to reputation for leather goods and loafers. Additionally, the Gucci brand would be synonymous with sex. In fact, starting with these white dresses, every subsequent collection and ad campaign was built around a sexuality far more in-your-face than playful, with one campaign even featuring pubic hair shaved into the GG logo. This new positioning redefined the brand and redefined Ford. Until his departure from Gucci, any designer creating a collection steeped in sensuality was tagged as following his lead.

A man so on-target in exposing a woman's erogenous zones with such accuracy is worthy of homage. For a gay man to pinpoint them implies near-spectral power. No wonder retail greeted his return to ready-to-wear in the fall of 2010 with an elation which matched that of the 1990 reunification of Berlin.

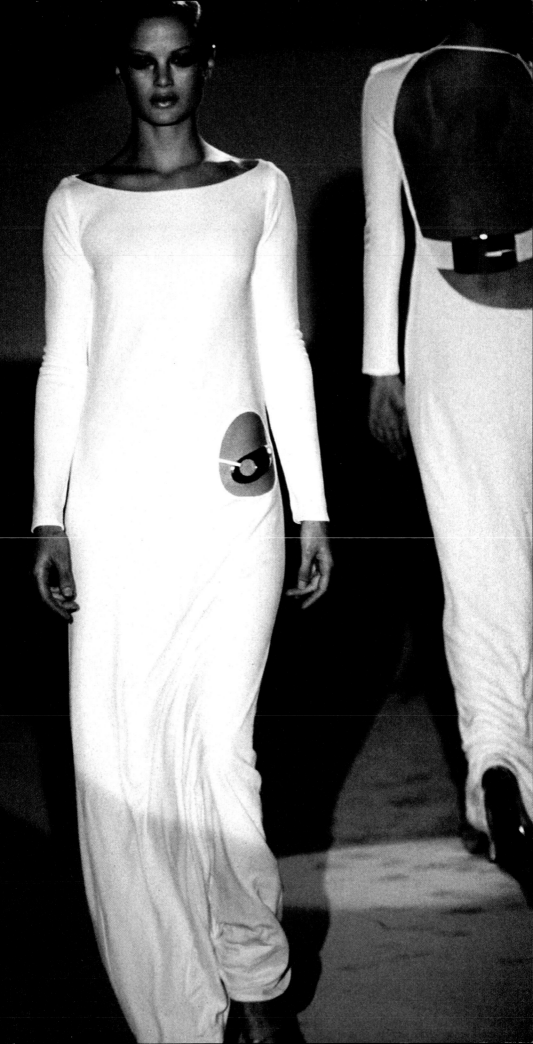

SATELLITE DRESS

Giorgio Armani · 2010

It's a toss-up as to who benefited most from this duo's stealth sartorial attack at the 2010 Grammys. Was it the young woman who so threatens the wattage of every other pop singer's spotlight that contemporaries as formidable as Beyoncé, Rihanna, Christina Aguilera, Pink, and even Carrie Underwood have forsaken routine runway fashion to play Extreme Costume Makeover in both concerts and videos? Or was it the Silver Lion of Milan whose birth certificate boasts fashion's most recognizable name?

The collaboration of Lady Gaga and Giorgio Armani, not once, not twice, but four times during the 2010 awards telecast was an unforeseen, unequivocally triumphant hijacking. So intergalactically fabulous were the combo's polished, planetarium-ready creations—from the quadruple diagonal lightning-bolt headpiece to the asteroid-size crystal shoulders Gaga wore while playing opposite Elton John—that there was no chance of looking anywhere or at anyone else. Even those at home bearing witness via flat screen could see the look of defeat on Gaga's fellow nominees' faces. Mind you, this was before she won her two golden Victrolas.

No doubt the crestfallen expressions began at the sighting of Gaga's initial look. Below a sunburst-yellow mane, she was cocooned in a construction that offered enough similitude to qualify as a gown but was actually a fitted bodice and bell-curve skirt that served as a gravitational base camp for an orbiting mesh, tulle, and metal galaxy. The multiple encirclement actually bore a startling resemblance to the scene in *Superman II* when the Man of Steel, driven to turn back time to undo Lois Lane's accidental death, circumnavigates the globe

with such speed (to reverse its rotation) that his entire girding path remains visible. On this particular night, though, it was Lady Gaga's world, and welcome to it.

What made the Armani-Gaga coup so delicious was that it was both an unpredictable polar-opposite collusion and so secret that it was never leaked to the press. Despite all the prevalent collagen use, the fashion industry thrives on loose lips, so this stunt was about as good a "gotcha!" as it gets. But even if it hadn't been a surprise, the night registered as a big win for Gaga and Armani, though for different, if complementary, reasons. It's been written that Ginger Rogers gave Fred Astaire sex appeal, while Fred gave Ginger class. Similarly, Giorgio Armani brought the Fame Monster credibility as a fashion muse, while she ensured him a much-craved shot of cool.

Unlike contemporaries such as Valentino, Emanuel Ungaro, and Calvin Klein, who have either happily or reluctantly left the industry, Armani has intensified his involvement in his aggressively expanding empire. In addition, he has been unashamedly vocal in his perception that every designer in the marketplace, new or established, young or old, is a potential combatant. Having recently embarked on some sharp turns off the greige-brick road that leads to his multibillion-dollar Oz, Armani has produced several collections (most prominently, his way-beyond-futuristic haute couture presentation for spring 2011) that have confused fervent fans and customers due to bolder uses of color, a more overtly sexual thrust, and drastic detours from minimalism. But dressing Lady Gaga was Armani's declaration that he has no interest in playing the éminence grise or in doing what's expected of him. He'd rather have a blast.

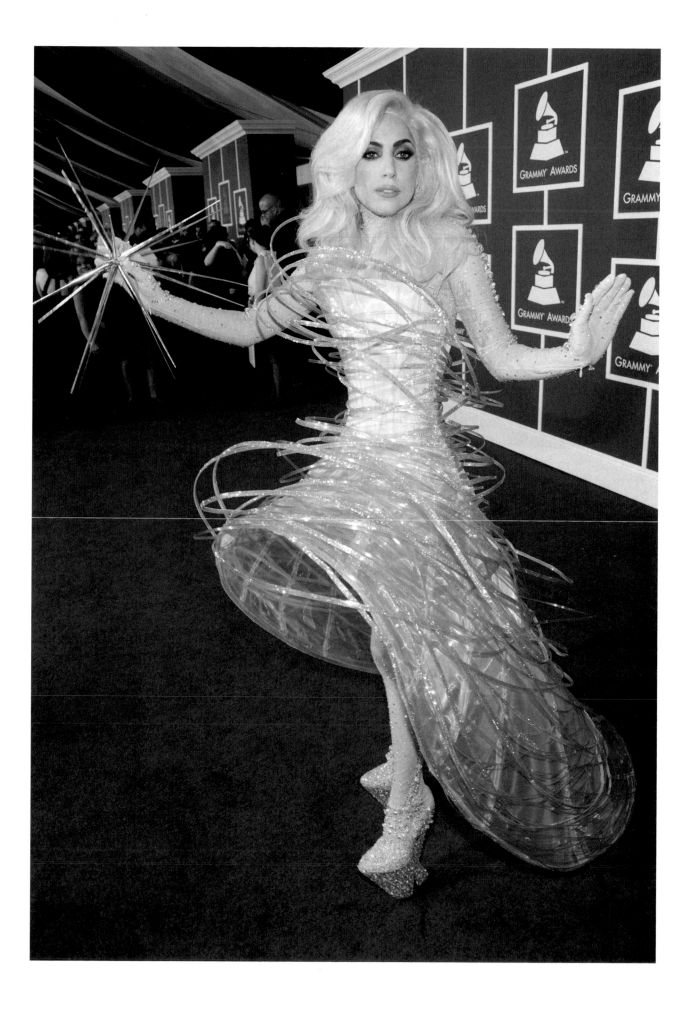

BANDAGE DRESS

Hervé Léger · 1989

In 1989, Hervé Léger had already been in business for himself for four years but had yet to have that runway moment that set his label apart from the competition. Though he had worked for a half decade designing everything from swimwear to bouclé suits for both Chanel and Fendi, he related more to the sensibility of Tunisian designer Azzedine Alaïa. Léger admired the more obvious sexuality of Alaïa's clothes, which were cut close to the body, accenting women's curvaceous torsos, thanks to the designer's inclusion of Lycra in his fabrications. Léger believed that an even more emphatic silhouette of the female form was what he needed to achieve, so he searched mills for a fabric that would enhance a woman's body, as well as hold her curves in place. Léger found what he was looking for in one factory's discard bin, which was stacked high with cut strips of thick stretch material used to make foundation garments.

Léger began by wrapping the bands in different configurations around a dressmaker's form until he settled on his design: a horizontal-banded, thin-strapped, V-necked mini that, not surprisingly, looked like a very dressy version of a very long line bra. He called his creation the "bandage dress."

Léger's original version of the dress was fabricated from nylon, with both rayon and, most important, spandex woven throughout. Wearing the dress was an obvious self-declaration of bombshell status, and the dress did its utmost to support the message by manipulating the wearer's body into an hourglass shape reminiscent of—depending on which critic you read—a halter-neck one-piece swimsuit that pinup starlets modeled in the 1950s or a "very glamorous mummy," according to Amy Spindler of the *New York Times*. Whatever the allusion, the dress was an instant smash, selling as fast as Léger created variations of it—strapless, scalloped or striped, with crisscrossing bands on the back or with a fantail to create a longer gown. As timeless as it is recognizable today, no an awards season goes by without some star turning up "bandaged."

Unfortunately, though he designed other clothes for the runway, Léger's label was regarded as a one-trick pony that eventually couldn't hold its own against a legion of imitators. In 1999, his company was acquired by Max Azria (the first time an American design company bought a French one). While Léger was promised a free hand and full support, he was ousted within six months. Léger still designs, under the name Hervé L. Leroux, but most of his dresses are crafted in stretch jersey in a draped style that recalls the early work of Madame Grès and Guy Laroche.

Many retailers now produce a version of the bandage dress, with prices as low as twenty-nine dollars. However, Azria has relaunched the Léger line using the original fabrication and process and sells the dresses for about fifteen hundred dollars. Is there a difference? Put it this way: there is a very fine line between sexy and tacky, and it's a long way between twenty-nine and fifteen hundred dollars.

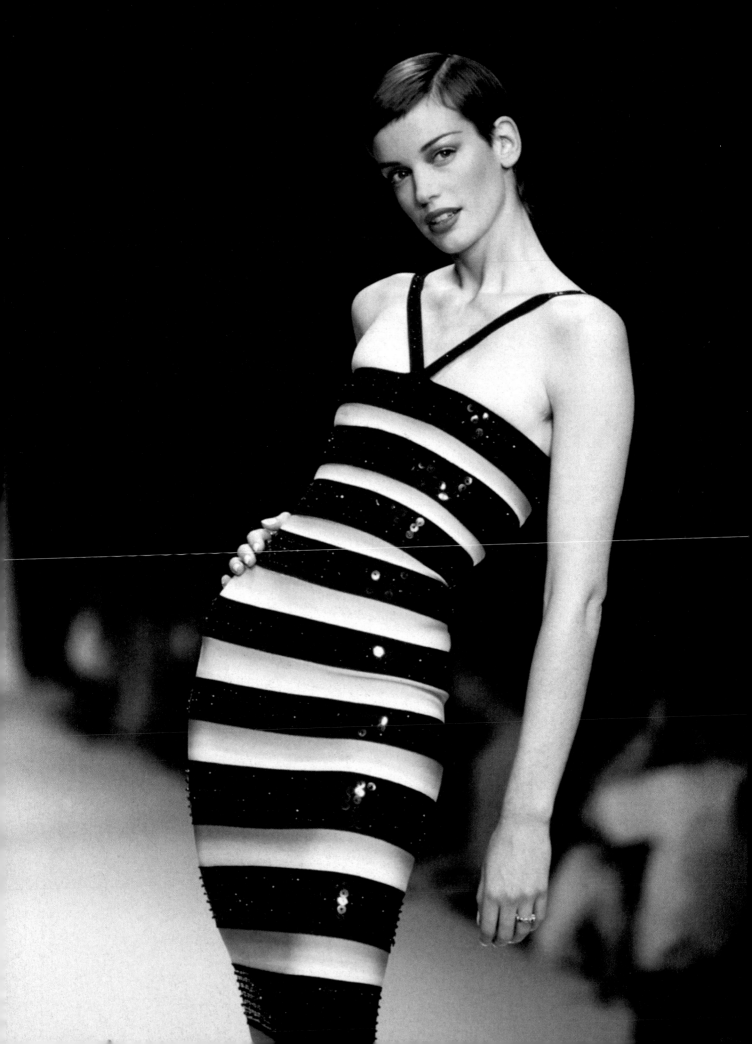

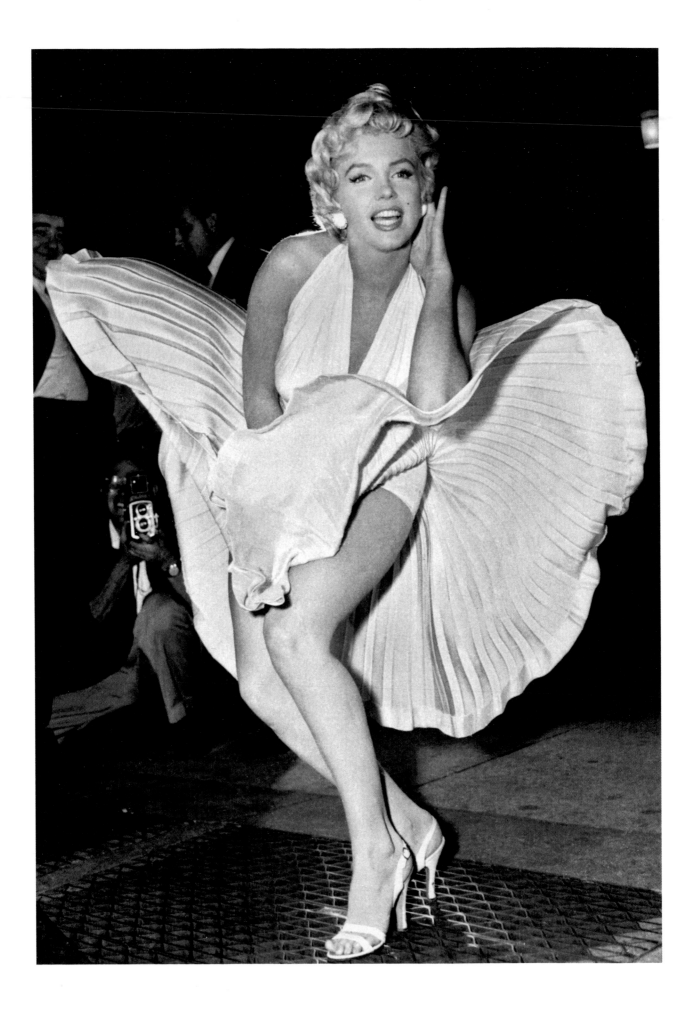

WHITE HALTER DRESS FOR
THE SEVEN YEAR ITCH

William Travilla · 1955

The image of Marilyn Monroe giggling while standing over a subway grate in Travilla's white halter dress has been gauged as the second-most-marketed screen image of all time; only King Kong holding Fay Wray has her beat. Why the continued frenzy for an almost sixty-year-old summer halter? Because of how it looked on the woman who wore it. As an icon, Marilyn is still regarded as a watermark for beauty, sexual joy, and innocence. Her uncensored blush of celebration is what's at the heart of this dress's appeal.

For this scene in *The Seven Year Itch*, filmed in the heat of summer in New York City, Travilla (who created most of Monroe's screen wardrobes) designed a classic pleated halter dress using sunburst pleats converging at the waistband of the skirt to emphasize Monroe's hips, as well as bring the eye to her cleavage. But what elevated the dress to immortality was director Billy Wilder's decision to place the bountiful movie star over a subway grating on Lexington Avenue and Fifty-second Street and then wait for the back draft of a train zooming to Grand Central Station to give Monroe's skirt a lift. Unfortunately, the crowds grew so large, rowdy, and flashbulb-happy (Monroe's eager playfulness only egged them on), they made it very difficult for Wilder to shoot and caused baseball great Joe DiMaggio, the star's husband at the time, to leave in a huff. The scene actually used in the film was shot in a studio.

Once the film was released, the scene itself, the stills, and the movie poster of Monroe coyly trying to tamp down an unwieldy, weightless dress in the ecstasy of an updraft immediately cemented this image in the public's mind, an enduring symbol of summer in the city and titillation at its daydreamy best.

Today, that image is as strong as ever. You can buy copies of the dress on eBay. It comes in plus sizes up to 24 as well as petite (Monroe was a size 12 to 14). Prices range from eight to one hundred forty dollars. Several websites make emphatic claims to have one of the originals. Debbie Reynolds bought an authentic one for her now-defunct Hollywood Motion Picture Museum and has supposedly never sold it.

The impact of the image is so strong that the marketplace is perpetually flooded with merchandise galore based on this famous image: more than a dozen different versions of the film poster, copies of Travilla's charming original sketches for the halter neck in white (the star's favorite color), porcelain and crystal dolls, and even ashtrays painted in a high glaze or made of metal are among the scores of goods out there. My favorite venue for the dress, however, is a website that sells three versions of the dress in different stages of liftoff. Touch any of the three dresses at a specific point, however, and it flies even higher by way of an attached battery pack. They even throw in a grating for you to stand on. And, of course, there is a Facebook page, just for the dress.

TURTLENECK MINIDRESS FOR *LIZA WITH A 'Z'*

Halston · 1972

All performers age past their primes. Some evolve with grace or wisdom or insight to reveal new facets of their talent so that we never stop marveling at their hold on us. Liza Minnelli, however, is one of entertainment's most compulsively watchable broken unicorns. Adored, ridiculed, chronicled, but never ignored, with each comeback, we watch Minnelli perform while holding our breath, pouncing on flashes of magic, seeking sparkle from her Betty Boop eyes, applauding her carefully rearranged musical "adjustments," rallying behind her pity-free self-deprecation, and filling gaps and gaffes with kindnesses that come from total recall that kicks in whenever we revisit performers who have earned the right to be identified solely by their first name.

Liza has earned all this because there was a time when she was the ultimate all-around entertainer. By 1972, she had already blown everyone away with her performance in the film version of *Cabaret*. Surrounded by many of the same collaborators who all lived by her code of "nothing exceeds like excess," Minnelli plotted with director Bob Fosse, *Cabaret* composer John Kander, and her two best buddies, *Cabaret* lyricist Fred Ebb and designer Halston, to create *Liza with a 'Z,'* an hour-long firecracker taped at the Lyceum Theater on Broadway and then broadcast on NBC. She sang, she danced, she reminisced, she clowned, and she killed. You name the award, *Liza with a 'Z'* won it, even a Peabody. (Minnelli is one of the few performers to have won acting's grand slam: Tonys, an Oscar, Emmys, and a Grammy.)

While Liza could move, she wasn't really a dancer. She didn't have a dancer's body. Short (five foot four), built too thick and solid, she didn't possess the long limbs, neck, and lithe torso of Fosse's muse and former wife Gwen Verdon. But Minnelli had ferocious sass, worked Fosse's trademark bowler hat as if it held her life force, and best of all, like her mother, Judy Garland, she had good legs. That's why in virtually every costume he created for her, Halston made sure that below the neck, the legs were the focus, never more so than in her dance routine based on Joe Tex's tub-thumpingly horny R & B hit "I Gotcha." Much of the choreography throughout the telecast was overtly sexual for its time, in a finger-pressed-to-the-lips "aren't we naughty?" kind of way. "I Gotcha" is Fosse at his down-to-my-last-pack-of-smokes coarsest: the number is all hips, bumps, kicks, squats, and thrusts.

Halston's costume for Minnelli was as crafty as the choreography, for it suited her perfectly. Adapted from one of his signature runway looks, the sleeveless, high-armholed, thigh-high, body-skimming, scarlet-sequined turtleneck micromini lengthened her torso, minimized her ample breasts, fudged her never-thin waist, and stopped just in time to focus on those gams. Red tights and red tap shoes added to the body elongation. Bookending her with two strapping backup dancers in wide black cowboy hats, big black boots, and wide ruffled shirts (a feyer composite of the Village People if that's at all possible) only made her look even more—well, if not demure, then at least nimble.

For Minnelli, the turtleneck minidress became her uniform. She wore variations of it on her concert tours (in black and white, as well), and it became her go-to disco outfit for years. Halston used the same shade of red when creating costumes for her Broadway musical *The Act* six years later. She'd never get away with it now, of course, but even in her midsixties, now riding high on yet another "return," Minnelli still has legs.

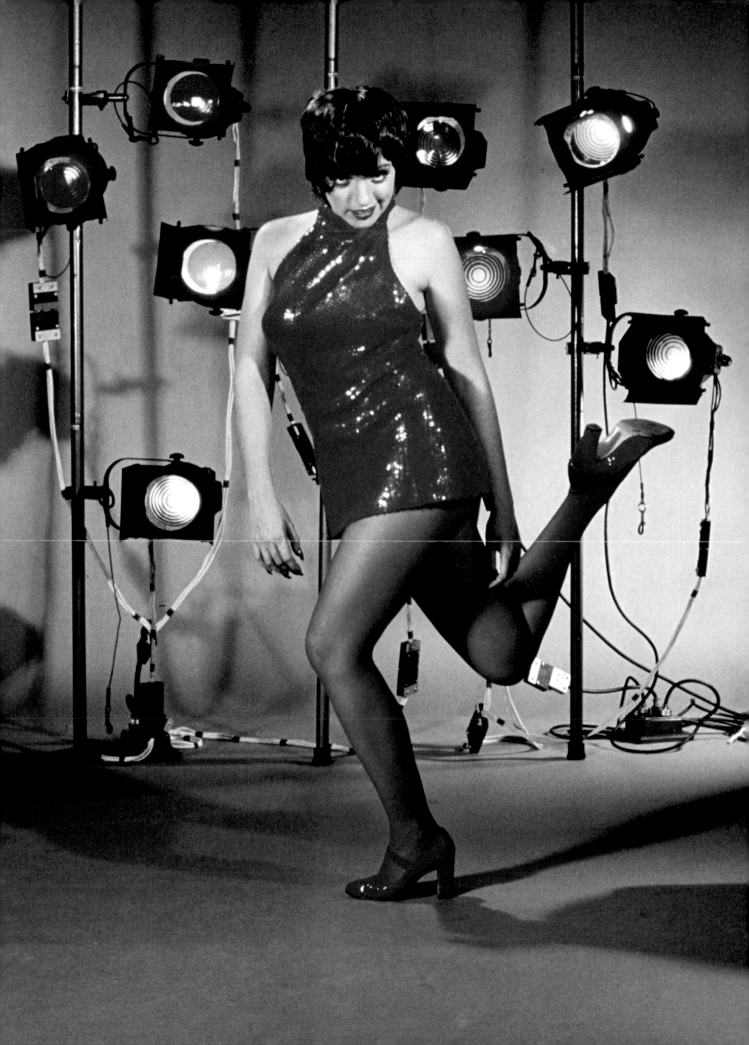

GOLDEN-AGE GOWN

Vera Wang · 2000

The diva-driven myth surrounding the creation of this gown has it that Charlize Theron walked into Wang's studio, placed two Fred Leighton art-deco diamond clips on a table, and asked her to design a dress around them. When asked about the story, Vera Wang said, "I love it! And honey, Charlize is demanding. But that's not how it happened."

The truth is that as the seventy-second annual Academy Awards approached, Theron was shooting Robert Redford's golfing film, *The Legend of Bagger Vance*, which was set in the 1930s. With her hair already bobbed for her role, Theron contacted Vera to ask if she would be interested in creating a gown evocative of the era. A first glance at the dress suggests that Vera's vintage referencing borrows from the slinky charmeuse peignoirs worn by worldly screen sirens like Jean Harlow, Norma Shearer, and Myrna Loy as they strode across Bakelite floors on their way to posing supine on a divan. But Wang's retrofitting ends there.

To begin with, or in this case, to end with—the back of Theron's tangerine chiffon gown never would have made it past that era's film-censoring National Legion of Decency. "We came real close," said Wang about the low-as-you-can-go open back. "We were within centimeters of danger. And Charlize is so tall with a wide dancer's back [the South African star spent a good part of her youth in demi-plié and danced with the Joffrey Ballet] that there's a lot of handsomely toned flesh walking away from you."

As for the commanding color choice, there's more to it than finding the bolt of chiffon with just the right shade of bright tangerine, insists Wang. "You can't get that depth of color using only one shade. You have to build one tone on another, like the way colors intensify in a Mark Rothko painting." The dress is actually multiple overlays of chiffon, each a different hue, including pistachio, lemon, vermilion, and pink, which gave the resulting tangerine a unique iridescence. The gown's radiant color applied to its daring architecture sinuously grazing Theron's statuesque form—along with her hair and makeup's handsome reference to the look of Hollywood's golden age—turned out to be far more riveting than the finished film that had initially inspired her.

Wang insists, however, that "the diamond clips were Charlize's additions, not mine, as was her hair and makeup. Don't get me wrong. They're fabulous pieces, and I'd sooner she wore those than a necklace. But I don't know, with that posture and that face, did she really need them?" Wang forgot to add, "And with that dress!"

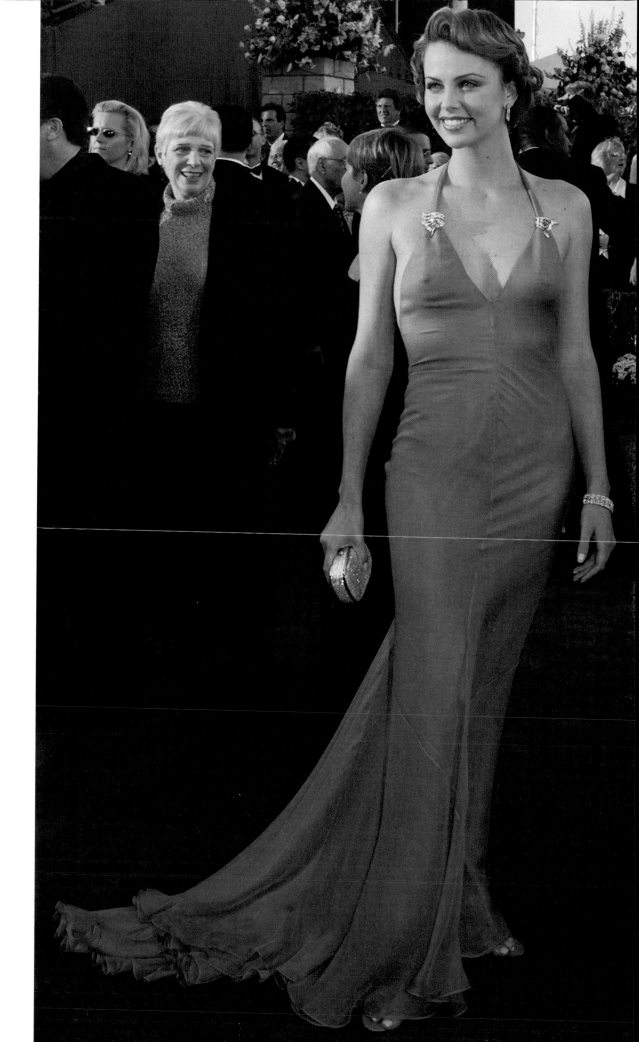

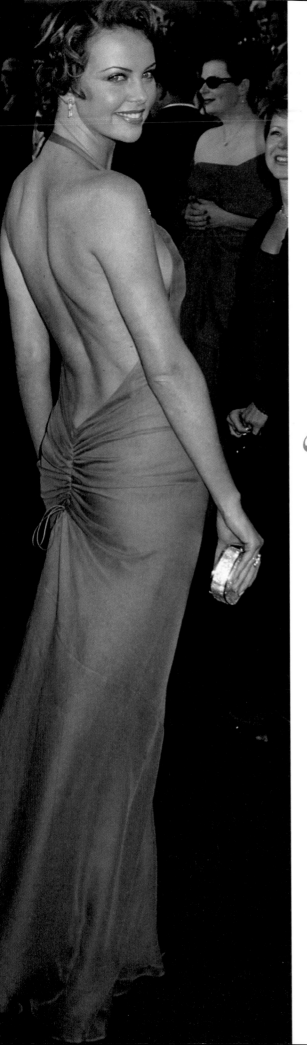

66 What's so sexy about a deep V in the back is that not only is it very erotic, but the wearer no longer sees it once it's on. Women are forever readjusting deep cleavage. They forget about being bare back there. But we don't. 99

—VERA WANG

PSYCHEDELIC GOWNS FOR THE SUPREMES

Michael Travis · 1968

When Berry Gordy, Jr., created Motown's "House of Hits," his goal was to take R & B and soul music mainstream so, not only would his groups' singles be able to reach number one on the pop charts, but his singers might gain enough respect to break out of what was known as the Chitlin' Circuit, the name commonly ascribed to a loosely linked chain of clubs, dance halls, dives, and theaters that made up almost all the venues where black performers could appear without incident. Gordy had his sights set on high-end boîtes and nightclubs, such as the Copacabana in New York City, the Cocoanut Grove in Los Angeles, and the Sands Hotel in Las Vegas.

The supper-club-infused glamorization of Berry's girl groups, including Martha Reeves and the Vandellas and the Marvelettes, began with Motown's charm school, run by Maxine Powell. She forbade cursing and gum, and taught the girls how to dress and act like ladies. But Gordy never took his eyes far off his prize trio, the Supremes. He was sure they were destined to reach the top, for not only did they have a sound more feminine and kittenish than any girl group on any label, but more than anyone else at Motown, Gordy knew Diana Ross was going to be a star.

They say in business that you should dress for the job you want to ascend to. So as soon as the group started earning money, Gordy started outfitting the Supremes for the big time: simply, chicly, and identically. With their hair straightened and coifed, eyes prominently lined, and shift dresses perfectly pressed, the Supremes were polished and presentable to white American television audiences. The Supremes had their first big hit, "Where Did Our Love Go?" in 1964 and by 1965 they were touring the world. That's when Berry tossed out the shift dresses and moved them into attention-getting gowns.

The Supremes' gowns were like spin art: body-hugging Vegas-ready creations that riffed off op art and some of the more fluid patterns that were being integrated into costumes for English bands infiltrating the rest of the world in what is known as the British Invasion. The earliest gowns looked better from a distance: they sparkled, but they were not that well made and did not hold up on the road.

But when the group started appearing on television, Gordy connected them with Michael Travis, a costume designer for NBC, who more than anyone did the most to enhance their new shimmer-friendly image, particularly when the Supremes landed their

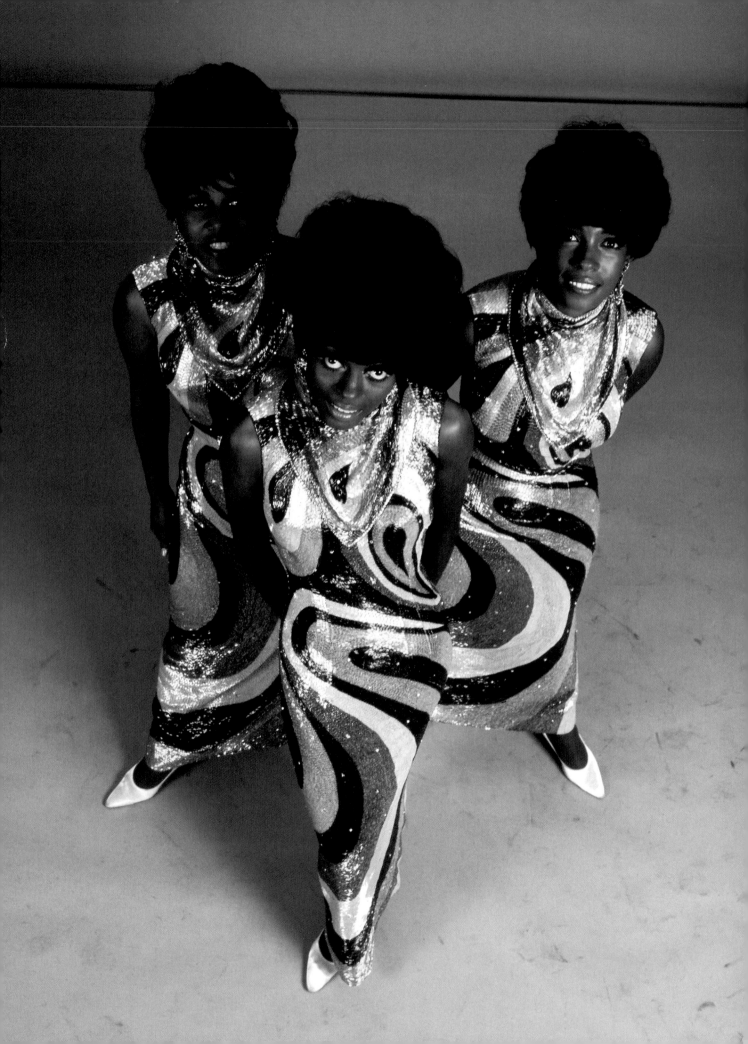

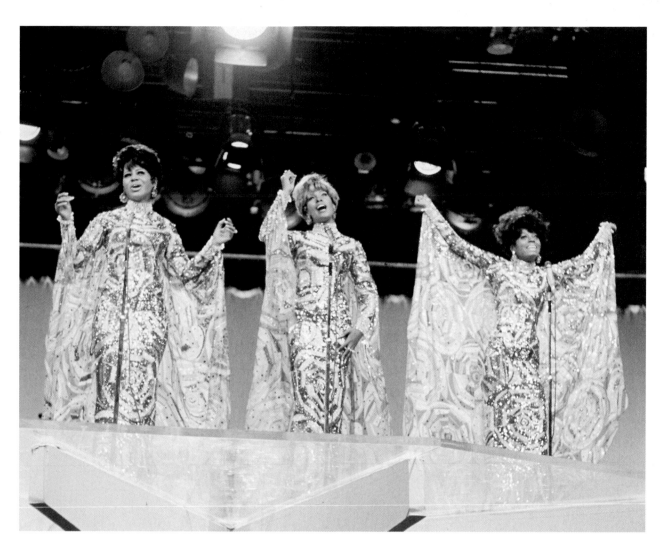

first special. For *TCB* (*Taking Care of Business*), starring the now renamed Diana Ross & the Supremes along with the Temptations, Travis went wild with his designs. The girls—in high-necked sleeveless lemon, white, kelly-green, and emerald-green sequined gowns (opposite)—made their entrance onto a clear glass central stage atop a multipronged pedestal. For the show's central performance, a speeded-up medley of their hits, they strode out in their most flamboyant "Mackie-vellian" costumes yet (above), riffing off the showgirl-loving designer's splashy showmanship: identical funnel-necked, long-sleeved gowns resplendent with myopia-inducing disks, each seeming to rotate in concentric circles of gold, yellow, rust, black, white, and red sequins. As if that wasn't dizzying enough, the dresses had long sheer capes made from a fabric that mimicked the dress pattern attached to the sleeves so that when the Supremes raised their arms, the effect

was that of kaleidoscopic bat wings. At the end of the show, Diana had a solo, a Martin Luther King–themed version of "Somewhere," which she performed in a white-crystal-dotted long-sleeved gown with a jeweled bib. They all wore the same dress later that year when they met Her Majesty Queen Elizabeth during their European tour.

Bob Mackie did work with the Supremes a few years later, and Travis went on to do the costumes for other television programs. But Travis has never received the credit he is due for his integral contribution to the Supremes' image, not to mention the ripple effect it had on other soul groups in the industry. The public became aware of his work only when Mary Wilson cited him during interviews promoting an exhibition of Supremes costumes on display at London's Victoria and Albert Museum in 2008. It's too bad "You Can't Hurry Love." Travis deserved better.

THE PLUNGE

Donatella Versace · 2000

No single outfit has ever caused more commotion on any red carpet anywhere. Love it or hate it, this creation is the showstopper against which all sartorial daring has been measured since Jennifer Lopez wore it to the 2000 Grammys. (Cher's litany doesn't factor in because she's always regarded her wardrobe as costumes.)

Yet, when model Amber Valletta strutted down Donatella Versace's runway in fall 1999 wearing the silk chiffon blue-and-green palm tree print with the plummeting neckline to end all cleavage descents, straight down to the Versace medallion anchored well below her navel, nobody cocked an eye. Donatella Versace herself even wore it out in public, and no heads spun. But then came J.Lo.

Upon her arrival, she laid waste to the red-carpet press corps, with cameramen losing their footing, desperately trying to decide if they should come in tighter or pull away to avoid censorship. Lopez stayed calm, even when she walked onstage to present the evening's first award with David Duchovny, despite the audience whistling and bellowing, too deliriously flabbergasted to even care if she spoke. Duchovny, who was at the height of his *X-Files* fame, graciously stepped back to give her the stage, admitting, "I'm sure that for the first time in five or six years no one is looking at me." No one was paying much attention to Lopez's date, then-boyfriend Sean Combs, either. Combs, however, blatantly sulked, displaying none of the self-effacing grace that Hugh Grant did when Elizabeth Hurley garnered global attention for the Versace safety-pin dress she wore to accompany him to the London premiere of *Four Weddings and a Funeral* in 1994 (see page 14).

But then, this was no safety-pin dress—it was too late for pinning. Actually, the dress was similar to a jumpsuit in that the bodice and skirt were firmly affixed to the jeweled bikini bottom worn under the flowing chiffon. To her credit, Lopez didn't backtrack, apologize, blush, or get defensive. Her hair and makeup were almost girlishly lovely; her skin, especially luminous. Her double-stick tape held firm. So in this case, slatternliness was in the eye of the beholder—and there were millions of them, as the entire world saw her in this dress: Lopez's photograph appeared in four hundred and fifty newspapers and was reprinted nearly six million times in the first month after her Grammy appearance. In more than a decade, no red-carpet outfit has ever cast a shadow on its fame, but for all that notoriety, it never did generate racks full of knockoffs. Anyone surprised?

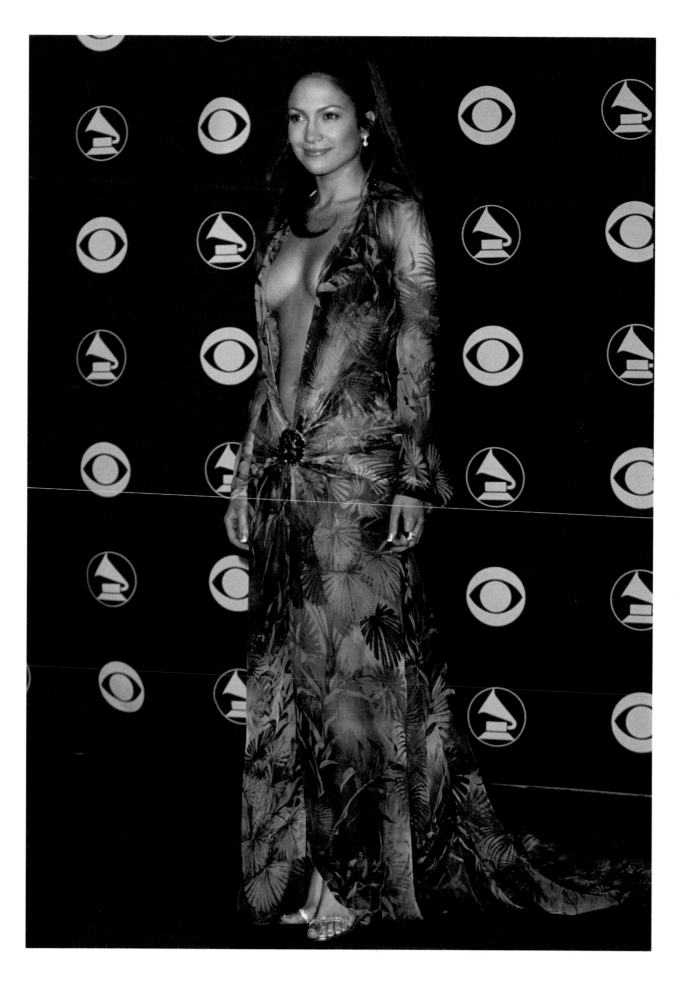

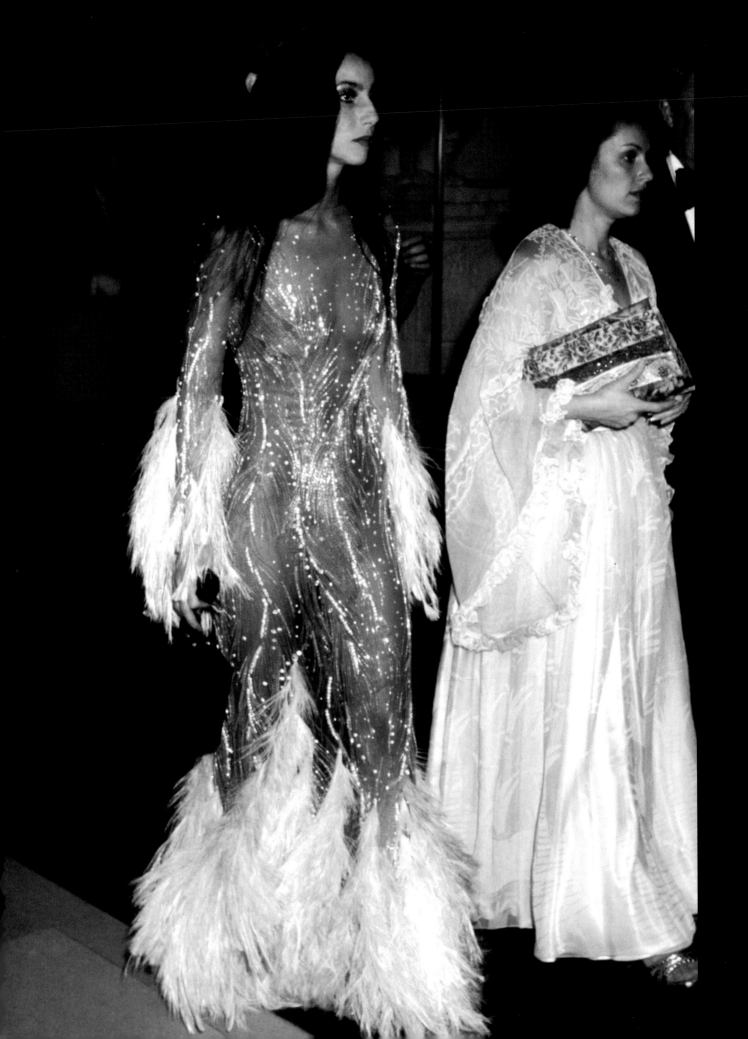

Cher

DRESS FOR THE COSTUME
INSTITUTE AT THE
METROPOLITAN MUSEUM
OF ART GALA
Bob Mackie · 1974

———

DRESS FOR THE ACADEMY
AWARDS
Bob Mackie · 1986

———

DRESS FOR THE ACADEMY
AWARDS
Bob Mackie · 1988

———

Bob Mackie would be the first to tell you that Cher's wardrobe, mind-altering as it is, is kind of weak on clothes. And that's his fault. "Oh, my God," he exclaims. "They're the *worst* clothes, the most horrible I've ever seen. They're all costumes. With Cher, it is like it is because she's not going out in public in—how do people say it—a dress. You have to be kidding."

Cher is not a star whose style you hope to emulate. She has never sported an iconic uniform as Katharine Hepburn did—turtleneck, mandarin-collared wool coat, and camel pants—nor has she been defined by a particular look, like Marlene Dietrich in her tuxedo. A leather jacket and fishnets aren't much to build on. But that's the point. What Cher's worn has never had anything to do with you—or her, for that matter. It's all about diversionary tactics. It's all show.

Mackie has designed for many other stars, like Diana Ross, Bette Midler, Ann-Margret, and Bernadette Peters—and some of these women like to connect with their fans. But if that was what was expected of Cher, "she'd just as soon stay home," Mackie says. What has made the Mackie-Cher collaboration so memorable is not the costumes' obvious outlandish luxury or their audacious complexity. It's their incongruous wit.

For example, if you closed your eyes as Cher rendered a classic rock ballad like

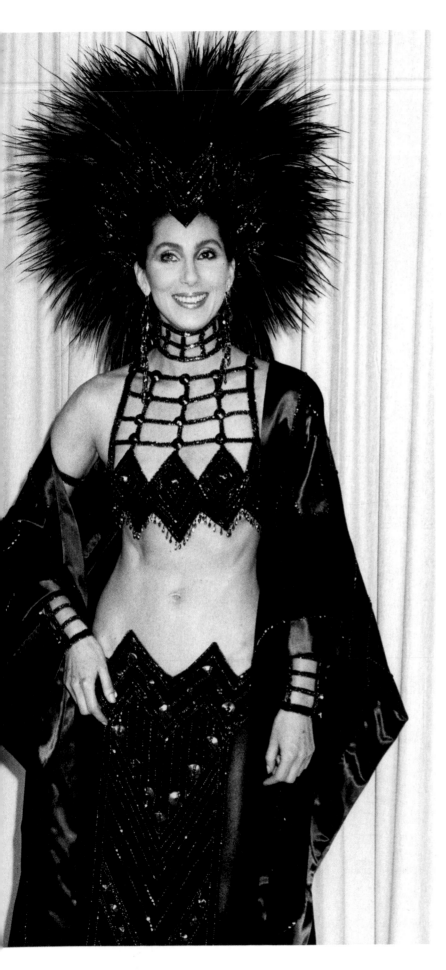

"A Song for You" on *The Sonny and Cher Comedy Hour,* her vocals would sound straightforward. But open your eyes, and you'd see her standing there, not a twitch of irony on her face, singing Leon Russell's love song in a white-feathered Indian chief's headdress, navel-baring bandeau top, and a skirt slit wider than a teepee.

When renowned fashion editor Diana Vreeland curated special projects for the Costume Institute at the Metropolitan Museum of Art in New York City, she staged the *Romantic and Glamorous Hollywood Design* exhibition in 1974, the largest show the museum had ever produced devoted to film costume. Its opening-night gala is remembered as one of the most star-studded in New York City's history. Guests were instructed to come dressed as elegantly as possible. I was working as a waiter at the gala that night, transfixed by a frail but still-enchanting Lillian Gish in a pale Mainbocher gown with a portrait collar sitting in shadow except for the light of one candle from her café table. It was a bewitching scene, as if D.W. Griffith had lit her himself.

Just as I was about to walk over and gush, in strode Cher with Bob Mackie. Cher had on a beaded body stocking made of soufflé, a mesh fabric that literally molds to the skin with strategic insets of thousands of hand-sewn brilliants anchoring ostrich feathers, which were also hand-sewn to the garment's lower arms and legs (see page 60).

"Oh, my!" said Ms. Gish to her companion.

"You could see the museum through [Cher's] legs," says Mackie.

As Cher proceeded into the building, she created pandemonium. People kept bumping into one another. Waiters were dropping trays. "But Cher walked through as if she had on jeans," says Mackie. The morning after, from the look of the dailies, you might have thought that no one had attended the gala *but* Cher. Her picture was first and foremost everywhere, even eclipsing details of the exhibition.

Cher's pronouncement upon walking on center stage at the 1986 Academy Awards is now legend. She waited until the audience had fully taken in her Mohawk-, Maleficent-, Spider Woman–inspired ensemble (this page)—a

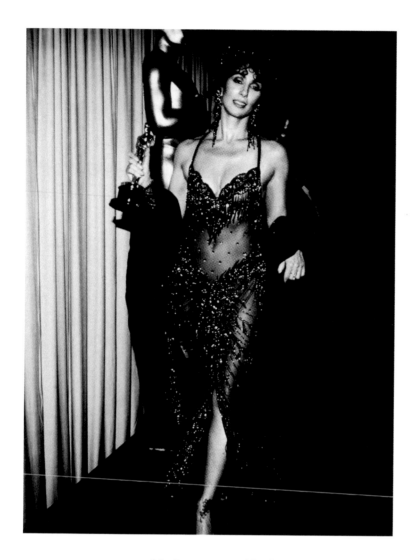

black sequin-webbed bodice with choker neckline and harlequin bra, sequined skirt with an equally jagged waistline cut lower than most bikinis, a velvet stole, and her face framed in a corona of black feathers—and then flatly stated that it was obvious that she had perused the Academy's manual on how to dress "like a serious actress." The audience roared at the mockery, but the truth was Cher was angry about being snubbed for her performance in *Mask* and told Mackie that she was in no mood to follow any guidelines. Mackie asked her to hold back on the Mohawk headdress. "The Academy was very conservative back then. I didn't think they'd let her onstage." Cher's reply? "No choice."

But it becomes slightly harder to shock if people expect it of you. In 1988, Cher finally won the Best Actress statuette for *Moonstruck*. Mackie dressed her in another jet-beaded fantasy (this page) that revealed more flesh

than her previous presenter's garb. Yet this time, because devotees had grown accustomed to her award-time outrageousness, they were more impressed by how much the sheer mesh gown, with a formfitting sequined bra and the addition of a host of comet-like brilliants emanating from one strategic location, resembled art-deco artist Erté's illustrations of showgirls. As revealing as the outfit was, it evoked true Ziegfeldian panache.

Today, most celebrities are sartorially risk adverse and stylist driven, except perhaps for Lady Gaga. Cher should open the kind of finishing school they used to have at the studios in Hollywood's golden age, where she could teach aspiring headliners a thing or two about how to angle your head when singing under a twenty-pound headdress. Even more important, she could teach new stars and celebrities how to be in on the joke. But for that, she'd need an auditorium.

MERMAID GOWN

Norman Norell · 1963

Norman Norell was the first American designer to stitch only his own name into a label, as well as the first to promote an eponymous perfume. A former costumer for Rudolph Valentino's silent films and the Ziegfeld Follies, Norell brought back the flapper chemise in 1942 (Balenciaga was heralded for doing so in 1957). He deserves credit for popularizing animal prints in the 1940s. Though he received no recognition, since American designers didn't work under their own names at the time, Norell showed dresses with nipped waists and long flared skirts a year before Dior's revolutionary New Look in 1947. Norell made sailor dresses a favorite for grown women in the 1950s, and he was one of the first to send out jumpsuits for evening in the 1960s. As an American, he was automatically labeled a ready-to-wear designer when he opened his house in 1960, but every garment on his runway was made by one person, from start to finish. He even insisted on hand-sewn buttonholes.

But for all of his couture-level innovation, the most striking aspect of Norell's career was his refusal to let go of a good design. Rather than move on or worry about imitators, his collections repeatedly featured variations on successful looks he had already introduced, like the sailor dress, patch-pocket coats with oversize buttons, dolman-sleeved wool turtleneck dresses, sleek furs, short sleeveless shifts that buttoned up the back, and his most celebrated and copied gown for evening: the mermaid dress.

It may have lacked a fish tail, but the mermaid dress transformed a woman into a near-mythical creature. Each version was a sequins-laden, gleaming second skin molded to the body on silk jersey. During certain seasons Norell gave it a halter or a cowl neck or capped or dolman sleeves. He also created short and belted versions, as well as one with a midcalf skirt. But the mermaid's most memorable silhouette featured a high, rounded collar, tight full-length sleeves, a nearly seamless gathering at the waist, and a hip-grazing columnar skirt with just a hint of flair at the bottom. Norell showed the monochromatic body-hugging sparkler in almost every color, too—including scarlet, deep purple, pale lavender, midnight blue, black, and gold. These color choices were completely at odds with the era's prevailing attitude toward formal evening wear, which was marked by faint pastels and princess-like volume (see Jacqueline Kennedy Onassis, page 88).

Norell's sleek lightning bolt of flash was urban, modern, highly sensual, and immediately desirable. Its unflagging success notably influenced his contemporaries, such as Bill Blass, Geoffrey Beene, and Halston. Jane Fonda wore a version of the dress in *Klute*, and costumer designer Anthea Sylbert borrowed the profile for Julie Christie in *Shampoo* (see page 66). Norell fancied sequins so much that he worked them into his designs in every way that he could. He used them on lounging pajamas, wraps, and even his "subway coat," which looked like a straight-lined wool topper buttoned up but, when opened, featured a full lining of neon-bright sequins.

Regardless of his quest for variation, Norell featured the mermaid dress in every collection until his death in 1972. Today, the dress is readily knocked off by designers of lesser talent who have worked it into less publicized resort collections and precollections simply because they know it will sell. But an original Norell mermaid dress is timeless: it remains one of the fastest sellers for shops and websites specializing in vintage clothing. Unfortunately, the subway coat is much harder to find.

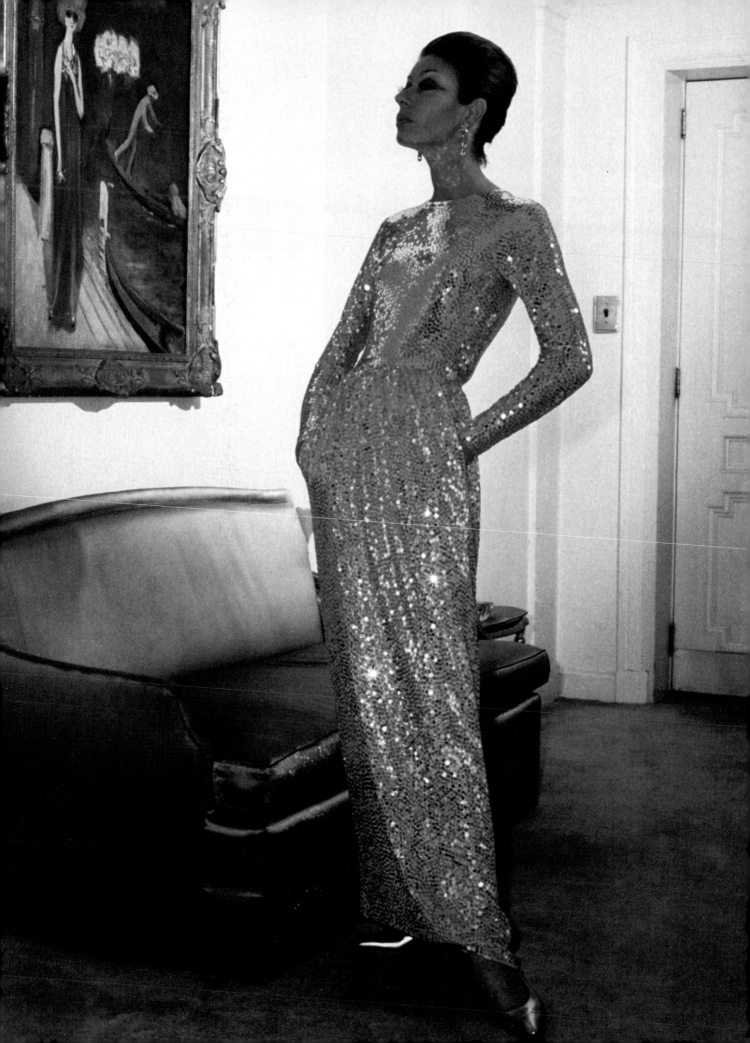

BACKLESS TURTLENECK GOWN

Anthea Sylbert · 1975

The film *Shampoo*, starring Warren Beatty at the height of his shaggy-haired roguishness, is a sardonically funny satire about sex, politics, and sexual politics. Beatty plays George, an irresistibly satyric hairdresser with a list of client-bedmates played by Goldie Hawn, Lee Grant, Carrie Fisher, and Beatty's girlfriend at the time, Julie Christie.

In the film, Christie entered a key restaurant scene in a smashing second-skin black-sequin turtleneck gown. Costumer Anthea Sylbert's takeoff on Norman Norell's sequined torso-defining column presented Christie—at the height of her diamond-in-the-rough allure—as almost demure, covered from neck to floor and shoulder to wrist in a gleaming skintight sheath, which generated flattering pin spots of light that danced around her face. But when Christie turned away from the camera, the dress revealed its secret weapon: a circular opening from delt to delt and down to just above the tailbone exposed Christie's entire back, unbalancing the actors in the film as well as the audience. More than just a teaser: by the end of the scene its bareness punctuated a memorable sexual sight gag with Christie under the table.

When asked to name his favorite films, Johnny Depp notes *Shampoo* as being high on the list and also cites Christie as of his favorite actresses. In fact, he tried to buy the backless gown as a gift for his then-girlfriend Kate Moss. Unable to track down the original, he commissioned a copy of Christie's dress for Moss, which she wore to accompany him to the Golden Globes in 1995. Once again, the dress's black panther–like sheen caused quite a scene, but with no table in sight, Depp and Moss's evening didn't end the same way.

ULTRASUEDE DRESS

Halston · 1972

Halston (born Roy Halston Frowick) was perhaps ready-to-wear's first international superstar. His unwavering passion for simplicity in fashion belied a life lived in excess. The rueful irony is that while his innovative talents were fervently used in the service of luxurious minimalism, his visage became synonymous with the relentless, sometimes-rabid indulgences of the era. Whenever the press focused on Studio 54 as the ground zero of decadence, Halston was always prominently cited or photographed as an inner-circle denizen.

The tall epicene designer possessed a glittering circle of client-friends (Liza Minnelli, Babe Paley, Bianca Jagger, Diana Ross, Martha Graham, and Marisa Berenson), all of whom lazed about his East Sixty-third Street townhouse habitually attired in his minimalist aesthetic of cashmere gowns latched with Elsa Peretti snake belts, chiffon caftans, sequined T-shirt minidresses, and bell-bottoms. Because they were unadorned and appeared so unconstructed, Halston's clothes could be easily misconstrued as facile. Halston began his career as a milliner (he created Jackie Kennedy's legendary pillbox hat while at Bergdorf Goodman, although Oleg Cassini insisted it was *his* idea), but so adroit were his dressmaking skills he could cut an entire single-seamed bias gown from a bolt of fabric without employing a pattern. He did this by first working out his ideas on paper in an origami-like process.

However, the designer's greatest popular success was with his Ultrasuede shirtwaist, made from a fabric never developed to be worn by women lunching at Le Cirque or downing sidecars at the Maidstone Club. This machine-washable knockoff of suede was invented by a firm named Toray Industries in 1970 and introduced as Ecsaine for use in interiors and automobiles (Lexus used it for upholstered seats in its IS300 models). Halston wasn't the first designer to run the fabric through a sewing machine: Issey Miyake used it for men's shirts. Under the name Aquasuede, Bill Blass and Calvin Klein worked it with little fanfare.

But in the fall of 1972, Halston showed model number 704, a fully buttoned-down shirtwaist dress made of Ultrasuede. The material gave the illusion of frailty, yet it could be spin-dried. Originally, the dress was priced at $185. Demand was so immediate the price quickly doubled. No matter. The Ultrasuede dress sold sixty thousand copies in its first season and, along with the turtleneck minihalter dress he designed for Liza Minnelli for her special *Liza with a 'Z'* (see page 50), became one of his hallmark designs. Today, the fabric is a staple of bridge-market collections—and den furniture.

DOVE-GRAY MINIDRESS

Azzedine Alaïa · 2010

Azzedine Alaïa is fashion's most independent and dynamic force. Alaïa does not present his most recent collection during Fashion Week anywhere in the world—not even in Paris, where he has worked out of the same studio in the Marais district for nearly three decades. That's because Alaïa creates a collection according to his calendar. No public-relations firm guides or advises him. He does not court retailers or editors, nor does he send out lookbooks to entice them to choose his clothes for their magazines.

Alaïa shows his clothes when they're ready. And before they are, he has a fit model living with him twenty-four hours a day because he prefers to work late at night into the morning and believes that construction on a form is no match for creation on a real body. When Alaïa is ready to show his new work, he invites whomever he pleases. That crowd may be fashion's most exclusive club, consisting of a small circle of favored journalists, faithful retailers, younger designers whom he admires almost as much as they crave his blessing, and his favorite women to dress—Naomi Campbell, Stephanie Seymour, and Grace Jones (who wore several of his dresses in *A View to a Kill* and literally carried the minuscule designer onstage when he was given the French Ministry of Culture Designer of the Year award in 1985).

Alaïa has gotten away with such idiosyncratic behavior for virtually his entire career because, as this gray woolen stretch mini demonstrates, he makes the most exquisitely crafted, unabashedly sexy clothing in the world. Alaïa's output doesn't change radically from season to season. He literally clings to what he likes best. This dress is from 2010, yet Alaïa's dresses from a decade ago would look just as contemporary because the body, not his art, is what he places front and center.

Alaïa will painstakingly cut, fit, and drape on the body itself as many as forty pieces of fabric to craft one short dress. Each of the vertical stripes on this skirt is a separate piece of fabric, seamlessly stitched with techniques normally reserved for crafting lingerie, which Alaïa developed while studying the work of Madeleine Vionnet. Not every stripe is the same texture of flexible knit, as Alaïa will experiment with combinations of spandex, Lycra, and stretch for just one dress. If he employs laser cuts or sheer panels as he does here, he uses a flesh-toned lining to allow the illusion of nudity. While the result is a garment that seems to reveal a traffic-stopping body, the dress does as much to control and hold the torso in shape.

However, if you want to wear Alaïa, even the designer admits that being built like Stephanie Seymour helps. Yet Michelle Obama has worn his designs on several occasions. So just make sure you have some curves you don't mind showing off, because a dress by Alaïa is not about to hide them.

PROLOGUE DRESS FOR *BYE BYE BIRDIE*

Marjorie Wahl · 1963

Riffing on the national hysteria generated by Elvis Presley's 1957 draft call into the U.S. Army, *Bye Bye Birdie* is built around a nationwide search for the perfect all-American girl to bestow one last kiss on the less-than-perfect teen idol Conrad Birdie before he reports for duty and broadcast live onstage during *The Ed Sullivan Show.* Broadway's first musical score to acknowledge rock 'n' roll, *Birdie* was a breakout hit for its two stars, Dick Van Dyke, who played Conrad's songwriter-manager, and future theater legend Chita Rivera, as Van Dyke's simple-life-wanting girl-friend. As Kim McAfee, the lucky girl chosen to pucker up for Birdie, Susan Watson was pert and kissing-sweet. You don't know who she is, do you?

That's because Hollywood has a history of making major alterations when stage musicals are fitted for the silver screen. Ethel Merman, Carol Channing, and Julie Andrews hit career zeniths with *Gypsy, Hello, Dolly!* and *My Fair Lady,* respectively. Yet, none of those women repeated their notable stage triumphs on film.

For the transfer of *Bye Bye Birdie* to film, Van Dyke was cast. Rivera was not, but replaced by Janet Leigh, who could barely carry a tune, so most of her character's songs were cut. But then, the focus of the story changed, too: While the movie still tracks the ups and downs of the songwriter and his girlfriend, the tale of the teenager chosen to kiss Birdie is now allotted equal screen time. Why? Because that girl was now being played by Ann-Margret.

Birdie was only Ann-Margret's third film, but in her first, *Pocketful of Miracles,* she'd held her own opposite Bette Davis, and in her second, the otherwise-pallid remake of the musical *State Fair,* she was so smoldering as the feigningly innocent temptress, you hardly noticed Bobby Darin or a bare-chested Pat Boone, who played the men she was two-timing. *Birdie* director George Sidney was equally smitten with the twenty-two-year-old Swedish-American. Before showing the first cut of the musical to Columbia Pictures executives, he proposed opening and closing the movie with two musical sequences, each showcasing her. The studio heads said they wouldn't pay for it. Undaunted, and at his own expense, the director commissioned a new song from Charles Strouse and Lee Adams, the show's original tunesmiths, rented a studio and crew, and had *Birdie*'s costume designer Marjorie Wahl whip up a new dress.

When the movie premiered at Radio City Music Hall, Ann-Margret, alone on that huge screen against a vivid peacock-blue backdrop, was in a deeply scooped, bodice-clinging, tightly belted, filmy-skirted, cantaloupe-color frock not likely to be worn by any coed in the 1963 Sweet Apple, Ohio, high school yearbook. The sequence featured the flame-haired ingénue repeatedly running toward the audience, flipping both mane and skirt high as she cooed, wailed, and occasionally sang the film's plaintive new title song "Bye Bye Birdie." Bob Mackie remembers the film's first-billed star being caught a little off guard at the initial screening. "I thought this was going to be a Dick Van Dyke film," the actor half whispered to Mackie. "Boy, am I wrong!"

Bye Bye Birdie broke the house record at Radio City Music Hall. Columbia happily reimbursed the director all the money he had fronted. The film's final sequence returns Ann-Margret to the same blue screen in her one-way-ticket-to-detention garb, singing the same pouty lament, ending with a wink, a whispered "Bye now," and of course, one last flip of the dress.

ASYMMETRICAL ONE-SLEEVED GOWN

Alber Elbaz for Lanvin · 2008

Dressing actress Tilda Swinton gives a savvy designer an unfair advantage. From the moment she transfixed audiences worldwide with her unsettling androgynous beauty in the film *Orlando*, she emerged and has remained one of the most idiosyncratically captivating women on the planet. No one remotely resembles her, on-screen or off-. Dutch designers Viktor & Rolf honored Tilda's matchless magnetism in their fall/winter 2003–2004 collection, entitled "One Woman Show." As more than twenty models, each deftly made up to look like Swinton, walked down the runway, the actress read a poem that she had written, which assured the show's attendees, "There is only one you. Only one." Then Swinton herself came out to model the final look.

Amplifying Swinton's translucent alabaster complexion, vibrant titian hair and knowing exoticism is a fashion sense that revels in her own singularity. While many of today's Hollywood ingénues and sirens too often favor a strapless fish-tail gown or whatever designer their stylist is besotted with this month, the predictable or trendy have no place in Swinton's closet. If you look like no one else, why dress like anyone else?

Swinton may never have chosen better than the draped, asymmetrical, single-sleeved, black velvet cassock gown Lanvin designer Alber Elbaz created for her to wear to the 2008 Academy Awards. The high contrast of her pale skin, red hair, and black velvet, accentuated by the juxtaposition of one bare white arm against the other cloaked in a densely furrowed sleeve and cuffed by a wide jagged swath of Damiani diamonds, created a silhouette so outside the parameters of red-carpet ritual that the next morning, the self-deputized cable, online, and tabloid fashion police placed the dress, the actress, and the designer square in their crosshairs and began to shoot. One self-proclaimed seer and critic even predicted that Elbaz's days at Lanvin were numbered. Today, Elbaz is the golden boy of Paris, having revitalized Lanvin into one of the hottest houses in town.

The critic's bad call stems from the fact that Academy Award preshow hosts love to proclaim Oscar night as "the world's biggest fashion show," but the description doesn't really ring true. At a bona fide runway show, familiar clothing generates disappointment among the press and retailers. However, the parade astride Oscar's scarlet yardage is less directed toward wowing insiders and more toward a viewing public that is desperately seeking glamour's equivalent of comfort food. While there's no fault in that, it does make the event a demilitarized zone for the innovative, the eccentric, or the unexpected.

But ground-shifting pop culture is never a sudden move. Mocking animosity initially greeted answering machines, pegged pants, going green, skinny jeans, and screw tops on fine red wine, too. Eventually, the public comes around, as they have in appreciating the allure of Elbaz's less-than-camera-ready sensuality. Ample proof of this was the designer's first capsule collection for H&M in fall 2010, which resulted in four hundred women lining up before dawn on opening day and the collection selling out nationwide within hours, even with the stores restricting customers to two pieces each. Fashion critics and the public alike are even starting to accept and eagerly anticipate Swinton's consistently fearless choices. Good for them. But it's not like she cares.

OSTRICH FANTASY DRESS

Karl Lagerfeld for Chanel · 2010

Gianni Versace once said Karl Lagerfeld "is the only one who should be called a genius. The rest of us are very good at making dresses." In his late seventies, Lagerfeld is at the height of his faculties, sending out six major collections a year for Chanel and two more for Fendi, each one a startling exhibition of peerless craftsmanship, of a restless mind fueled by fearless vision and a flash of irony. Because of him, Chanel is the one brand desired equally and unequivocally by women of all ages.

Lagerfeld also loves to put on a show—as long as it's a big one. "Why not have some fun?" says Karl. "If fashion is only about clothes, it gets boring. You need something to look at in between the girls." With Chanel willing to give its gifted maestro a blank check whenever he sticks out his fingerless-gloved and ring-stacked palm, he has presented collections in an airplane hangar in Los Angeles, along the harbor of Saint-Tropez, in a massive Zaha Hadid–designed pod-like portable exhibition hall in Victoria Harbour, and in the midst of Moscow's Red Square. Best of all, he has taken over Paris's restored and reopened nineteenth-century Grand Palais with some grand gestures, producing set pieces such as giant quilted Chanel bags and perfume bottles; elaborate carousels; a 70-foot-long, 40-foot tall, 8-ton golden lion (Chanel was a Leo) with its paw on a Chanel pearl; and a 265-ton iceberg imported from Sweden and sculpted by a team of thirty-five to be the backdrop for his fall 2009 presentation.

But in the fall of 2010, Lagerfeld topped himself. To present his spring 2011 collection, Lagerfeld used the entire exhibition space, whose towering glass roof covers several acres, to seat 2,800 people around a staggering black-and-white reimagining of the formal hedged gardens depicted in the film *Last Year at Marienbad*, using black and gray stones instead of vegetation to form topiary and hedges around three enormous fountains. Lagerfeld called it "Versailles after the Apocalypse." Then, with an eighty-piece symphony orchestra playing "Isobel" and "Bachelorette" by Björk, Lagerfeld sent out perhaps the most gorgeous and varied collection of his career.

These days, a fashion show offers approximately forty looks. If there are more than fifty, people begin to slyly look at their watches.

> 66 All intellectual
> conversation,
> especially
> about fashion,
> is overrated. I
> much prefer to
> be surrounded
> by really pleasant-
> looking people.
> It makes it much
> easier to stay in
> a good mood. 99
> —KARL LAGERFELD

With talent to match his conceit, Lagerfeld showed eighty-six looks—and everyone was riveted. It took each model five minutes to walk the garden paths, which were designed so that clothes were coming at the audience from all directions.

Then came look number 82: model Carmen Kass was completely cloaked in a dress embellished with extraordinarily long pale orange ostrich feathers, swaying, rising and falling to match her every footstep, hip shift, and arm sway. What made the dress so magical was that when Kass would pause and pose, the feathers sheltered her like a cape, but then when she walked, the lightness of the chiffon backing caused the feathers to flutter behind her to reveal her shapely torso. Models rarely smile these days, but you can sense when they enjoy what they're wearing. Kass could barely contain her delight in knowing that she was the envy of the full crowd, models included.

"Where do you wear that?" asked one confounded retailer.

"Anywhere you want to," snapped an editor without ever looking over her shoulder. And whoever winds up lucky enough to wear that dress will go anywhere she wants to.

LITTLE BLACK DRESS

Coco Chanel · 1926

The great French couturier Paul Poiret derided the simplicity and utility of the little black dress as "poverty de luxe," but when he confronted his contemporary and rival about her favorite new creation, sarcastically asking her, "For whom, madame, do you mourn?" Coco Chanel responded, "For you, monsieur." Because as Christian Dior said in homage to her years later, "With a black pullover and ten rows of pearls she revolutionized fashion."

Coco Chanel was not the first designer to create a simple black dress, but it was she who decided that its appearance shouldn't be restricted to funerals and to women of questionable reputation (such as Virginie Amélie Avegno Gautreau, portrayed by John Singer Sargent in a low-cut black gown that exposed a great deal of skin in his painting *Portrait of Madame X* [1884]).

One or all of the following factors could have instigated the fortuitous timing for the dress *Vogue* predicted would become fashion's Model T when it published Chanel's sketch. First, the designer had been raised in a French orphanage, surrounded by the all-purpose austere garb of the nuns who oversaw her daily life. Second, Chanel was always vocal in her admiration of the go-anywhere convenience and limited parameters of menswear. Third, Chanel was devastated by the death of her first benefactor and lover, Arthur "Boy" Capel, who not only gave her the money to open her first hat shop in 1913, but subsequently financed the creation of her Paris salon at 31 rue Cambon (which still serves as Chanel's headquarters) just before he died in an automobile accident in 1919, allegedly on his way to a Christmas rendezvous with her. Upon hearing the news of Capel's death, Chanel supposedly declared that she "would make the world mourn for him." Capel was fond of black blazers, so Chanel

took to wearing them and making matching dresses to wear as a suit. Black was basically the only color she wore for the remainder of her life. Finally, probably the most significant force propelling both the LBD's introduction and its immediate success was Paris's year-long obsession with a massive installation of the World's Fair in 1925. Formerly titled *Exposition des Arts Décoratifs et Industriels Modernes* (the term "art deco" comes from the abbreviation of "Arts Décoratifs"), the enormous exhibition of household arts stretched from Les Invalides to the Grand Palais. The fair's celebration of black lacquer on walls, screens, furniture, floors, and glass has had an enormous influence to this day.

Black as an option for interiors is a safe bet now, but it was revolutionary in the 1920s. Almost immediately, virtually anything related to the color became a sensation. The most

popular dance in Paris was the Black Bottom. Jazz, which originated in the black community in New Orleans in the 1890s, became ubiquitous. *La Revue nègre*, an all-black cabaret show featuring nineteen-year-old Josephine Baker, was the hottest ticket in town. Well, what other color would you wear to indulge in this newfound hysteria?

Chanel had originally created the LBD as a day dress in wool jersey. But immediately sensing its potential, she created a long-sleeved sheath in crêpe de Chine, a sleeveless one in cotton voile, and one in satin with a two-tiered skirt. Regardless of the fabric, all the dresses were devoid of ornamentation and frou and hit the middle of the knee.

Eventually, Poiret introduced a little black dress into his collection. So has every other designer who has ever wanted to stay in business.

WRAP DRESS

Diane von Furstenberg · 1978

In the early 1970s, New York City was soaring toward its hedonistic apex. Regardless of income, sexual proclivities (always plural during this decade), or an impending 9 A.M. meeting, if you were young, thin, and cute—or wanted to be surrounded by the same—you went out every night to discos like Le Jardin, Hurrah, Hippopotamus, Les Mouches, 12 West, and Flamingo. (Studio 54 was still a few years away.) The sun piercing the horizon brought no rush of remorse to hustle clubgoers home. Instead, it was merely a cue to move en masse to the Brasserie for breakfast. Only then, after a hot meal—or a liquid one—did you scoot home, rinse off, do a quick change of clothing, and get to work just in time for that morning meeting with no one the wiser—except maybe for that teeny fleck of glitter stuck right above your cheek.

At the nucleus of this giddy, guiltless, exuberantly pansexual, and consequence-adverse whirlwind, there was, according to a *New York* magazine cover story, "The Couple Who Has Everything." Egon von Furstenberg was a German prince—and charming. His wife, Diane, was his Belgian-born princess. They were famous for being famous long before the boom of self-promoting vehicles like YouTube and reality television. Neither was classically beautiful, but at a time when individuality and flair were considered more seductive than surgically enhanced profiles or rock-hard abs, the von Furstenbergs were bewitching, especially Diane, whose allure was an irresistible composite of Scheherazade, Salome, and Hadassah president. ("I don't

care what my friends were on. They had to eat.") Everyone who knew them wanted to be with them, on top of them, or underneath them, or better still, *be* them.

Sadly, a foreshadowing coda to *New York* magazine's anointing cover line read, "But Is Everything Enough?" Unfortunately, it wasn't. The von Furstenbergs separated in 1973 and divorced ten years later. Diane recalls, "I was now on my own, with two children to support and not wanting to rely on anyone. Luckily, I had what I thought was a good idea." Except, it wasn't good. It was brilliant.

The DVF wrap dress was a "why didn't I think of this?" masterstroke of simple logic and astute psychology. A variation on Claire McCardell's shirtwaist dress, von Furstenberg jettisoned the crinoline for a leaner silhouette, and then made the dress lighter, washable, easily packable, and unexpectedly affordable. The diagonally wrapped silk jersey made a woman's breasts and hips appear shapelier by grazing forgivingly instead of clinging. A button-down version came with a belt that could be placed anywhere to lengthen or shorten the torso. The patterns usually ran vertically, which was slimming. The dress was tailored, yet it flowed. It offered urbanity without pretension. Accessorized appropriately, the dress worked at the office, at a cocktail party, even at a wedding. Best of all, it was universally flattering.

However, the key to the wrap's instantaneous success was the woman who stepped out in it first. In the 1970s, a determined von Furstenberg, clad in one of her dresses, staged countless trunk shows of her collection at boutiques and department stores across the United States.

> **❝ I'm proudest of two things in my life: my children, and that I've never met a woman who doesn't look good in my dress. ❞**
> —DIANE VON FURSTENBERG

And in keeping with the American infatuation with royalty, women jumped at the chance to meet a real princess (even though she legally lost the title with the divorce), then got even more excited when the woman whom they met turned out to be a beacon of independence and self-esteem, urging them, as she did in her ads, to "Feel like a woman. Wear a dress!"

The clever tagline actually resonates more effectively when you consider that, thanks to baby boomers coming of age and a severe recession, women were entering the workforce in greater numbers than at any time since World War II, guided by a dress code that suggested that it was better to dial down one's femininity to compete in a man's world. Von Furstenberg firmly believed that a woman's sexuality was an integral part of her power, and women responded to her message like a devoted congregation after a fiery sermon. By mid-1976, von Furstenberg's factories were

shipping twenty-five thousand dresses a week, with more than five million sold. The dress is now in the permanent collection of the Costume Institute at the Metropolitan Museum of Art in New York City.

Von Furstenberg overextended her company with licensing agreements in the late 1980s but successfully revived her business in the early 1990s (and the wrap dress in 1997) by being one of the first designers to believe in the power of home shopping. It's often assumed that her husband, media titan Barry Diller, introduced Diane to QVC, but she's the first to tell you, "It was the other way around." Today, thanks to a new generation who have rediscovered her foolproof idea, von Furstenberg's business is once again as vibrant as the woman herself, currently the most popular president ever of the Council of Fashion Designers of America. But then, who could ever resist her?

Feel like a
woman,
Wear a dress!

Diane Von Furstenberg

Jacqueline Kennedy Onassis

VERSAILLES DINNER GOWN
Hubert de Givenchy · 1961

———

APRICOT DAY DRESS
Oleg Cassini · 1962

———

STATE DINNER GOWN
Guy Douvier for Christian Dior · 1962

———

WEDDING DRESS
Valentino · 1968

———

Even before her husband was elected president, Jacqueline Bouvier Kennedy possessed a quiet magnetism rarely encountered in a politician's wife. She naturally spoke in a soft angora voice that 1950s movie starlets used to adopt when they were trying to gain attention; except in her case, the conversation was rarely superficial. As first lady, she was younger, more attractive, better dressed, and more serenely poised for the pomp and protocol than any of her predecessors. But Jacqueline Kennedy wasn't content to merely look and play the part. Instead, she re-created the role, setting a new standard against which every woman who has subsequently taken up residence at 1600 Pennsylvania Avenue is measured.

Well-educated, raised with an appreciation for culture and the arts, and literally trained in the highly persuasive power of charm blended with intelligence, Kennedy had an immediate goal once her husband took office. A lifelong Francophile and former Sorbonne student, she understood all too well how America's European allies perceived its citizenry. As long as Americans stayed in uniform, they were the hope of the free world. Otherwise, as fascinated as Europeans were by the country's pop culture, they considered Americans rubes who were addicted to rock 'n' roll, hot dogs, blue jeans, and television. Kennedy was also well aware that the fixation

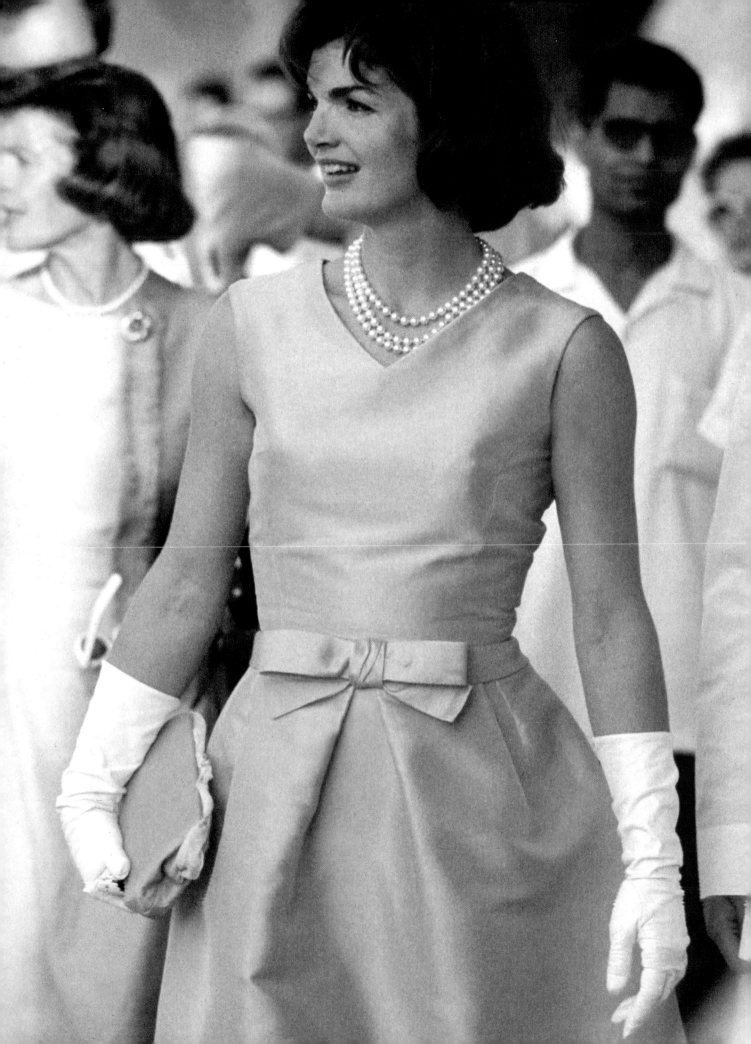

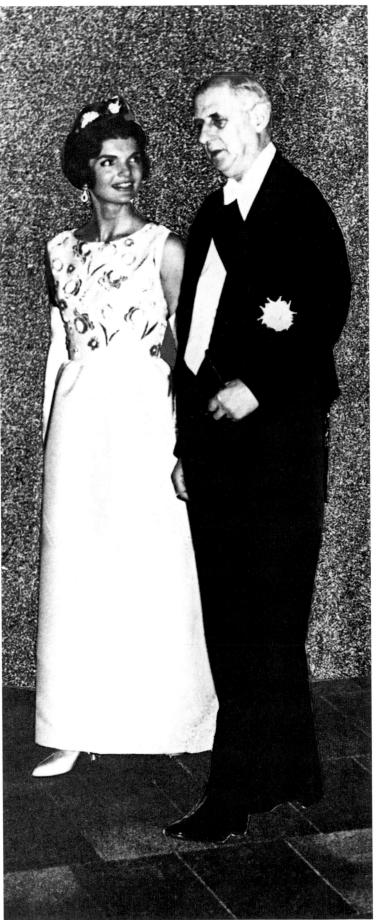

with Camelot's new couple—women were already copying her hairdo and causing a run on pillbox hats—was universal, but especially strong in France. So why not strategically direct her style and charm to level the playing field?

President Kennedy's gallant quip at the climax of his trip to Paris in June 1961 is well-known: "I am the man who accompanied Jacqueline Kennedy to Paris." Packing two trunkloads of clothing, Jackie wowed her hosts at every turn, mainly with couture-quality outfits created by her unofficial new American designer Oleg Cassini. However, for the trip's climactic dinner at Versailles hosted by President and Madame de Gaulle, Kennedy made a brilliant choice of attire: an ivory gown of silk ziberline by Hubert de Givenchy (opposite). What was so savvy about her selection was that the dress was composed of gently sensual lines. The neckline wasn't décolleté, but offered a discreet but alluring swoop in the center. The seaming on the bodice curved under her breast and continued down to the waist, gracefully accentuating her figure. Except for small tucks at the waist, the skirt was an unadorned swath of pristine fabric. But at dinners, of course, all one really sees of a dress is above the waist. To that end, Givenchy had chosen Hurel, the renowned embroidery house, to cover the entire bodice of the first lady's gown with an exquisitely strewn bouquet of textured florals in lavender, yellow, and green crafted of silk floss, silk ribbon, and seed pearls. It's no wonder that when de Gaulle staged a 101-gun salute for the president, it was drowned out by thousands of Parisians screaming, "Vive Jacqueline!"

Paris, however, was just a rehearsal for Jackie's solo goodwill tour to India, where she consistently wrapped herself in shawls reminiscent of saris in the brilliant vegetable-dyed colors Indians have an affinity for. When she was invited to the Maharana of Udaipur's white palace across Lake Pichola, Kennedy was briefed that the crowds along the shore would be enormous. For that appearance, she wore a Cassini-designed sleeveless dress of striking neon apricot (see page 85) with a matching coat, both in a silk ziberline Cassini found that was even stiffer than taffeta so that not only would everyone be able to see her clearly against the vast landscape, but her outfit wouldn't wilt in the heat. The deep pleat in the center of the skirt created a shadow that gave the dress even more depth in the bright sunlight.

A year later, in May 1962, Kennedy completed her conquest of the French. She held a state dinner for French Minister of Cultural Affairs André Malraux. Though it was not standard protocol to stage an event of this caliber for someone who was not a head of state, she had an ulterior motive, as Malraux had access to something she wanted desperately in her desire to make Washington a world cultural capital. For the evening, she wore a strapless silk dupioni shantung gown by Guy Douvier for Christian Dior (see page 88). The dress was fitted but unadorned save for a back panel. Jackie added only two accessories: a jeweled ornament in her upswept hair and long white gloves to highlight the beginnings of a summer tan. However, what turned the absolute simplicity of the gown into a scene stealer was its pink-cotton-candy

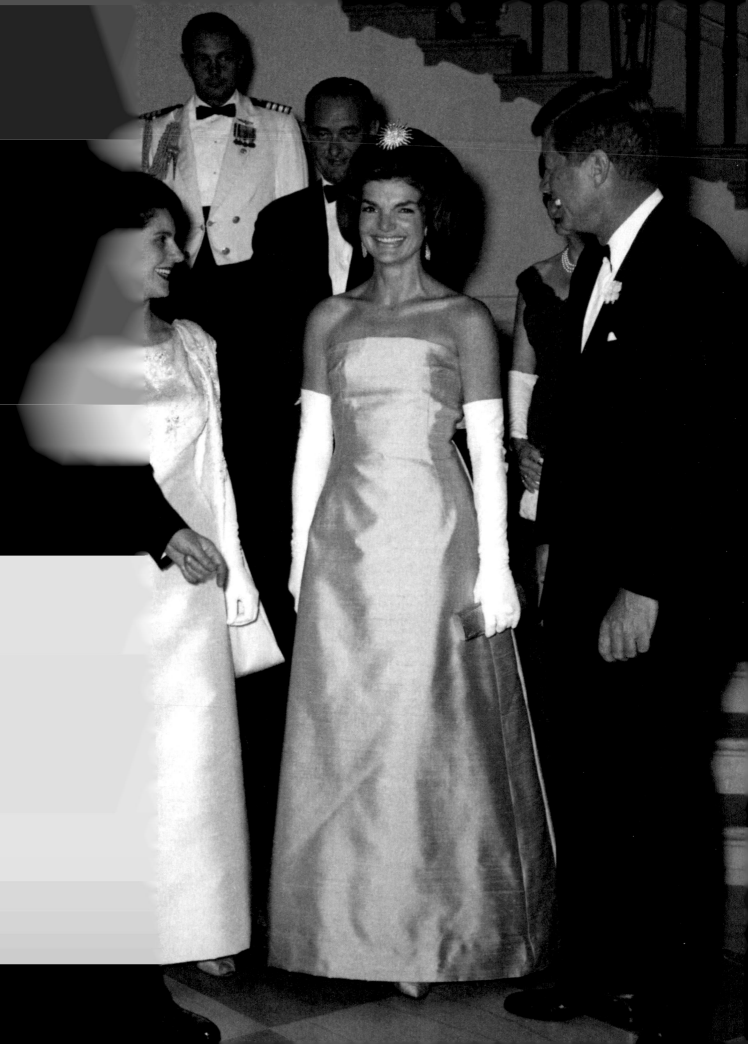

color. She clearly commanded Malraux's attention, for by the end of the evening, he had promised to lend her perhaps the Louvre's most prized possession, Leonardo da Vinci's *Mona Lisa*. Mission accomplished.

By 1968, though, the world was a very different place for Mrs. Kennedy. After several years of semiseclusion following her husband's assassination, she emerged as the ultimate jet-setter. Still fiercely private, more restless than flamboyant, she seemed to be everywhere, with a newer, hipper wardrobe. But after the assassination of John's brother Robert in June of that year, Kennedy's life and image took a radical turn when she announced a surprise engagement to Greek shipping tycoon Aristotle Onassis, whom she planned to marry in October on Onassis's private island, Skorpios.

For her wedding dress (above), she chose the jet-setter's favorite designer, Valentino, who had just received extravagant praise for what is referred to as his White collection. Kennedy had already contacted the designer prior to his presentation. By the time the very short funnel-necked, lace-embroidered beige knit minidress with long lace sleeves came down the runway, it had already been promised exclusively (at least, initially) to the new bride for her nuptials. Because Skorpios

was private property and the groom had as little love for the press as his intended, few pictures were taken of the wedding. But those that emerged featured a very startling image of the former first lady. The dream of a reimagined Camelot was still so fixed in the public's collective memory that it was probably easier for many to cast Jacqueline Kennedy Onassis as a perpetual widow than a miniskirted bride with a teased head full of ribbons.

Nevertheless, Valentino, who frequently outfitted and became a close friend of Onassis after her second marriage, claims not only that designing for her was the highlight and provided the biggest boost of his career but that her wedding dress was the best-selling piece of couture his atelier ever produced. For those who couldn't afford the perpetually tanned Roman's wares, the new bride's choice sent a message to women who were neither marrying rock stars nor exchanging vows in a field: that a grown woman could walk down the aisle wearing a mini, too. The striking increase in the sale of minidresses, for both bridal and evening wear, meant that women were still watching and listening to Jacqueline Kennedy Onassis, no matter how softly she spoke.

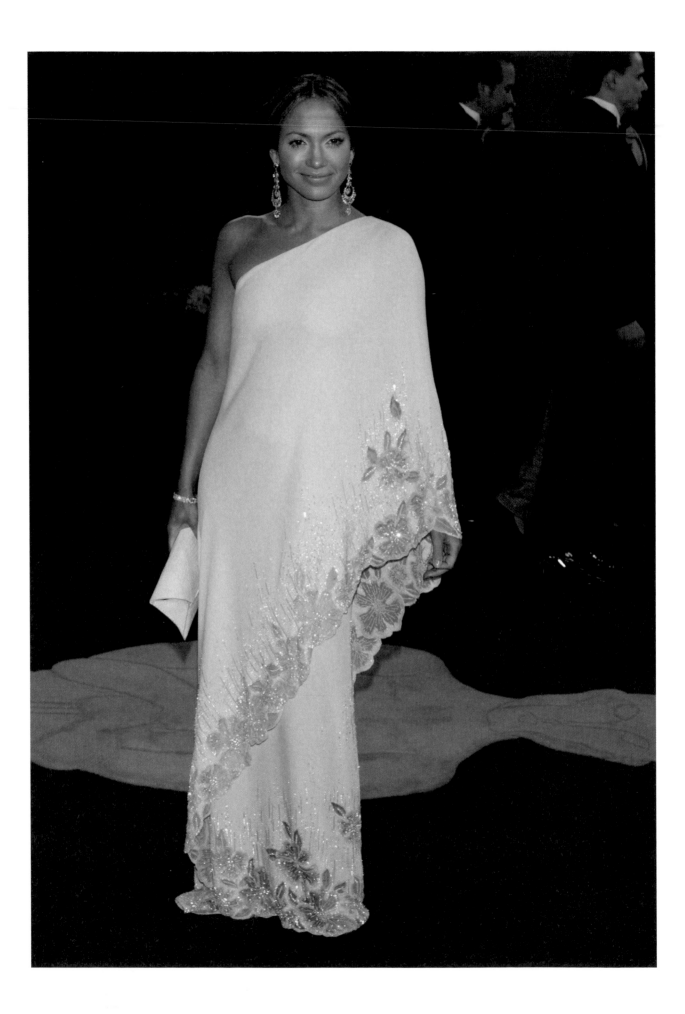

"JACKIE" GOWN

Valentino · 1963

The problem with having a reputation is that once you've earned one, you are stuck with it. And if being the ultimate pulse raiser was what she was aiming for at the 2000 Grammys, then Jennifer Lopez shot straight through the heart with decimating accuracy with her Versace number (see page 58). So what do you do for an encore?

To her credit, she seemed to know that there's no winning when playing "can you top this?" against yourself, so Lopez tried to steer public perception from Jenny on the Block back to Jennifer Lopez, movie star. Blessed with skin so luminous that even face-to-face she seems to be lit from within, and with the fact that every designer wanted to dress her, her attempt should have been one smooth ride. But sometimes you don't see a pothole until it's too late.

For the 2001 Oscars, Lopez turned to Chanel couture, which clothed her in what initially appeared to be a classically sedate choice: a ball gown with a full dove-gray taffeta skirt and a greige chiffon top that fell from one shoulder, twisting and looping around to the other. With her hair slicked back, a nude lip, and tasteful diamonds on her ears, Lopez probably glanced in her hallway mirror and left swearing she had nailed it.

But no home lighting matches the intensity of stage lights or the combined wattage of the red carpet. In the harsh light, Lopez's featherweight couture bodice turned almost completely sheer, revealing all that she had managed to hide the previous year via double-stick tape. Naturally, industry charmers assumed she had planned the reveal all along.

So in 2002, Lopez went back to Versace, who gave her more than mere coverage.

Her strapless gown was a latticework of folded and draped, intricately woven, trapunto-stitched bubblegum-pink, water-stained satin. Imagine a prom dress made on a loom. The thought of a high school beauty queen so inspired Lopez's stylist, Oribe, that he teased, wove, and curled her tendrils into a high, lacquered, no-bangs flip straight out of the 1960s. Sandra Dee would have loved it. Almost nobody else did.

In 2003, Lopez's search for redemption led her to Valentino, who sent Lopez a picture of Jacqueline Kennedy Onassis in a one-shoulder mint-green silk gown he had made for her for a goodwill trip to Cambodia in 1967. He offered to remake the gown for Lopez, adding that this was the only dress she should consider. Because it would take countless hours to reproduce the gown's intricate handiwork, Valentino gave Lopez a firm deadline to respond. Given the racks upon racks of options always made available to her, Lopez initially wavered. Yet the confident designer was sure she would come around and told his workroom to make the reproduction regardless; by the time the star notified him that she would take him up on his generous offer, the dress was finished.

As Lopez glided down the Oscars' walk, bronzed, pale-pink-lipped, her bare arm gently resting against the unruffled caftan-like gown with its graceful lace and sequin-flower-embroidered borders, there were no malfunctions, no catcalls, and no sly questions. It took once, twice, three times to feel like a lady again. Thanks to Valentino, she was a shimmering star in the cinema firmament once more. And then five months later, *Gigli* opened.

BIAS-CUT SLIP DRESS

Calvin Klein · 1996

In 1996, the supermodel era was coming to a close, and the mind meld between celebrity and fashion was about to fuse. Thanks to the immediate success of celebrity-driven magazines, actresses were beginning to grace the covers of women's fashion publications. Designers, sensing their best new ambassadors might be best found in Hollywood, not on the runway, began to court actresses, saving their best gowns for them to wear on the red carpet. Intrigued, the women responded by selecting more arresting, even operatic, choices. Jewelers took note, too, and began loaning statement pieces worth millions.

The Academy Award for Best Actress went to Susan Sarandon, who wore a deep-cleaving, aisle-blocking, fiery-copper Dolce & Gabbana gown. Best Supporting Actress went to Mira Sorvino, wearing a bell-skirted pale blue–striped Giorgio Armani gown and a comet tail of gleaming rocks around her neck. A necklace one could build a heist film around collared Angela Bassett. It was all very grand—maybe too grand. At least it seemed so when a lithe New York actress with a very handsome boyfriend showed up and, without any malice, made everyone else look overdressed.

"The thing about Gwyneth back in those days is that she was the easiest, most pleasant person I had ever worked with," recalls Calvin Klein. "I never liked dressing lots of celebrities.

I wasn't comfortable making clothes for people I didn't know or who didn't know what I stood for. It's funny because I'm a minimalist, which some people think of as very modern, but when I look at movies, my idea of glamour goes back to those black-and-white films where Myrna Loy, Carole Lombard, Jean Harlow, and Paulette Goddard would slink around in charmeuse. When Gwyneth came here she went right over to the bolts of fabric and picked out a pale charmeuse. I knew she was my kind of girl."

Klein cut her a lingerie-inspired sequined slip dress on the bias. "She perfectly fit the samples, she could read sketches, so I think we had maybe two fittings." Normally Klein would make suggestions about hair, makeup, and jewelry, but "I sensed that she got it right away. After all, she hadn't come up with anyone, no entourage; she wasn't seeking anyone else's advice but mine. So why would she have chosen me if she was going to muck it up?"

Hardly. With corn-silk blond hair flowing, a mere swipe of pale lavender shadow just above her lids, skin gleaming and unadorned, Paltrow's arrival sent out an almost-deafening message about the sensual sway of simplicity and of the command you can possess when you aren't upstaged by your clothes. She did have one thing on her arm, though—her trim and tieless beau, Brad Pitt. "They made one gleaming couple," says Klein. So, who needs diamonds?

66 I always designed
for what clothing
revealed, not what
it covered. It's all
about knowing
how to make fabric
fall against a body
so that we see the
woman and not
the dress. **99**
—CALVIN KLEIN

LAVENDER OSCAR GOWN

Miuccia Prada · 1995

The devil and anyone else who can afford it wears Prada now, but in 1995, the company was still making the most of its income on variations of the ubiquitous, chicest knapsack to never grace a schoolyard. Thanks to their wildly successful black satchels, totes, and messenger bags, the brand transformed the public perception of nylon into a fabric as sophisticated as leather and the triangular metal Prada placard into a talisman of cool. Though Prada's ready-to-wear collection was already eight years old, the brand remained a critic's darling, primarily prized, analyzed, and editorialized because of the clothes' subversive interpretation of minimalism (the spare silhouettes only looked simple to achieve); a noted preference for innovative techno fabrics (its tricotine pants and trench coats fit like gloves and resisted wrinkles but generated heat like battery-operated electric blankets); and designer Miuccia Prada's relentless infatuation with off-kilter colors. Red-carpet clothes did not use up a lot of Prada runway time because, although numerous adjectives were summoned in praise of the growing brand, "pretty" was rarely one of them.

The label's consistent-seeming shrug at glamour made it all the more surprising when, in 1995, Uma Thurman, who was nominated for Best Supporting Actress for *Pulp Fiction*, stepped onto the red carpet at the Academy Awards, her carriage, ethereal beauty, and aristocratic stature enveloped in Prada's gossamer swirl of lavender chiffon. The gown's hem was sparely beaded with raindrops of sequins. A chiffon shawl that seemed crafted from a breeze framed Thurman's swan-like neck. She didn't score an Oscar, but as for who won the night's best dressed, there was no contest.

The actress was a shrewd choice for Prada's big Hollywood moment because Thurman's performance in *Pulp Fiction* was a tour de force against type; this serene Buddhist-raised beauty had transformed into a mesmerizing force of carnal yet comic power. Instead of playing off her role's raw sexuality, the gown (actually designed by Barbara Tfank for Prada) made our on-screen fascination with her seem like a fever dream. How could all that unbridled lust have been unleashed by this near-mystical vision in a cloud of lavender?

Adding to the Prada resistance of total red-carpet capitulation is that the gown is a one-off, for neither it nor any facsimile ever came down Prada's runway, either before or after Thurman's red-carpet appearance. Although cheaper clothing lines like A.B.S. reaped the benefits of producing more affordable knockoffs within weeks, no official duplicate was produced for Prada's boutiques. Nevertheless, the gown was money in the bank for the label because, in one night, the reflex association of Prada with that black nylon backpack was replaced by the image of a fresh screen goddess dressed to dazzle all mortals.

Someone else eventually went home with an award that owed something to the impact of the lavender gown that night, though. Three months later, Miuccia Prada received her first statuette from the Council of Fashion Designers of America, signifying her recognition as Womenswear Designer of the Year.

WEDDING GOWN FOR LINDA CHRISTIAN

Sorelle Fontana · 1949

She was a great beauty, a contract player for MGM who made thirty movies, but unless you did graduate work in Mexican cinema (she also made films in her homeland) or have a thing for barely B epics like *Slaves of Babylon* or *Tarzan and the Mermaids*, it's doubtful you would know actress Linda Christian from the screen. She became famous, not for her talent or her fluency in seven languages, but because she married someone much more famous and almost as beautiful as she: Tyrone Power.

Initially considered far too darkly dashing to be taken seriously as an actor, Power turned out to be a pretty good one—and an even better swashbuckler (he had a huge hit with *The Mark of Zorro*). He cut short his career to serve his country in World War II, picking acting up again, although not quite as successfully, after the war. Linda was hardly the only woman mad for Power when he was in his prime. Gossip columnist Hedda Hopper adored him, as did her legion of female fans, so when the actor announced he was marrying Christian, it was major news. Christian followed with big news of her own, and though initially it didn't seem nearly as juicy as what most gossips clamor for, the result has proved so significant that the Camera Nazionale della Moda Italiana, the organization that currently runs Milan Fashion Week, should erect a statue in her honor.

Unlike most of Power's costars—who enlisted the talents of studio head designers like Orry-Kelly, Travis Banton, or Adrian, or hopped a flight to Paris to ensure a highly photogenic couture wedding gown—Christian wasn't a name in Hollywood. The studios' costume designers did not know her well, so she most likely knew that designing a wedding dress for her would not seem as attractive an opportunity as designing a wedding gown for Grace Kelly (see pages 172–73). Instead

of using her fiancé's fame to ease her way in, she approached Sorelle Fontana, a six-year-old design house run by three sisters, Zoe, Micol, and Giovanna, who had chosen, despite their training in Paris and Milan, to open their first atelier in Rome in 1943. Though success came quickly within an elite circle of world travelers, the house was little known outside of Europe. Christian's hiring Sorelle Fontana marked the first time an Italian atelier had been chosen for a wedding of such international scope: paparazzi from all over the world came to Rome to cover the Hollywood star marrying a great beauty in the church of Santa Francesca Romana.

Sorelle Fontana designed an extraordinary dress, one with a distinctively vintage charm and highly appropriate for a Catholic wedding. The densely floral, embroidered white satin gown with a fifteen-foot train was notable for its high neckline and discreet bracelet sleeves. Photographs of Christian walking down the aisle recall the dramatic processional in *The Sound of Music* when Maria marries Captain von Trapp.

Response to the reserved yet lovely gown was strong—and significant in fashion history, for two years later, in 1951, Sorelle Fontana participated in what is considered to be the birth of Italian ready-to-wear, the nation's first fashion show presented in Florence's Sala Bianca ("White Room"). That same year, Christian brought the sisters and their designs to Los Angeles, presenting them to the likes of Ava Gardner, Elizabeth Taylor, Audrey Hepburn, and Grace Kelly. The next year, these same actresses came to the Sorelle Fontana atelier in Rome for fittings, now as regular clients. And though the host city of choice has generally shifted to Milan (Gucci and Valentino are notable exceptions), both stars and their fans now regard Italy as one of fashion's three great destinations.

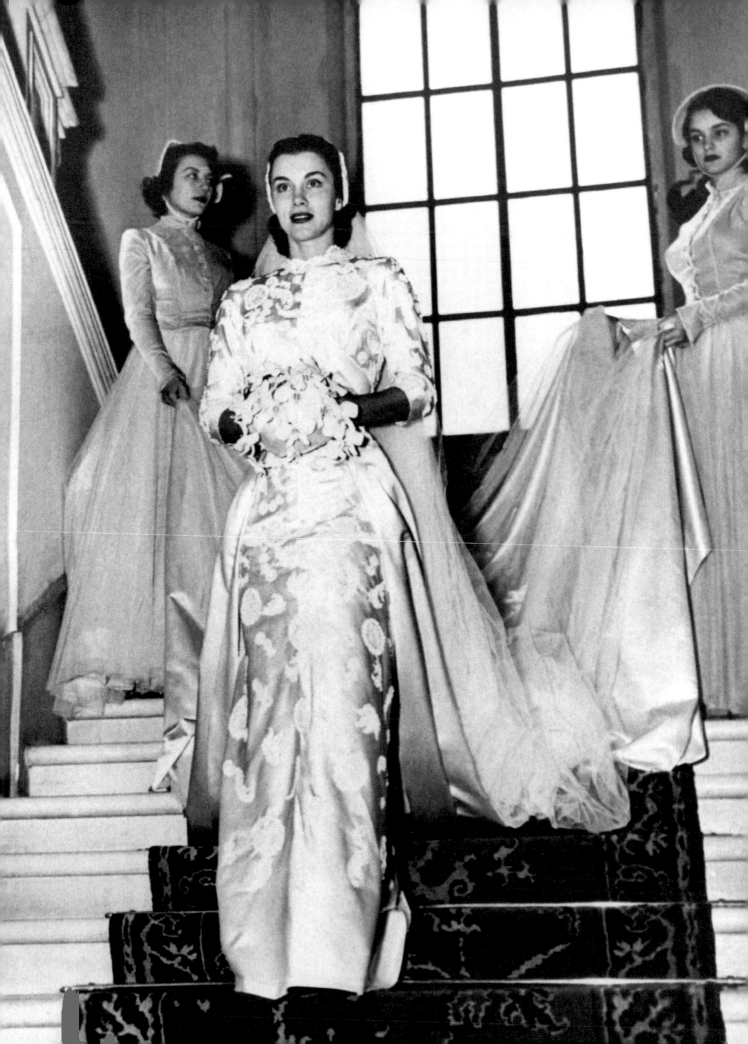

COLD-SHOULDER DRESS

Donna Karan · 1992

She's hardly the first woman to call attention to bare shoulders. Bacall whistled over her left one to lure Bogie. Rita Hayworth worked both into a slow shimmy while peeling off a single glove (see page 160), and Mae West merely had to roll either of hers to get someone to come up and see her sometime. But Donna Karan was the first to design an entire line around a bare pair.

Karan's now classic black jersey cold-shoulder dress is a canny and insinuating act of illusion. Worn under a jacket, the dress can make a woman appear almost monkish, as if she's wearing a floor-length turtleneck. Doff the jacket, and just one body part—a barely risqué one at that—becomes starkly exposed. But Karan's sly genius was in taking advantage of the fact that "every woman I know dislikes at least one area of her body, but I've never met one who hates her shoulders. It's the only place where you don't gain any weight. That's why women are never self-conscious about showing them off."

The manifestation of this fail-safe revelation almost never made it on or off the runway. Originally created as a top, both in turtle- and V-neck, the cold-shoulder pullover was a fall 1992–collection design discard, an extra separate consigned to a secondary rack, until Karan, short on something neutral to put under a highlighted jacket on Linda Evangelista, gave the top to the supermodel to wear as a base. Today, anyone with one webisode of fame is classified as a supersomething, but in the 1990s, only a handful of models could lay claim to the prefix, because they were blessed with more than mere beauty. Designers saved their bests in show for these special creatures to wear because each possessed several notable characteristics: a singular runway personality, a come-closer-even-though-I-might-hurt-you allure, and a narcissistic self-satisfaction that radiated brilliantly whenever they were "working a look" for the crowd—all of which combined to form a force field of spotlight-grabbing power.

Evangelista took such a fancy to the top that not only did Karan refashion it as a dress, but at the end of the runway, the model slipped out of the jacket, revealing her never-to-be-fat glenoids. *Women's Wear Daily* took special note of Evangelista's ad lib "and knocked the piece to death," recalls Karan. "They hated it." A few days later, however, when Karan was helping Liza Minnelli, who had come to the designer's studio looking for clothes for a European tour, the singer "went mad for the

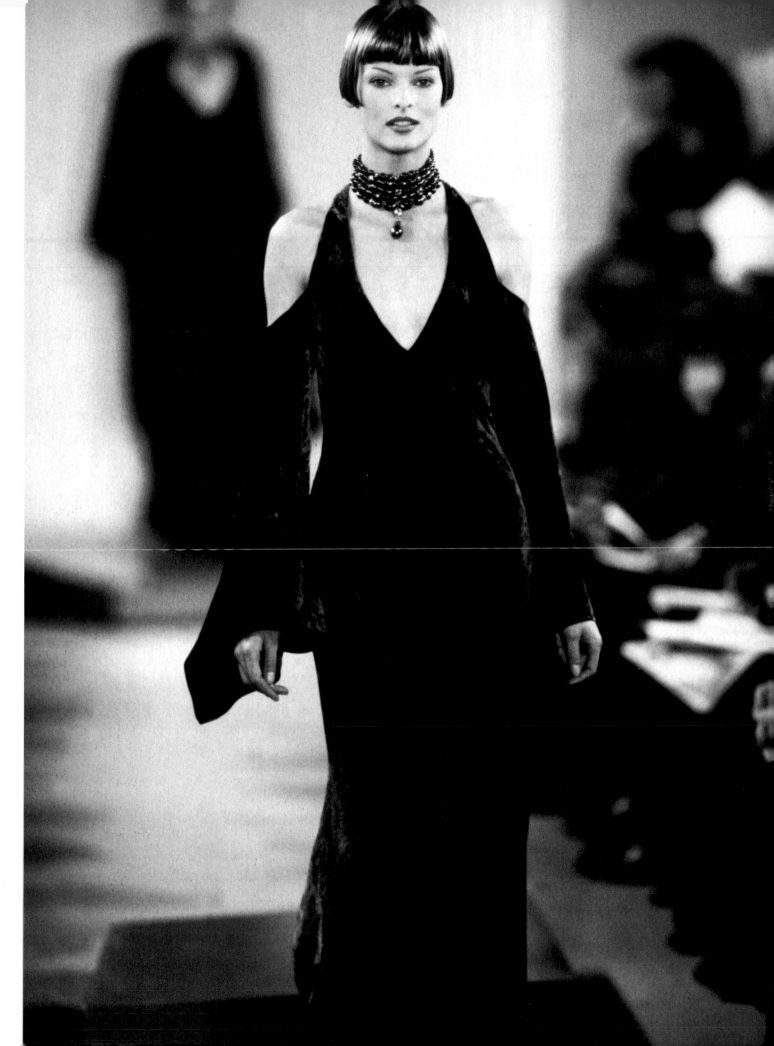

McCardell designed a long-skirted dress of calico cotton (she claimed calico reminded her of the American pioneer women who cooked while traveling west across the plains), in a series of bold prints, checks, and stripes because patterns would camouflage errant food spots better than a solid color, all with a matching, detachable apron that women could tie on when it was time for that graceful sweep around the living room to see whether guests needed to have their drinks freshened.

Not only was McCardell's solution an instant hit at Lord & Taylor, but a decade later the dress became the idealized uniform of the postwar suburban American homemaker, thanks to its wholesale adoption by television's first platoon of perfect moms, shown here from top to bottom: Donna Reed as Donna Stone on her eponymous sitcom, *The Donna Reed Show*, *Leave It to Beaver*'s mom June Cleaver (Barbara Billingsley), and *Father Knows Best*'s wife Margaret Anderson (Jane Wyatt).

There was one big difference between this trio and Claire McCardell, however. The sitcom mom cleaned, cooked, and solved all family problems while wearing high-heeled pumps. She was terrific—and tireless. However, beginning in 1942, McCardell was almost always photographed in sensible ballet flats because, like most women who worked or ran a household, sometimes her feet hurt. That's why her influence on how we dress has lasted so long.

TOURING DRESS

Prada · 2004

For her spring 2004 collection, Miuccia Prada began with the most mundane of wardrobe categories, traveling clothes from the 1950s—cotton day dresses, circle skirts, V-neck sweaters, shirtdresses, button-down blouses, lightweight trenches, and capri pants—then with a combination of handwrought artisanry, technological innovation, and an acute perception of current habits and desires, reimagined and reintroduced each of these pieces without a trace of nostalgia or whiff of vintage sensibility, designing a wardrobe for comfort and, even better, for wanderlust.

The clarity of Prada's vision and the dexterity of her technique are exemplified in this effortless A-line dress. Reconfiguring the print of the classic box-check shirtwaist by applying the grid on silk with a complex tip-dye technique produces a hand-painted effect that transforms what was rigid geometry into more painterly brushstrokes of color that range from sand to deep cinnamon. Instead of buttoning up the front, Prada eliminated the plaquette and the collar and tightened

the bodice so that, while the dress still retains a jewel neckline, its formfitting contours are now much sexier. The skirt, however, falls gently in an easy flow. The silhouette is hardly shocking now, but during a season when Prada contemporary Tom Ford was labeling his diaphanous and body-clinging Gucci collection "eye candy," while Dolce & Gabbana were sending out one wild skin-tight supergraphic floral suit after the other, the effect of this Prada dress was striking for its level of calm and ease. Instead of making a statement, stealing a spotlight, or causing a stir, Prada presented a dress that was made for strolling, taking one's time, and relishing the swing of the skirt. It was a quiet but big step toward the return of ladylike dressing, which is the polite way of saying "dressing like a grown-up," and by the following spring, as is so often the case, Prada's shadow was full of designers falling in behind her. Suddenly, women weren't chasing after pieces that would rekindle their youth and instead were looking for pieces that celebrated their maturity—all because of one breezily seductive walking dress.

BARE EMBROIDERED GOWN

Elie Saab · 2002

Calvin Klein once said, "There are lots of incredible dresses. And there are lots of beautiful women. But to do something memorable you have to know which one incredible one dress is exactly right for that one beautiful woman."

Elie Saab achieved that indelible moment with Halle Berry in 2002, the year she became the first African-American woman to win a Best Actress Oscar for her performance in *Monster's Ball*. Because the gown he designed for Berry was so right on her, it is the only one we ever imagine her in, regardless of how many premieres, award ceremonies, and cosmetics promotions she graces.

It's highly unlikely that the dress would have had the same impact on another actress. It's certainly not a zip-and-go gown. The garment's illusion top is strategically embroidered and very daring, exposing Berry's torso extensively, then descending quite a bit farther to expose her left hip. Phillip Bloch, Berry's stylist at the time, claims that he pressured Saab to add more embroidery to the top of the original dress because it exposed too much (the dress appeared on the runway with fewer flowers about the waist), so Saab complied. The bottom of the burgundy satin gown, with its folds of fabric and sweeping train, is elegant and operatic in effect. Once again, the original design featured a fuller burgundy skirt, but

Saab wisely pulled it in to take advantage of Berry's terrific figure.

But the key to the gown's cohesion and ultimate "wow" is the woman's exceptionally sumptuous skin tone. It's not merely that this isn't a dress for a pale white woman; very dark skin would equally unbalance the dress, muting the color. Berry has a glowing, even mocha complexion that blends so harmoniously with the gradations of green and pink on the torso of the gown that her skin almost works as soft backlighting for the embroidery. In fact, Saab's rich hues and Berry's warm complexion are such a perfect mesh it's hard to believe that Saab didn't choose the colors specifically for her.

This was one unabashedly sensuous gown, worn by a woman who possesses one of the most enviable figures and loveliest faces in film today. Yet it was the actress's boyish haircut that gave the whole look a cheekier, even sexier, edge. There stood Berry—all dressed up for the ball— with a haircut that pretty much defined her as the kind of girl who'd just as soon climb a tree as a stage to retrieve an Oscar.

While Saab's actual dress remains one of the most popular of Oscar-night gowns, it's way too tricky to be easily copied. But the force of Berry's overall ensemble is easily applicable to every woman: playing your feminine side off your masculine creates intrigue that just might spark a memorable impression, no matter what color carpet you're standing on.

DRAGON-LADY GOWN

Travis Banton · 1934

Wong Liu Tsong was the first female Asian-American movie star, a testimony to both her talent and her bewitching looks. But the fact that she achieved lasting fame—after her family thought it wise to rename her Anna May Wong—playing a stereotypical siren of menacing mystery is a telling commentary on the inherent racism that governed Hollywood in its early days.

She played Lotus Flower, the doomed heroine, in an adaptation of *Madame Butterfly* called *The Toll of the Sea*; the 1922 film became a surprise hit, partially because it was the first general release film shot totally in Technicolor, but also because of seventeen-year-old Wong's unexpectedly mature and moving performance. Nonetheless, it's pretty difficult to become a leading lady when you are ethnic Chinese in a country that forbids interracial marriage and has only one male Asian film star, Sussue Hayakawa. Instead of being able to parlay her success into major roles, Wong was first relegated to featured parts playing an Eskimo, an Indian, and the exotic Tiger Lily in the silent film version of *Peter Pan*. Her double-edged career-making and career-defining breakthrough came in 1924 when Hollywood's biggest star, Douglas Fairbanks, Jr., cast her as the scheming Mongol slave in his epic blockbuster *The Thief of Bagdad*. Simultaneously, a star and Holly-wood's "dragon lady" was born.

Though readily accepted on Broadway and the London stage, and welcomed as a film star in Europe (fluent in French and German,

she made films in both countries), Wong was deemed too Chinese to play Chinese heroines in Hollywood, so the studios hired Helen Hayes, Myrna Loy, and German-born Luise Rainer to play Asian instead. But when it came to casting an irresistible "Oriental" vixen for a film like *Daughter of the Dragon* or *Limehouse Blues*, Wong was Hollywood's girl. She was a knockout, in both her performance and her appearance.

For *Limehouse Blues*, Wong is in only two major scenes as Tu Tuan, but the gown Travis Banton created for her is far more memorable than the film: a streamlined and formfitting variation on the classic cheongsam, eliminating the diagonal button closure at the top, the piping, and the traditional printed embroidery. In its place, he worked with a high-necked, long-sleeved, curvaceous second skin of bias-cut high-sheen black satin that emphasized Wong's lithe frame and height. But the spectacular highlight of the gown is the pair of dazzling, brilliantly executed gold-and-silver-sequin-scaled dragons, one running up the front of the dress, the other running down the back and along the nearly three-foot-long train. The gown was accessorized with big disk earrings, and Wong's complete image was made all the more dramatic by her highly arched, drawn-on eyebrows and piercingly long fingernails.

If you're going to be typecast as a dragon lady, then you might as well look as if anyone crossing you is playing with fire. And though actresses from every era continually gush about how much they relish playing wicked, too few have burned as brightly as Anna May Wong.

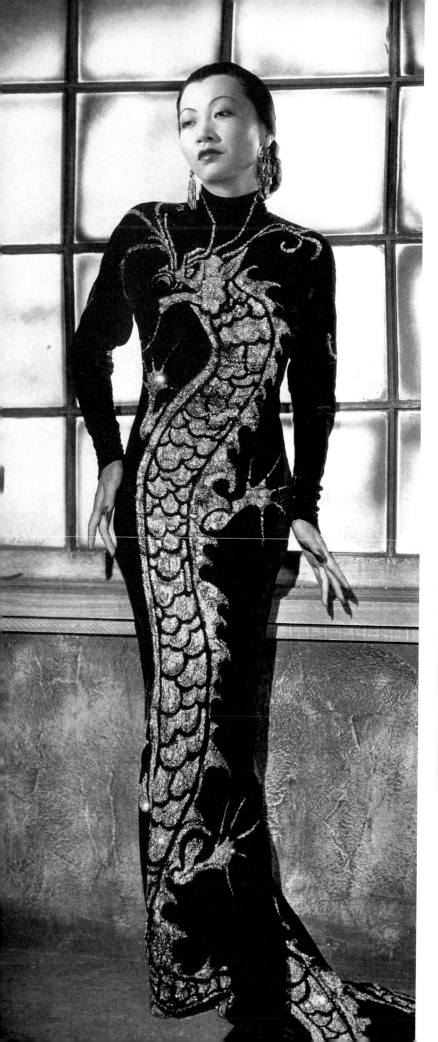
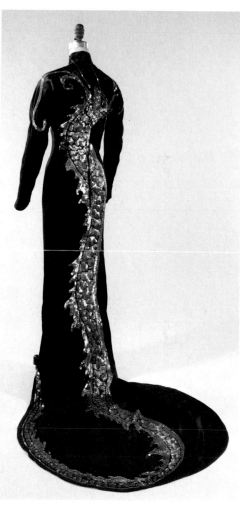

SAFARI DRESS

Yves Saint Laurent · 1968

In terms of overall popularity, Yves Saint Laurent produced no other globally influential silhouette that can match the longevity of the safari look. In fact, the international retail giant Banana Republic owes its very existence to this aesthetic. The safari dress works on a much more basic plane than Saint Laurent's other motifs. It's an amalgam of function, androgyny, resilience, and washability. Although the safari jacket is the key piece of the look, the safari dress possesses an eroticism that the jacket lacks. The dress is actually designed more like a slightly long tunic, with four strategic patch pockets—two on the breast and two on the hips. You definitely can't glam it up for evening. But it's the deep V-neckline, crisscrossed with loosely threaded laces, that gives it an inarguable dose of sensuality, especially for daytime wear.

And when those Xs down the décolleté are shown with a belt that features a series of metallic O-shaped belt holes, the dress takes on a salaciously witty gamesmanship.

Supposedly, the dress was inspired by Saint Laurent's thick-as-thieves muses Betty Catroux (shown here at left with the designer) and Loulou de la Falaise (right), who loved that they could wear it with thigh-high leather boots instead of pants. But for all its brevity, cleavage, and graphic visual tease, the single most suggestive element of the safari dress was the two laces that hung from the top of the neckline to just below the waist. When laced wide open on a beach in St. Tropez, let's just say they had a certain pull.

GALAXY DRESS

Roland Mouret · 2005

The Galaxy dress was the first look of Roland Mouret's fall 2005 collection, but after model Carmen Kass walked across a bare loft space wearing a knee-length, body-hugging, teal blue stretch wool dress with its now-unmistakable square neckline and ruffled cap sleeve, he could have ended the show right there. The eyes of the fashion industry's front-row habitués were darting full tilt around the room like Ping-Pong balls, betraying the requisite wordlessness with a "did you just see what I saw?" intensity.

The Galaxy dress was an urbanely chic day-to-night dress. Mouret claimed that he had been inspired by shapely actresses like Scarlett Johansson who were frustrated by designers who created looks for women with more boyish features. "I designed a dress for women who wear bras," was his often-quoted explanation. But there was far more to it than that. Made of either wool or viscose with Lycra, the dress clung to the torso but allowed complete freedom of movement, despite the razor-sharp pencil skirt. It also had something in common with Diane von Furstenberg's wrap dress (see page 81) in that it appealed to women of many different shapes and sizes. But it was unlike the wrap dress in one distinctive way. It fused the ladylike with the lady-be-bad.

In 2005, Mouret, a native of Lourdes, France, and former Jean Paul Gaultier model, who emits his own devilishly sexy vibe, had been designing and showing in London and getting good reviews for his work, but London is a quirky and not heavily attended fashion market. Mouret wanted to reach a bigger audience, so he moved his presentation to New York City to see if he could attain wider recognition.

The teal dress was a skyrocketing start. There were only three dresses in the entire collection that fit the exact description of the Galaxy dress, but three times was the charm. Mouret's dress caused a sensation because, quite simply, most women thought they looked amazing in it. Harrods sold out its first order of the dress in one hour, prompting one British fashion writer to report that she had every intention of getting into it through a system of pulleys, levers, winches, hoists, the cabbage-soup diet, and Vaseline. While she was enacting her labyrinth, it was quickly seen on Cameron Diaz, Naomi Watts, Victoria Beckham, Dita Von Teese, Rachel Weisz, and, naturally, Scarlett Johansson.

But as quickly as the Galaxy dress came in, Mouret's star flared out. Within months of his show, Mouret had a falling-out with his backers (who owned 100 percent of his company, including his name) and walked.

His backers continued to produce the dress, however, to meet the continuing demand. Using his initials, RM, Mouret created successful capsule collections for Net-a-Porter and Neiman Marcus, which have included variations on the Galaxy dress (with names like Minerva and Titanium). In fall 2010, newly backed by Simon Fuller, Mouret was able to buy his name back and rebuild his fashion house.

RED GOWN FOR *PRETTY WOMAN*

Marilyn Vance-Straker · 1990

This one's a bit of a cheat. The gown is just fine, but as transformation wardrobes go, it's not really a showstopper. It's no match for the appearance of Audrey Hepburn atop the stairs in the beaded white Empire gown she's going to wear to the Embassy Ball in *My Fair Lady* (see page 31), or Bette Davis's walking regally down the gangway of a yacht with an extreme makeover and an ultrasmart suit in *Now, Voyager*. But you can't let one of the most delightful star-making moments in film go by unnoted.

Pretty Woman is ostensibly the tale of a ruthless businessman falling for a streetwise call girl with a heart of gold. Yet it's safe to say that no matter how many times you have seen the film, the only moment you can clearly recall is the one when you fell hopelessly in love with Julia Roberts—and that moment is marked by a dress.

After Roberts's Vivian Ward goes on a shopping spree on Rodeo Drive, where she puts a judgmental saleswoman in her place, Gere's Edward Lewis comes to the Beverly Wilshire Hotel to pick her up for a "date" to see *La Traviata*. The girl Lewis initially solicits favors denim microminis, thigh-high patent leather boots, and a cheap blond wig; the woman who crosses the lobby to meet him is a glowing, bashfully grinning, russet-tressed knockout in a scarlet silk ball gown.

As perfectly as the dress fits and as irresistible as Roberts's Vivian looks, Edward insists something is missing, so he pulls out a jewelry box containing a diamond necklace Vivian may borrow for the night. As he opens the box to reveal the contents, Vivian can't believe what she is seeing is real, so she reaches in with her opera-length-gloved hand to touch it. But before she can even get close, her benefactor slams the box shut with a loud clap. Roberts jumps back with eyes gleaming and lets loose with a shriek, immediately followed by a raucous laugh that broadcasts unmasked joy.

In an instant, every beating heart that quickened to that cackle suddenly belonged to Julia Roberts. The sheer elation and sense of identification with someone who, no matter how dressed up she'd gotten, was still totally and comfortably herself immediately drew audiences to her. Jewels or no jewels, it was clear that this girl was going out to have a good time. By the time Gere fastens the diamonds around her neck and we watched the couple walk to the limo, Roberts had vanquished all pretenders to become the most desirable woman in film. So how can you separate the woman from the dress? And why would you when you can still recall the first time you heard that marvelous laugh?

WINTER NIGHT GOWN

Oscar de la Renta · 2001

Oscar de la Renta is fashion's last gentleman standing, especially if a woman walks into a room. To see him—always clad in a perfectly cut suit and colorful silk tie, his skin tan and hair slicked back—take a bow at the close of one of his collections is a reminder that fashion was once a craft driven by manners instead of rumors, where the primary goal was not to go global but to make women feel special.

As one of fashion's venerated elders, you might expect de la Renta to be looking back at all he has achieved rather than looking ahead. But this is hardly the case; his label is rapidly expanding, boasting a client roster as disparate as it is distinguished: Hillary Clinton, Cameron Diaz, Oprah Winfrey, Lea Michele, principal dancers of American Ballet Theatre, and board members of the Metropolitan Opera—of which he is one.

De la Renta commands such unabated devotion because he has never wavered or altered his philosophy: "When I see a woman, I don't think about her politics, I don't care about her age. All I know is that she wants to look beautiful. It's the one thing about women that never changes. And making clothes that are beautiful is the only job I've ever wanted to have."

"Beautiful" is exactly what Julianna Margulies said when she opened the huge box sent to her by her agent while the actress was deciding what to wear to the Golden Globes in 2001. Most often seen on red carpets wearing the handiwork of her close friend Narciso Rodriguez, Margulies admitted, "It was unbelievably beautiful and big, like something out of a fairy tale; endless yards and yards of the deep midnight tulle, the strapless top strewn with jeweled constellations, and the skirt covered in unbelievable diamanté beads forming these starbursts. I was blown away."

And afraid. "It was only my second year on *ER*. Maybe it was my third Golden Globes. I was nominated for an award, but I'm not good at being a show-off. I am so not a frou girl. I don't wear ball gowns. I like my fashion clean and fun."

But the underlying enchantment of de la Renta's creations is his wily implementation of his Latin heritage. For despite his cultivated association with the ladies-who-lunch crowd, the Dominican-born designer—who apprenticed under Cristóbal Balenciaga at Lanvin, and under Jean Dessès—never sends out a collection that is not replete with ruffles, bright Carnavale colors, and brilliantly hued and resplendent couture-quality ornamentation. Margulies's gown, called Winter Night, is a wonderful contemporary example of his trademark exuberance. The gown is reminiscent of the star-filled sky above the designer's waterfront home in Punta Cana, where he spends almost as much time singing and dancing the samba with guests as he does sketching. "I know it's a cliché," says Margulies, "but I put it on and felt like a princess. My room was full of other potential dresses, but I was done. However, I have to admit it was trial by tulle. What people don't realize is that you are only on the red carpet at these events for about twenty minutes, and then you have to sit in this voluminous dress for hours. There were yards of beaded tulle all over the table. No one could get near me. The next morning I swore I would never wear another gown like that again." But then she received something that changed her mind: "a letter from Oscar, thanking me for wearing the dress. I have never received a handwritten note from a designer before expressing gratitude. I should have been thanking him! I would wear anything that man asked me to."

Oh-so-cool dudes, take note: a true gentleman will always make a woman feel special.

BIG-SHOULDERED GOWN FOR *LETTY LYNTON*

Adrian · 1932

Why do film buffs love Joan Crawford so? Because her unbridled, ambitious hunger for attention and stardom and total annihilation of anyone in her path or threatening her close-up leaps from the screen with such blatant, unfiltered power, we cheer helplessly as she gets away with murder. So what could be juicier than a movie in which Crawford plays a woman who *does* get away with murder? Unfortunately, almost no one living has seen a full version of *Letty Lynton* in a cinema for more than seventy years. That's because in 1939, the U.S. Second Court of Appeals judged the film guilty of plagiarizing a British play called *Dishonored Lady*. The film itself is a doozy—featuring a love triangle so full of deceit, betrayal, poison, murder, and lack of remorse that it was also banned in Great Britain for justifying the murderess's right to a happy ending—having been produced before Hollywood studios capitulated to having films reviewed by the National Legion of Decency.

But the true crime of *Letty Lynton*'s MIA status is that this was the seminal film in which Adrian, MGM's head costume designer, first clad Crawford in what were to be the trademark silhouettes of her unmistakable screen wardrobe. Here was the debut of those fur coats with collars so high they practically formed a headrest, the lamé gowns draped louchely round her hips, and her double-strapped crisscrossing halter-neck gowns that practically screamed, "Watch your back, and your man, honey!"

But the quintessential garment that lifted and buttressed Crawford's style into celluloid immortality and proved influential for decades was Adrian's white cotton organdy gown with shoulders padded in chiffon ruffles nearly as high as the star's cheekbones. The frilly but formidable dress created such a sensation that, though the number of copies sold overall following the film's initial release varies widely—from fifty thousand to a million— Macy's claims to have sold five hundred thousand copies within the first six months.

Adrian's wide, unsloping yoke telegraphed Crawford's belief in the power of her femininity so effectively that any actress wishing to compete in a man's world—be it Rosalind Russell, Greer Garson, or Jane Russell—co-opted the pads. In the 1980s, when designers like Giorgio Armani and Donna Karan determined that women needed a wardrobe that would empower them in the workplace, what did they reach for but Joan's shoulder falsies? Since fashion is cyclical, a combination of a renewed interest in both the 1980s and structured tailoring has seen yet another return of the squared shoulder, which does make a woman look more imposing, especially if paired with a fitted waist and a full skirt or a peplum. However, if you increase the shoulder height to 1930s levels, you're in danger of creating a gown worthy of an alien queen battling the Starship Enterprise.

Occasionally, a pirated version of *Letty Lynton* turns up on YouTube, then vanishes almost immediately. In a climate as amoral as ours, crimes of passion no longer startle. But it would be a crime of fashion to withhold the debut of this eternally influential screen goddess donning her padded coronation robe for the first time.

TENT DRESSES FOR PHYLLIS DILLER

"Omar of Omaha" · 1960

In 1955, Phyllis Diller, thirty-seven, signed for a two-week engagement at San Francisco's comedy venue, the Purple Onion—a show that was then held over for seventy-nine more weeks. In that year and a half, she charted female stand-up comedy's future, chronicling all aspects of her life with her husband, "Fang," and reveling in her housewifely acumen long before Roseanne Barr laid claim to title of "domestic goddess." ("Clean my oven?" cried Diller. "There's so much caked-on grease in there, I have to make cupcakes one at a time.") And Diller had a look. Except you didn't really look. You gaped.

Veteran Borscht Belt comediennes like Jean Carroll would go on *The Ed Sullivan Show* in a sheath draped with a mink stole, but Diller's shtick didn't call for bar mitzvah attire. Outfit for outfit, she was one of the most outrageously dressed comediennes of her time. Carrying an extraordinarily long cigarette holder, echoing Auntie Mame in her short-gloved hands, and trotting onstage in go-go boots, her broomstick-dry bleached hair sticking out like solar flares around the sun, Diller appeared in an array of often blindingly printed, optically painful, garishly embellished beltless tent dresses. Her look was

a violent cross between a Pucci mini and a Hawaiian muumuu attacked by a rhinestone stud gun and a flock of peacocks. Her dresses would feature a plethora of feathers around the neck and at the hem, or a bejeweled fur collar and cuffs, or sequined and beaded bodices against garish brocade patterns. ("You think I'm overdressed? This is my slip!")

Diller claimed her dresses were made exclusively for her by her couturier, "Omar of Omaha," but in fact, Diller and a dressmaker named Gloria Johnson, who actually did live in Omaha, designed them as a joint project. Their collaboration produced a wardrobe that equated fabulous with vulgar. But more important, when Diller first appeared onstage, she didn't have to say a thing. Leading with her cigarette holder, she'd walk out, stand, turn to the right, then to the left so everyone could get a good look, and then throw her head back and release that loud, gravel-rattling cackle of hers.

The audience laughed right back. Her outrageous outfit always won over the crowd before the first flick of her cigarette. After that, everyone was primed to hear about how her "mother-in-law is so fat that once a month they pull her through the Holland Tunnel . . . to clean it."

THE POUF

Christian Lacroix · 1987

66 Ten years ago, I did an all-black collection,
but after the show a TV reporter
said the colors were marvelous. 99
—CHRISTIAN LACROIX

For one brief shining moment, Christian Lacroix was hailed as fashion's savior. When he left the House of Patou in 1986, he wasted no time positioning himself in haute couture, presenting his first collection a year later, just as fashion's ultimate expression of craft was in danger of falling into a state of stultifying irrelevance. But Lacroix believed in haute couture. "It projects a dream," he wrote. "In such a flat world we need one-of-a-kind."

And Lacroix is one of a kind, with a wildly flamboyant sense of color, acquired from the Gypsies he admired in his hometown of Arles, and an unapologetic love for the excessive, which he giddily attributed to being part of "the era of *Dynasty* and *Dallas* . . . of big spenders and new money, open-minded, but a little bit vulgar." Lacroix thought that the problem with couture was that "everything was a pastiche of the 1940s and the 1950s [but] nothing's new." Lacroix's first couture show took care of that.

The pouf—a ball gown stuffed into a minidress—was a sensation the moment Lacroix sent it down the runway. He had actually developed the form at Jean Patou, but the house's backers hated it. The *Times* of London declared the pouf the most exciting thing to happen in fashion in twenty-five years. Lacroix loved to show it in bold florals, often spotlighting carnations, his favorite flower. He also did a full-skirt version and adapted it as a gown, and though the latter had the proportions of a taffeta pup tent, haute couture customers went wild for it. Retailers knocked it off like mad. It seemed as though Lacroix had started a true trend.

But alas, the trend turned out to be a fad, a fabulous, revitalizing fad, but like all fads, it burned bright and then flamed out, leaving Lacroix indelibly linked to a garment and an image he could never shake.

Unfortunately, Lacroix's haute couture never brought in enough ready-to-wear customers to make his business work. In fact, when he left Patou, the house sued him for making an unsalable last collection and won. Lacroix had to pay damages. For many years, with the support of various backers, Lacroix tried to tweak, adapt, and simplify his aesthetic with bridge lines and capsule collections, even turning to contemporary art for a less exuberant inspiration so his clothing would appeal to a larger audience. So much of his work was one-of-a-kind, but perception is everything in fashion. Sadly, he closed his atelier, declaring insolvency in May 2009.

BALL GOWN FOR GRACE JONES

Keith Haring · 1987

Designers and artists have consistently worshipped the fierce, unearthly beauty of Grace Jones. Azzedine Alaïa, Thierry Mugler, Stephen Burrows, Viktor & Rolf, and Jean-Paul Goude have all made clothes for her concerts and her personal wardrobe. The stage costumes the Japanese film, opera, and stage designer Eiko Ishioka made for her so surpass the imagination of anyone working today they give credibility to some of Jones's umbrage at a music industry she believes is filled with a generation of female artists who have ripped off her outrageous acts of performance art.

On New Year's Eve 1987 at Roseland Ballroom, artist Keith Haring created what may have been one of her most amazing looks. He used white body paint to cover her naked torso with his characteristic stylized forms and covered her lower half in white canvas with black markings that spilled over the entire stage. Jones began to ascend in midchorus of her song, and as she rose to about five feet above the stage, the canvas became an enormous ball gown. But then she kept on rising: ten, fifteen, twenty feet in the air—and when she reached balcony level, the canvas was a towering conical totem with her dancers writhing beneath her. Then she let out her soul-thrashing cackle. Having been there that evening, I can say I wasn't quite sure whether this was the coolest way to welcome the New Year or I should brace myself for how the spirits would pay me back for my paganism.

Still fierce in her early sixties, Jones is regarded as a novelty act in the United States but is considered a major star in Europe and in many capitals worldwide. Lady Gaga should sneak in and take notes. There's still a lot to learn.

MONDRIAN DRESS

Yves Saint Laurent · 1965

Mary Quant, Twiggy, fashion photographer David Bailey, the Biba boutique, and all the Nehru-jacketed bands who led the charge of the British Invasion can take credit for ushering in the androgynous geometric figure-hiding mod look in the mid-1960s, but it was French couturier Yves Saint Laurent who gave this youth-infused take on minimalism stature and resonance.

Melding mod's streamlined silhouette to a bold canvas, Saint Laurent appropriated the geometric block paintings of the Dutch artist Piet Mondrian to a collection of dresses. Confining his palette to black, white, and the three primary colors, Saint Laurent reconfigured Mondrian's work to experiment with focusing attention on different parts of the body. Though its iconic landscape has been consistently copied for more than forty years, the original Mondrian dress was hardly as simple as it appears.

Unlike the knockoffs, Saint Laurent's creation is not a sack dress but rather boasts a defined shape and interior construction that allows the double-faced wool jersey to yield gently to the lines of the body. That structure is ingeniously hidden. While not suggested anywhere by external stitching, the seams of the dress are buried within the black demarcation lines of the "painting." Those black lines are more than strong graphics: they actually shape the dress.

Instantly successful, the Mondrian dress was important to fashion in two notable ways: It confirmed minimalism as a style worthy of the ready-to-wear and couture ateliers of Paris, quickly filtering down to mainstream sportswear due to its seeming simplicity. It also revealed the modern-art gallery as a potential inspiration for fashion. In later years Stephen Sprouse appropriated the work and even the visage of Andy Warhol. Ossie Clark looked to David Hockney; Vera Wang tried on the colors of Mark Rothko (see page 52); and Marc Jacobs collaborated with both Haruki Murakami and Richard Prince. But as many designers are happy to attest, almost all roads in modern fashion lead back to Yves Saint Laurent.

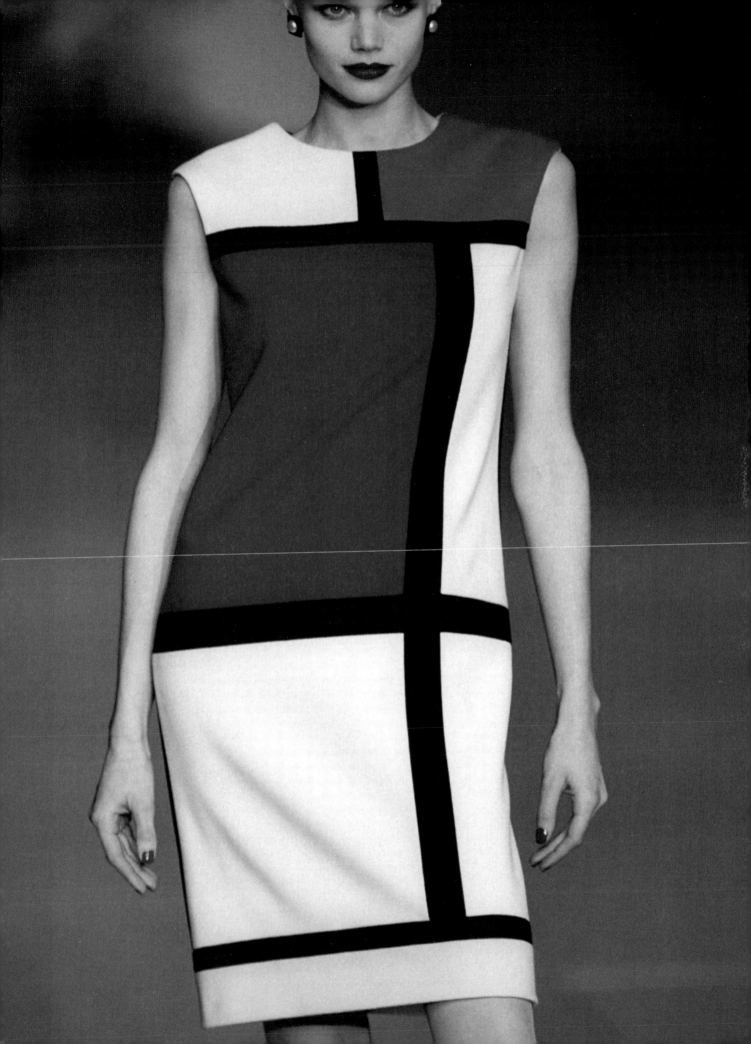

REVENGE DRESS

Christina Stambolian · 1991

In a seminar I share with women on style, a section is devoted to becoming a better shopper. Of the twenty-five rules I present, only one abandons logic: If you find an item you're unexpectedly wild for, do not talk yourself out of buying it with rationales such as, "But where am I going to wear it?" If you love the item, get it, and the where will find you. Or you will find the where, no matter how long it takes.

One summer Saturday in 1991, Her Royal Highness Diana, Princess of Wales, and her brother, the Earl of Spencer, strolled into Christina Stambolian's London boutique. Diana must have been impressed, because she purchased several items and then told Stambolian that she needed an occasion dress. Stambolian, fairly beside herself that the princess wanted her to design a dress, produced a few sketches. Diana immediately fancied one, but retreated from it just as quickly, voicing concerns about where she would wear the dress, that there was perhaps too much leg showing, that the neckline was very open, and so on. The designer and the earl, however, voted for taking the risk.

Two weeks later, Diana had her final fitting. Once again, she was skittish at the sight of the low silk jacquard neckline and the height and weightlessness of the ruched chiffon skirt. But she wrote a check—to be drawn from her husband's account.

Three years later, Diana had yet to wear the dress in public. But on June 29, 1994, the night she was supposed to attend an event at the Serpentine Gallery (in a borrowed Valentino), Prince Charles elected to appear on national television to publicly acknowledge his affair with Camilla Parker-Bowles. Clearly, her husband's confession would be front-page news, and Diana's appearance at the gallery, very likely a ticker item. Diana knew all about playing the press, and so the Valentino went by the wayside.

That evening, just as Prince Charles was making his television appearance, his spurned wife stepped out of a car, looking ravishing and flagrantly audacious, her gym-toned body poured into Stambolian's all-ruched black dress, its sleeves pulled down as low as the neckline, its minitrain flying off her hip as she strutted down the sidewalk in a pair of killer black stilettos—and a winning smile.

The next morning, the image of Diana, clad in the second-most-photographed dress she ever wore, graced the front page of every London newspaper. It was probably the best nine hundred quid she had ever spent.

So remember, buy it and the where and when will come.

Cate Blanchett

She speaks English the way you would like to. She carries herself the way all women should but rarely do. Since she can effortlessly transition from playing Queen Elizabeth I to Katharine Hepburn, from Bob Dylan to Blanche DuBois, she's never typecast. Cate Blanchett is one of the most versatile and commanding actresses working today.

Because she carries herself regally off-screen as well as on, you wouldn't assume that Blanchett would be a designer's dream mannequin. But she chooses her clothes with the same knowing discrimination as she does her roles, and when Blanchett puts on a garment that's particularly right for her, the miraculous happens—it seems as if the clothes are truly her own, not borrowed from a designer or suggested by a stylist (even though she does employ one).

When attending the Academy Awards ceremonies as a first-time nominee for her performance as Elizabeth I, Blanchett savvily moved as far away from the look of the severely intimidating monarch as she could. She and Galliano conspired to capture her in a body-grazing silk knit of midnight violet with delicate floral embroidery around the neckline (see pages 134–135). But it was when Blanchett turned away that she garnered everyone's attention. From her shoulders down to a deep V-back, Galliano suspended in an illusion panel a resplendent spray of pink, rose, and

lavender flowers, and in the midst of them, just off-center, a scarlet-and-green hummingbird poised to take full advantage of this marvelous garden. This was a gown, not for a legendary monarch, but an undeniable siren, and the sharp contrast of the captivating, then-nearly-unknown Australian actress with the forbidding woman on the screen was a strategic career boost and fortuitous shock to those in Hollywood who would be only too quick to lock her into regal roles.

Blanchett has had a very successful, though not exclusive, relationship with Giorgio Armani. Armani's slightly harder edge when it comes to haute couture suits her naturally patrician looks, exemplified by the dark luster of the pewter column dress she wore from his Privé line when nominated for an Academy Award for Best Supporting Actress for *Notes on a Scandal* (see pages 136–137). In fact, if director Ridley Scott had set *Robin Hood* as a modernist adventure, she could have used the Armani gown when she took on the role of Maid Marian. Both the appliqués of red stones above the hem and the rough gems on the shoulder have a medieval air. And the form-fitting pewter beads could make for a couture suit of armor.

In the gown Dries Van Noten designed for her to wear to the 2008 Academy Awards in the late stages of pregnancy (see page 137), Blanchett went from gleaming warrior to glowing earth mother. The dress was adapted from his sensational spring collection that year, one of Van Noten's best, replete with rich, saturated colors, incorporating sterling silver and semiprecious bead accents on the

cuffs, collars, and embroidery. The gown Blanchett chose is a deep yet warm purple; the multiple silver, stone, and enamel chains around her neck are actually the halter of the dress. It's important to note that this was not merely an excellent choice for a woman expecting. It was a wonderful gown, period.

On the opening night of the 2010 Cannes Film Festival, Blanchett paid homage to the late designer Alexander McQueen by wearing a gown from his final collection (see page 132) that the two had chosen together for her prior to his death. The unparalleled attention to the detail of the silver embroidered eagle (about half the size of the real bird) carrying garlands of roses threaded in the same silver over silk jacquard is as extraordinary as the balance of this dress, which seems to flow on a diagonal, from the wing tip at the left shoulder to the illusion of the bird lifting the gown and exposing the tulle at the right hem. This is a big dress, grander and more dramatic than most that Blanchett wears. The embroidery alone could easily overshadow an actress of lesser presence. Aside from her so-far-limitless talent, the fact that one first responds to how sensational Blanchett looks in the gown rather than what a sensational gown she is wearing is one reason why it would be swell to have her nominated for a major film award every year. Blanchett makes red-carpet watching an edifying, as well as gratifying, delight.

GREEN EVENING GOWN FOR *ATONEMENT*

Jacqueline Durran · 2007

In the film *Atonement*, when Robbie, the son of a servant whose employer has paid his way through Cambridge, writes his benefactor's daughter Cecilia, he begs forgiveness for his skittish behavior during their last meeting, claiming, "I feel rather lightheaded and foolish in your presence, and I don't think I can blame the heat."

As anyone who has seen the film can attest, Robbie (James McAvoy) should be forgiven. The sight of Cecilia (Keira Knightley) in her emerald-green satin gown is breathtaking. An unyieldingly sorrowful adaptation of Ian McEwan's novel that stabs at the pain caused by class, envy, false perception, and the penalties of deceit and war, *Atonement* was filmed by director Joe Wright in settings of stifling refinement, shadows, and smoke. But against this cheerlessly recalled landscape, he centers Knightley on-screen so that all else fades around her.

Cecilia's pivotal gown is actually a bit out of period, more sinuous and sexy than anything women would have worn in England during the mid-1930s. The back is extremely bare; the knot at the crotch, a bit obvious; and the fall-away front pleat splits too immodestly. But the designer, Jacqueline Durran, deliberately wanted the gown to appear as a beacon of "heightened perfection," skimming the body rather than clinging to it to "add to a feeling of semi-nakedness." Because the dress is intimately described in the novel, Wright demanded a specific insistent green, one that would radiate disquiet, passion, jealousy, and false hope. The result is achieved through a combination of lime-green silk, green-black organza, and emerald chiffon. Its one nod to modern technology is that instead of adornment, the neckline is strewn with laser-cut holes to reveal flashes of skin.

Because the dress was so fragile (it needed to get torn in the library seduction scene with Knightley and McAvoy), ten versions of it were made. In that memorable encounter, what we see is a young couple so desperate to be consumed by their mutual fever and longing that they ignore logic, propriety, and consequence. For Robbie, Cecilia is not just an object of desire. She is his horizon, his future, his sole chance for happiness. Who wouldn't want to wear a gown that instills such irrational ecstasy?

After the film was released, retail manufacturers made more copies of it than of any other dress featured in a film that year. One of the original versions was auctioned online for the Hollywood star-based charity Clothes Off Our Back. It went for forty-six thousand dollars, used.

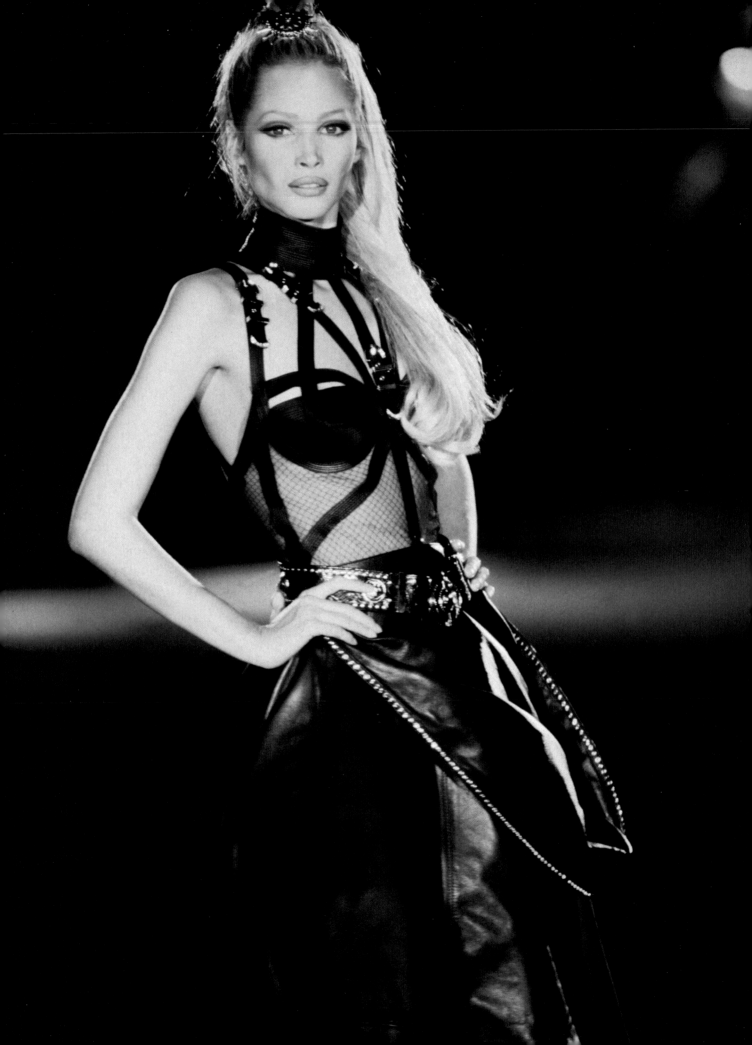

BONDAGE DRESS

Gianni Versace · 1992

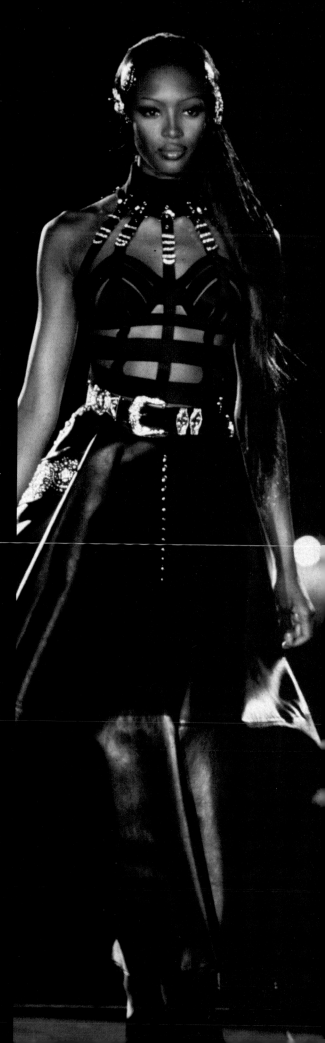

Gianni Versace once used Queen's "Bohemian Rhapsody" as the central song for one of his couture shows. He loved to play the album in his studio because its symphonic extravagance almost reached the level of his love of grand opera, and he'd hum along as he sat among bowls full of crystals, bolts of leather, and yards of dazzlingly printed silk as he sketched their next life. But he always began to sing along when Freddie Mercury got to the lyric, "Is this the real life? Is this just fantasy?" That line always made him smile because, to Versace, they were one and the same.

When Versace put jeans on his runway in 1980, the French yelped that it wasn't couture. Traditionalists stepped back when he turned metal mesh into an evening gown. Retailers didn't know how to hang his open-looped computer-generated knits. They'd fall off hangers; they didn't stay folded (you have to lay them flat). The fun part was that every time he produced another success, an audience of professionals thought they understood him, that they were on his wavelength. And then he'd change the frequency.

But when Versace released his Bondage collection, it was as if Tina Turner had jumped up to testify amid a congregation of Carmelite nuns. Skeptics, retailers, even the most sexually emancipated editors were uneasy. Versace had reached his hand way into the depths of people's fantasies and snatched them up to play with in the daylight. He laid out their dark dreams in black silk and satin, buckled them with gold

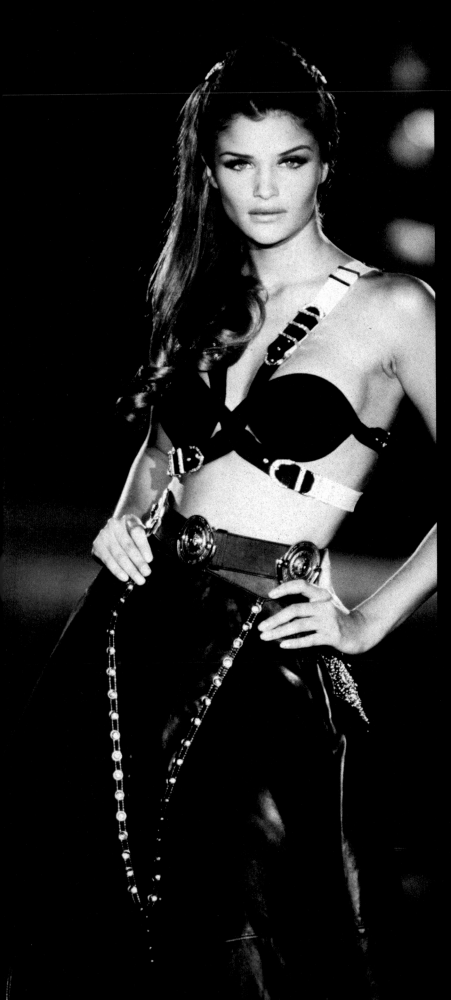

Medusas, and then strapped them together with butter-soft leather in intricate starburst weaves that would have brought about *oohs* and *ahs* if the clothing had been rendered in quilted crepe.

But can you make a voluminous ball gown out of supple black napa and send it out there without a smile? Well, maybe a more humorless designer could. But it tickled Versace to provoke. He snickered at every shudder. He'd hold up two elaborately buckled pieces against his body, point to one and then the other, and say, "This is a bra. This is a slip. I'm exposing what? If I was to put it on or if I put it on Jeff [a male model], maybe, then maybe I see a problem. But on Linda or Naomi? Oh, darling. People must learn to relax. If you can't have fun with this, don't complain to me."

It's not as if Versace expected leather ball gowns, harnesses, gauntlets, and gladiator sandals to become standard garb at the opening of the Metropolitan Opera. But what Versace accomplished with the Bondage collection was to drag black leather off its motorcycle, separating it from its close pals the white T and the faded jean, and declare that the fabric should go out more, to nice places, and that it should be seen with chiffon and sequins more often, because it's a fabric that deserves to be admired and savored. And it makes people feel sexy.

Versace never wavered, because he clearly saw how we could make our fantasies into our future. And he was perfectly happy to wait until the rest of us cleaned our glasses, or got the guts.

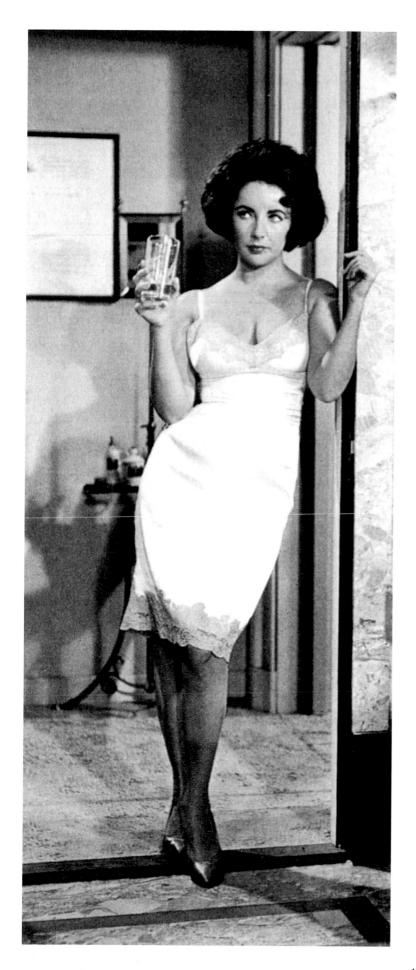

SLIP FOR
BUTTERFIELD 8

Helen Rose · 1960

Has any woman clad in silk and lace ever looked more bored yet more desirable holding a cocktail in a doorway? Technically, the garment Elizabeth Taylor wore in this scene from *BUtterfield 8* (a film she agreed to do because it guaranteed her next project, *Cleopatra*) is a slip, but with "boudoir" being a consistently dominant trend in fashion for the last decade (Dolce & Gabbana built their careers around their black version [see page 157]), you almost can't help perceiving it as a dress.

Sales of lingerie soared nationwide because of Taylor's pose and the film's unexpected popularity, which had more to do with her life-threatening tracheotomy earlier in the year than the film's quality. Also not to be overlooked was the star's role in the very public breakup of the marriage of Hollywood darlings Eddie Fisher and Debbie Reynolds. Consequently, Taylor playing a prostitute rang too true for some, amplified by her portrayal in the media as a wanton homewrecker—not that that stopped her from marrying Fisher, who in an eerie portent, starred with her in *BUtterfield 8* as her best friend. Then, having fulfilled her agreement with *BUtterfield 8*, Taylor moved on to her next project, *Cleopatra*, where she met her new costar—Richard Burton. And as everyone now knows, it wasn't too long before the next time Eddie Fisher would see Taylor in fabulous lingerie again was on the screen, along with the rest of us.

GOTH-GODDESS DRESS

Margi Kent, stylist · 1977

Stevie Nicks may be the most covered-up woman in the history of rock. Not an ounce of flesh greets the sun at an outdoor concert or the tainted air of an indoor one. In fact, unless you're sitting close up, it's impossible to tell what she actually has on. From a distance, the silhouette is a blowsier Morticia Addams. Approaching the stage, though, the look edges closer to Nancy, the hope-filled but hopeless wench in love with villain Bill Sikes in Dickens's *Oliver Twist*. But once you reach the premium seats, you realize she's neither of them. Morticia would never wear layers, and Nancy couldn't afford this many.

Stevie Nicks is a walking goth boutique. There's a French corset under a lace top wrapped by a fringed scarf surrounded by an antique shawl. And that's just the top half. There's likely to be a sheer skirt under a chiffon one, all topped by a flurry of handkerchief points and a lace apron. Of course, all is black, as are the tights and the lace-up boots. Nicks piles on none of it by accident, coordinating her soft inky armor—gathered from vintage shops, flea markets, shopping sprees, and impulse buys while on tour—with custom-

made pieces, all with the help of stylist and designer Margi Kent, with whom she has worked since Fleetwood Mac's *Rumours* tour in 1977.

Of course, none of this Salome-in-reverse garb truly comes to life until somewhere during a musical riff in "Rhiannon" or "Landslide." Nicks starts to spin, swaying first from one side to the other, until she finally lets go, transforming into a Gypsy whirling dervish on seven-inch heels, and all is dark with the world.

Is there any performer or Olsen twin who has ever toyed with goth who does not reference Stevie Nicks? Nicks claims that her look is a mix of the serene Russian ballerina Natalia Makarova and reclusive Greta Garbo, but has either ever held an audience tethered to so much fabric? Isaac Mizrahi, Anna Sui, Courtney Love, even Madonna have alluded to being influenced by her bewitching style. But none are willing to do what Nicks does: stay buttoned up. "I can be very, very sexy under eighteen pounds of chiffon and lace and velvet," says Nicks. "And nobody will know what I really am. None of these other singers will have a mystique, but I will."

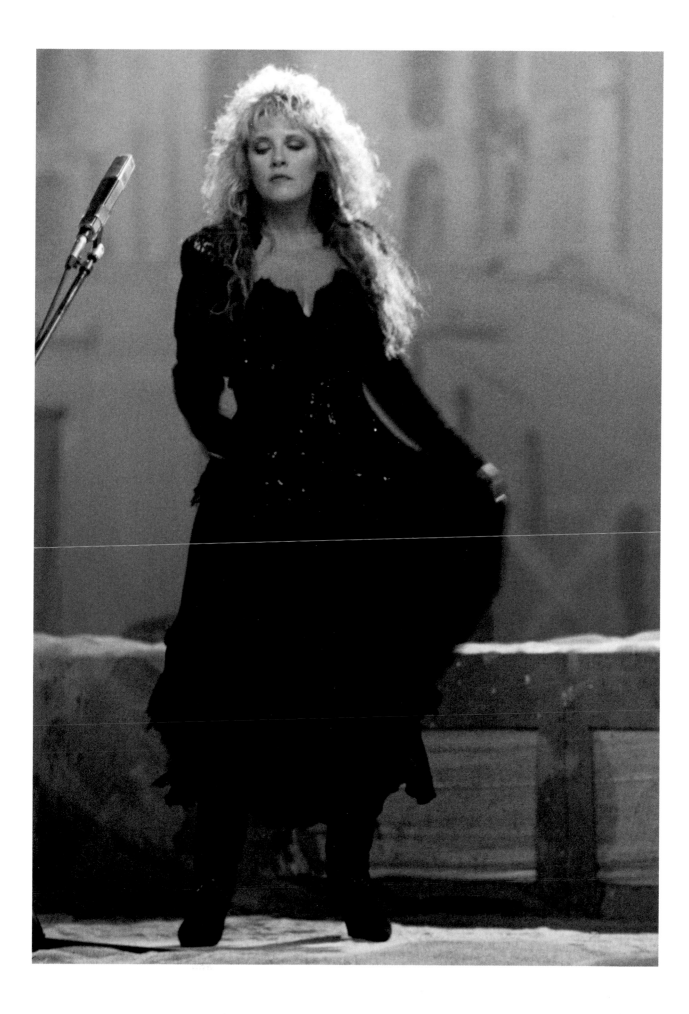

GOLD LACE EVENING GOWN

Donatella Versace · 2003

Born in Los Angeles and raised in Colorado by her mother, comedic actress Goldie Hawn, and her mother's partner, actor Kurt Russell, Kate Hudson is as close to a flower child as Hollywood can nurture, with a natural penchant for boho-chic. But when Oscar time rolls around, how do you dress the definitive California golden girl to present an Academy Award?

If you are Donatella Versace, you take a very literal approach. In an uncharacteristic mood to design a gown that conveys full-on romance, Versace commissioned her atelier to craft a coronation-worthy gown of gold. Hundreds of hours were spent joining by hand the countless sections of antique champagne lace, flowers, and circlets, some found in fabric archives, others matched by current craftsmanship, but all handmade with metallic thread. The lace was affixed to a top skirt made of yards of weightless tulle with several similar gossamer layers underneath in place of a petticoat. While the dress had the delicacy of a vintage find, like a true Versace, it did not exude the remotest trace of nostalgia.

With her hair smoothed gently and her jewelry as fragile as the process needed to weave such wonder, Hudson beamed as she walked across the stage, not as someone trying to be a movie queen, but as a young woman happy to be a movie princess. It's my favorite Versace gown to ever appear at the Oscars. Maybe my favorite Oscar dress, period—because of its delicate beauty and the fact that it was so effortlessly carried off by that young woman who usually hangs out in Malibu.

SWEATSHIRT DRESS

Norma Kamali · 1978

66 If you choose the right fabrics, your clothes can join you through the years, through all your changes, even a baby. Your body is going to snap back. Why shouldn't your dress? 99

——NORMA KAMALI

The pull-on stretch bikini, parachute pants made from real silk surplus parachutes from the Korean War, the sleeping-bag down coat, the jersey-and-Lycra dress that can be worn in a dozen ways, designer activewear—all these widely appropriated innovations seem to lead back to OMO (On My Own), Norma Kamali's headquarters on West Fifty-Sixth Street in New York City.

Kamali may be one of the most copied designers in North America. "Why should that bother me?" She shrugs. "I know what I've done and what I do well. Right now, I want women to buy clothing that adapts to their lives, and their shapes. Women's bodies go through so many changes. That's why women need clothes that are timeless and designed to adapt."

Thirty years after she came up with the idea, her store still sells the sweatshirt dress. "People don't remember," says Kamali, "that in 1978, adults weren't wearing hoodies and

running pants to go wherever they went to before they went to Starbucks. Athletes and kids wore sweatshirts, but they weren't part of an adult urban wardrobe."

Kids were her inspiration. Actually, it was herself as a kid. "I was obsessed with swimming, so I always had a sweatshirt for when I came out of the pool because it felt so good, like a cocoon. Well, since swimwear was becoming such a big part of my business, I thought why not make a sexy cover-up from sweatshirt material? And once Jones New York agreed to produce them, I didn't stop there."

The dress was a natural progression. She started with these two pieces, but there are now thirty-six in her sweatshirt collection. She credits her customers with coming up with many of the ideas that have adapted the dress and expanded the collection. "I'm proud of that," she says. "Once you decide to live in a way that's practical and smart, it's amazing where your imagination will take you."

PLUNGING HALTER-NECK GOWN

Alber Elbaz for Yves Saint Laurent · 2000

"I would never tell a woman to wear a long black dress in Los Angeles, though many of them do, and certainly not to the Oscars," says Alber Elbaz. "But Chloë Sevigny is not like most women. She is wonderful, and she is different, and like Tilda [Swinton; see page 74], she has such great intuition about style. Even in black she can make an amazing impression." And Sevigny did just that at the Academy Awards in 2000 when she was nominated for Best Supporting Actress for *Boys Don't Cry*. But Elbaz is being too modest because the gown that he created for the actress may be one of the most starkly compelling, effortlessly sexy gowns ever to grace Hollywood's biggest night out.

Elbaz had just presented his third collection for Saint Laurent, and though the press had welcomed his work immediately upon arrival, retailers were not as quick to warm to his less overt sense of luxury and his mature, flash-free concept of glamour. However, with this roundly praised collection, which began with a series of dramatic all-black looks—and foreshadowed his initial collections for Lanvin—the future looked brighter for Elbaz's tenure at Saint Laurent. Though custom-made for Sevigny, the black gown handsomely reflects the collection's opening and Elbaz's enviable ability to meld sophistication with insinuated sex appeal.

The touches are deft and subtle. The halter neck is twisted leather, as is the buckle-less waistband. The dress exposed Sevigny's entire back, as there is no fabric between the two pieces of leather comprising the halter and waistband. The well-anchored front of the halter offers ample fabric coverage, even up to the armholes on the sides, and the silk jersey plunges in a narrow V below Sevigny's cleavage, to just above the waist. In repose, the garment appears just slightly fuller than a columnar dress, except Elbaz has engineered pleats so deep that only when Sevigny walked did the sweeping fullness of the skirt and its slight train become apparent. A large Asprey & Garrard diamond Maltese cross added impact.

Unfortunately, Elbaz's triumph was temporarily stunted when the Gucci Group bought Saint Laurent later that year, and Gucci creative director Tom Ford was chosen to replace him. Saint Laurent's new owners, however, were less than delighted to see Sevigny prominently featured in so many major fashion magazines' best-dressed roundups for the year.

They say you can't keep a good man down, but how long before a great designer rises again? A year later, in 2001, Elbaz was made creative director of the house of Lanvin, and the rest is happy fashion history.

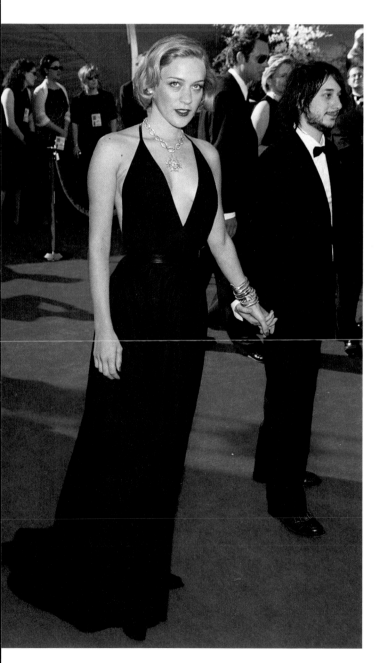
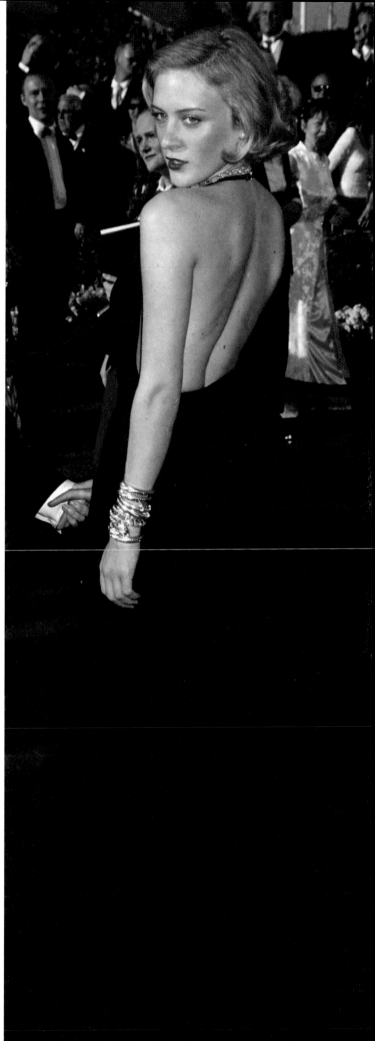

THAT GIRL'S A-LINE DRESS

Jonathan Logan · 1966

With her big bright eyes permanently FabuLashed and a brunette flip Aqua Netted to withstand even the stiffest updraft on the observation deck of the Empire State Building, Ann Marie moves to New York City to become an actress, finding a lovely apartment while the taxi meter is still running and, except for a rare acting gig here and there, never exhibiting any visible means of financial support over the course of the television series' 136 episodes.

Yet from out of *That Girl*'s closet comes a never-ending trousseau of Jonathan Logan dresses. While Marlo Thomas's rat tail–enhanced flip was as fixed as her defining vocal rasp, with each scene change—sometimes all it took was a new camera angle—there was Ann Marie in another dress. Technically, all the ensembles were more or less the same: a rigidly engineered A-line, almost always long sleeved, with a neckline so high that necklaces were not an option, save for the occasional daisy lavaliere. The range of color blocking, however, was kaleidoscopic, in patterns that were highly graphic. Occasionally, a dress with a pleat, inset, or white bib collar would appear, but otherwise the silhouette was as inflexible as a nun's habit.

In light of the positions women now hold in corporations, government, and military service, it's easy to overlook that *That Girl* was the first television series built around a single woman more eager for a career than a husband. (Adding validity, Thomas was executive producer of the series.) Yet, in its day, *That Girl*'s influence was significant on two other levels. By lengthening and relaxing the lines of the minidress, Logan made the garment suitable for conventional business attire. In fact, Thomas's powerful connection with the first coming-of-age generation of baby boomers' daughters turned the A-line into the wardrobe template for this soon-to-be-vital workforce. And then there is the reality that without the show's enormous success, audiences around the world may never have come to adore television's most famous working woman: Mary Richards. *The Mary Tyler Moore Show* was notable because not only did it feature a woman who actually walked away from a marriage to pursue a happier life on her own, but from a fashion standpoint, her clothing for the first two years of the program was inspired by—guess who?—Ann Marie.

GRAFFITI DRESS

Stephen Sprouse · 1984

Stephen Sprouse was the Bill Blass of punk. Like the man he once sketched for when he was still a teenager, Sprouse could make "downtown" look bright and shiny enough for Park Avenue ladies to crave it. He didn't merely tear clothes up and rejigger them with safety pins like half the crowd waiting to get into CBGB. Sprouse was much more of a Mudd Club and Area boy anyway, both of which were chicer nightspots. The latter's management was only too happy to indulge Sprouse, allowing him the space to create art installations that coincided with the club's thematic bimonthly "happening"-like transformations (such as "Gnarly," "Night," and "Confinement").

Unfortunately, the club gigs in the early 1980s didn't pay anything like his previous three-year stint as Halston's right hand during the designer's prime. Proof of how highly Halston valued Sprouse's eye came during the final run-through of a show. Sprouse was so insistent that Halston break away from the midi that the designer had helped popularize that he began hacking several of the dress hems from the new collection higher and higher—and with such enthusiasm that Halston and his entourage were soon goading him on with cries of "Skimpier! Skimpier!" The result was Halston's popular new take on the mini: the "Skimp."

Sprouse may have preferred his downtown life but his taste level, as punk as it appeared, was definitely uptown. His affinity for DayGlo colors, black paillettes, clear sequins, photo-screening on silk, innovative cutting, and love of Velcro long before all of these were either easily obtainable or cheap to produce resulted in headline-making but problematic punk wear, like his graffiti dress. Sprouse hand-painted all the graffiti himself—and such elaborate fabric treatment produced both a startling effect and a prohibitive retail price for a uniform of the counterculture: his dresses began at a thousand dollars and went up from there. Sadly, those who loved the dress didn't have the means to afford it, and those with the means didn't have the nerve to wear it. Everyone still got to see the clothes, as his roommate, Blondie's lead singer Deborah Harry, would often wear them onstage and in the band's videos, but that didn't put cash in Sprouse's or his company's pocket.

His undeniable talent consistently got him backers. Economics persuaded him to sign on for projects at Diesel and Knoll and got him a commission from the Rock and Roll Hall of Fame. Marc Jacobs hired him to inscribe the same staccato lettering on Vuitton bags as he did on that green dress. Within days of their debut at the label's spring 2001 collection, every Vuitton store around the globe had a waiting list for weeks. Vuitton was thrilled. Jacobs was delighted.

Sprouse was dissatisfied. Just as when he worked for Halston, he wasn't comfortable being a hired hand, much less one to a conglomerate. He wanted to get back to designing his own clothes. Unfortunately, though the collaboration at Vuitton aroused interest, spiking a minirevival of punk, and yet another specialty-store capsule collection, an international overload of flagrant imitations simultaneously appeared on the sidewalks of most major world capitals, denying Sprouse the ability to rebuild a self-sustaining company. A lifelong smoker, he died of lung cancer in 2004 at age fifty.

SICILIAN DRESS

Dolce & Gabbana · 1985

For all their multibillion-dollar global success, Domenico Dolce and Stefano Gabbana, to paraphrase a song sung by Marilyn Monroe, one of the women they idolize, "are just two little guys from Sicily." They're not alone in their myopic worldview. The one thing that seems to separate French designers from their Italian counterparts is that the latter appear to relish referencing their roots. French designers, especially those who take over the storied couture houses, often reference archives for inspiration. Italians go home and reference the world around them.

From the outset, Dolce & Gabbana has reveled in the rustic sensuality of southern Italy, where the terrain makes people tough, checked emotions are wasted ones, and sex never wanders too far from the frontal lobe. There is nothing cerebral about the intent of Dolce & Gabbana's clothing, be it for men or women.

The Sicilian dress is the essence of Dolce & Gabbana, the brand's sartorial touchstone. The dress takes its cue from a slip—but it's a slip that's adorned Anna Magnani, and it's a silhouette that has graced Anita Ekberg, Sophia Loren, Gina Lollobrigida, Virna Lisi, Claudia Cardinale, Silvana Mangano, and Sandra Milo. The straps fit tight to the body just as bra straps would; the neckline runs straight across but gets waylaid at least twice, once on each side to caress each breast and in the middle to meet an uplifting tuck that's giving a gentle push up. The slip doesn't just slide down, but comes in at the waist to hold the figure firmly but not too tightly and then widens to emphasize the hips, only to fall with a slight taper at the knees to guarantee that the hips will sway when the wearer walks.

Dolce & Gabbana has presented numerous variations on the Sicilian dress: in white with red cherries, in burgundy velvet, in leather, even in black satin with yellow roses down the side panels. It is the go-to dress for every actress who wants a bankably sexy look, whether she's Gwyneth Paltrow, Demi Moore, or Madonna (who wore it in two of the designers' 2010 ad campaigns).

For twenty years, the Sicilian dress has been the Birkin bag of the Dolce & Gabbana collection. And that's no more likely to change than Domenico Dolce learning to speak fluent English.

INAUGURAL BALL GOWN
FOR MICHELLE OBAMA

Jason Wu · 2009

66 White was the only color I ever considered for Mrs. Obama. I wanted you to be able to see her before you saw anyone in the room. I think I got it right. 99

—JASON WU

Like everyone else watching the telecast of the inaugural balls in 2009, Jason Wu had no idea what the new first lady would be wearing that evening. Not only had the information not been made public, but no inaugural gown had ever been produced under such covert conditions. So Wu was astonished when Michelle Obama walked onstage at the People's Inaugural Ball wearing what he thought was *his* dress.

Wu was one of several designers contacted in late October 2008, just prior to the U.S. presidential election to create a possible inaugural ball gown for Michelle Obama. Wu was given four weeks to come up with his concept, execute it, and ship it. He signed a confidentiality agreement that denied him the right to say who contacted him, although the consensus is that it was most likely a representative for Ikram Goldman, who owns an eponymous designer boutique in Chicago where Wu's clothes are sold and Mrs. Obama shops.

Wu and the three women on his team set to work, spending more than three hundred hours making the gown, which included creating five hundred hand-wrapped organza flowers, which they hand-sewed along with more than a thousand Swarovski crystals onto the ivory silk chiffon. He shipped the dress to Chicago at the end of November.

Since he was never sent any indication of his chances or notified that a choice had been made, Wu insists he forgot about it and wasn't even sure the gown was his when he first saw it. But within moments the congratulatory phone calls began—and lasted until dawn—confirming that Jason Wu, twenty-eight, was the youngest designer to outfit a first lady for the inaugural ball. His phone hasn't stopped ringing since.

As for the gown, it was an audacious choice for a woman nearly six feet tall to sparkle in that much ivory. While the overwhelming consensus on the dress was positive, some thought it too full, and some thought the single shoulder strap too wide; still others thought that the first lady should have practiced walking with a train. But only one critic really mattered, and here's what he said: "First of all," shouted President Obama to the crowd before leading Michelle onto the dance floor, "how good-looking is my wife?"

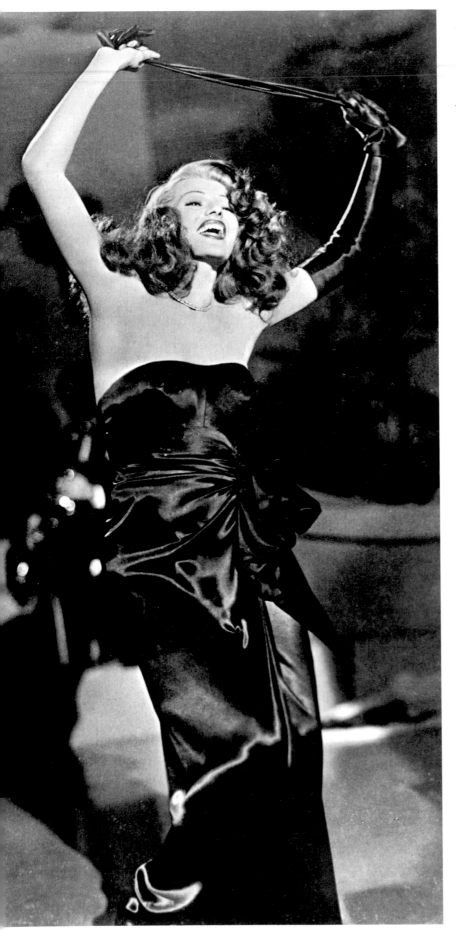

STRAPLESS BLACK GOWN FOR *GILDA*

Jean Louis · 1946

Strapless dresses owe their enduring popularity to Rita Hayworth. She may not have been the first woman to wear one on- or offscreen, but nobody wore one quite the way she does in *Gilda*. "Put the Blame on Mame" became the signature number of her career, the one that turned her into the original dream girl. It's a one-glove striptease in which Hayworth sashays around a nightclub, flipping her hair, shifting her shoulders, grinding her hips, and strutting some more while swinging around that errant glove, until she throws her head back and everyone on-screen appears completely in her thrall. In fact, the dance was considered mildly scandalous for its time, which certainly didn't hurt the desirability of her sexy attire.

But there is something off about the number. Certainly it's not her heat-wave-inducing beauty or the way her unstoppable body moves in that body-hugging gown. However, compared to Hayworth deftly going toe-to-toe and tap-for-tap with an obviously delighted Fred Astaire in *You Were Never Lovelier*, her movements in *Gilda* appear deliberately restricted, the choreography earthbound. It's hard to reconcile her as the same buoyant consort who could effortlessly keep pace with film's greatest song-and-dance man.

That's because the dress, as blatantly sexy as it is, is hiding something. Hayworth was pregnant during the making of *Gilda*, and her pregnancy was starting to show. So designer

Jean Louis and the gifted choreographer Jack Cole worked in tandem to keep her condition confidential. Cole eliminated complicated footwork and confined her movement to a constant arching of her shoulders left and right. Louis also built a harness inside the bodice of molded plastic with a set of stays to keep her breasts firmly in place. In addition, he placed a gorgeous, bountiful bow just below Hayworth's waist to camouflage her growing belly. From a design point of view, placing such a big bow on a strapless gown is a sound strategy, one that designers such as Oscar de la Renta and John Galliano, two big advocates of this dress, often employ to create a balance in it. The large bow lures the eye away from the bustline to the hips.

Naturally, anyone viewing the film was unaware of the dress's rigid interior construction. Instead, what women of the day thought they were seeing was that you could wear a strapless dress, and no matter how your body moved, your modesty and reputation were not going to be in jeopardy. Though some are corseted or boned, most strapless dresses don't have the security of Jean Louis's creation. Nevertheless, it's obvious from press coverage of any red-carpet and major black-tie event: the strapless dress has never waned in popularity. In fact, it is the best-selling neckline in the bridal industry. And for that, you can put the blame on Hayworth.

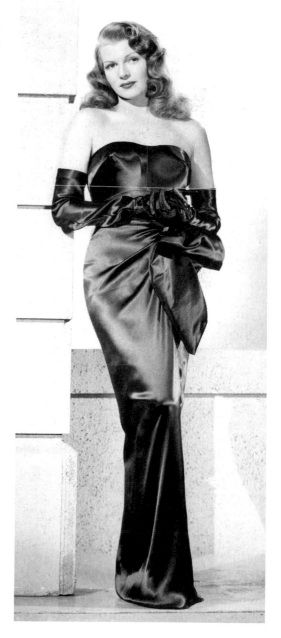

WINTER-WHITE GOWN

Carolina Herrera · 2004

The designer has dressed the actress for more than a decade. But unlike other famed alliances, such as Travis Banton and Marlene Dietrich or Adrian and Joan Crawford, Renée Zellweger and Carolina Herrera have confined their collaboration to life offscreen. Zellweger doesn't wear Herrera exclusively, yet appears consistently in her clothes, even at events where they don't necessarily hand out statues. But when they do, Zellweger usually has Herrera on her back.

In 2004, Zellweger was nominated as Best Supporting Actress for her performance in the bleak, wintry drama *Cold Mountain*. Herrera admits she normally adheres to her star client's penchant for understatement, except, as she said, "This time I had this feeling Renée would win. And I thought about all the photographers, the crowds on the carpet and at the parties, and her walk across the stage. Renée can be shy. So I wanted her to stand out. I wanted her to think *big*." Herrera, who few would argue deserves the title of "chicest woman alive," proposed that the actress should wear stark white—a color Zellweger rarely favors—in homage to the snow-filled landscape of *Cold Mountain*. Zellweger's trademark neckline is strapless because it shows off her porcelain skin and graceful neck, so that wasn't an issue. Since the actress doesn't indulge in bold jewelry and almost never wears earrings, Herrera felt it necessary to resort to fabric to make a statement—eight yards of matching white silk faille, to be exact.

Herrera used the material to gift wrap the star in a Herculean bow that tied at the back, then draped to the floor in an extended train. Zellweger is one of the few actresses who can actually negotiate a train with dignity, so that didn't daunt her. But she is known for being fanatical about fittings, so it's no surprise that she worried about being overwhelmed by the bow. In all, there were nine fittings, more than required for most haute couture outfits. Was it worth it? Well, Herrera's hunch was right. Zellweger did win the Oscar. Equally fortuitous was the designer's decision to "copy the bow for my bridal line. It became one of the best-selling gowns I've ever done!"

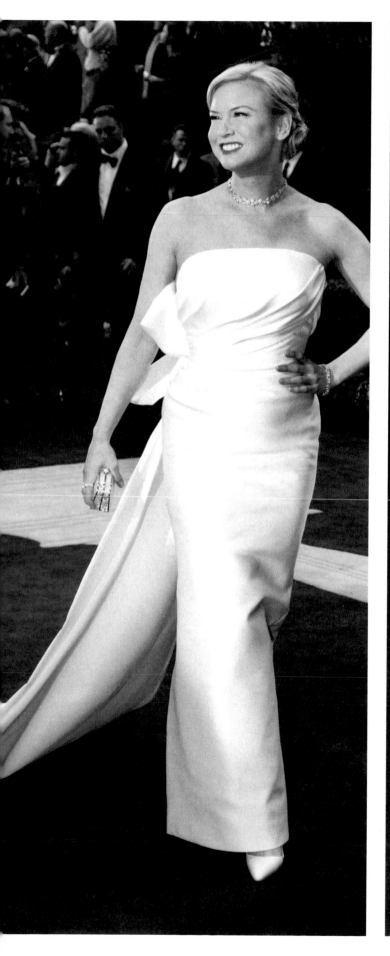
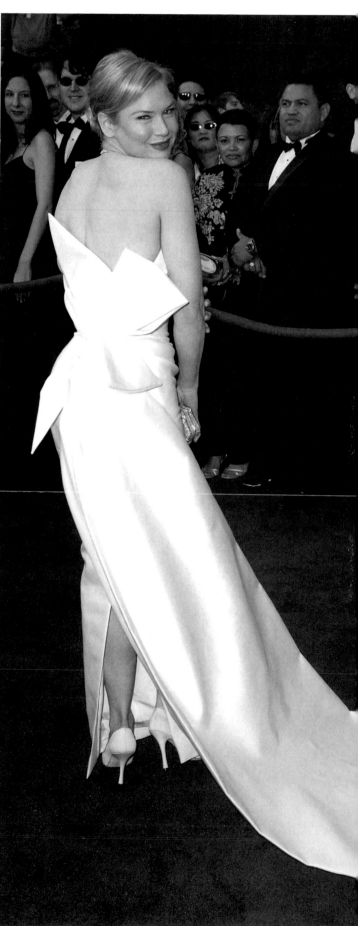

HEATHER-GRAY SHIFT

Narciso Rodriguez for Cerruti · 1997

Embroidered hummingbirds, silver-threaded eagles, Fortuny pleating, and illusion lace are surefire ways to garner attention, but not every memorable dress need have an obvious "wow" factor to make a lasting impact. That's because all of the above are literally embellishments, bonus points in the art of dressmaking. Any designer will concur, nothing is more important than fit. The wrong fit can reduce haute couture to sensory overload; the right fit can transform inexpensive clothes into catalysts for confidence; and a perfect fit can result in a memorable showstopper.

While designing for the House of Cerruti, Narciso Rodriguez sent a heather-gray bias-cut wool dress down the runway during his fall 1997 presentation. One of the best examples of Rodriguez's sensual minimalism, the shift starts at the top with a high boat neck with a bit of a dip and ends with a hem that drops just below the knee with a bit of a flair. Rodriguez describes what makes the shift so special: "There are a series of intricate seams climbing up the back of the dress that subtly contour the dress to the curvature of the torso. It's my favorite kind of dress to design because it's not

until you put it on that you understand the effects of its construction. With a little luck, magic happens."

In Rodriguez's case, the lucky charm was Kate Moss, who happened to be featured in Cerruti's ad campaign that season. "Granted, it doesn't hurt to start out looking like her, but no one beats Kate at spotting a great dress," says Rodriguez. "Though never pushy, she can tell an editor or a designer exactly what's right for her—and she is never wrong." When Moss agreed to accompany then-boyfriend Johnny Depp to Cannes for the premiere of his film *The Brave*, she nixed succumbing to the usual you-Cannes-do affinity for overwrought operatic chiffon. Instead, she called Rodriguez directly to borrow the dress. Photographs of Kate and Johnny appeared in tabloids worldwide. The dress made the annual "best dress" compilations in the U.S. editions of *Vogue*, *Harper's Bazaar*, and *InStyle*. Rodriguez admits, "For more than a dozen years, so many people repeatedly asked me for this dress that I made and finally brought back a version of it for my resort collection in 2011, though in pale pink. I want to remember the gray dress as Kate's."

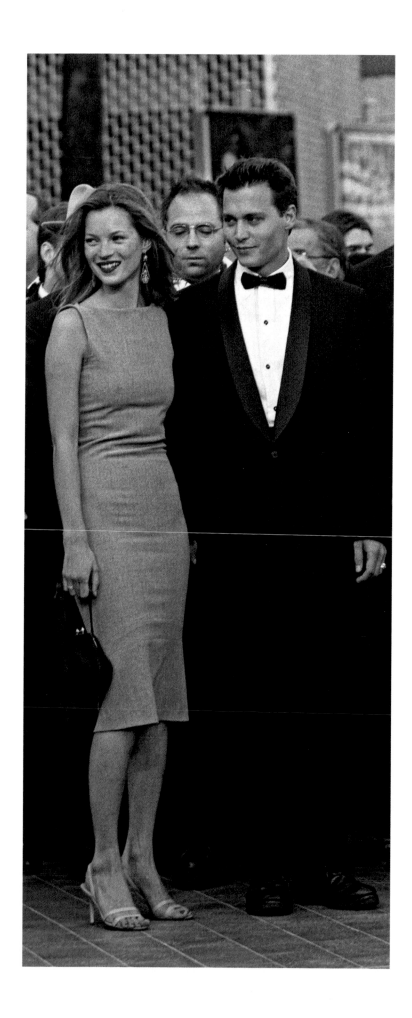

Grace Kelly

Grace Kelly is the definition of the classic American beauty. Ralph Lauren has hailed her as his lifelong muse; Tommy Hilfiger always cites her as a perfect example of American style; and Michael Kors repeatedly calls her out as a touchstone. Her favorite director, Alfred Hitchcock, was so hopelessly infatuated with her that he cast her in three of his films. After Kelly chose Monaco over movies, he spent the rest of his career recasting blonde after blonde in her image.

Nevertheless, obsession, like love, must be blind, because while praising the actress as his ideal leading lady to a reporter, Hitchcock predicted, "She'll be different in every movie she makes." But the most indelible aspect of filmdom and fashion's deification of Grace Kelly is the perpetually chic but stunning predictability of her style. With the sole exception of her wardrobe for *The Country Girl* (the seismic shock of seeing Kelly in a shapeless housedress and a dowdy, pilled cardigan probably had as much to do with her winning an Academy Award as her performance), there is an unwavering consistency to the clothes we remember best. Unlike Audrey Hepburn (see page 26), Kelly didn't appropriate trends and make them her own. Instead, couturiers as diverse as Christian Dior, Jeanne-Marie Lanvin, Hubert de Givenchy, and Oleg Cassini (one of her former lovers), as well as costume designers,

seemed to adapt their skills to harmonize with her patrician manner, statuesque posture, and air of alluring but untouchable reserve, which Hitchcock rightly labeled "sexual elegance."

In an industry where tales of actors' insecurities are as numerous as they are legendary, Kelly's poise and confidence helped turn artisans into coconspirators. Hitchcock, whose notes on costumes were so precise that specific colors, silhouettes, and details on accessories were written into his scripts, eagerly consulted with the former model and cover girl, even uncharacteristically yielding to her demands and suggestions. In *Dial M for Murder*, he wanted her to don a velvet robe to answer the plot's crucial late-night telephone call. Kelly replied that in the heat of the moment it was more logical for her to be in a nightgown. When he asked that she wear falsies under her nightgown in *Rear Window*, she refused, requesting that Edith Head take in the peignoir's lace bodice. Hitchcock relented.

Head, however, did exactly as Hitchcock instructed for the dress Kelly wore in the opening scene of *Rear Window* (see page 167). Hitchcock's notes stated that Kelly should first appear like a Dresden doll. Prior to her leaning in to kiss her wheelchair-bound photographer boyfriend, played by James Stewart, her shadow ominously looms over her sleeping lover. Then the camera turns to focus on a close-up of Kelly's porcelain-skinned, scarlet-lipped beauty. Framing her perfectly and without distraction is a nearly shoulder-to-shoulder unadorned black neckline that gives way to a sheer white shawl draped loosely behind her and just rising to the base of her neck, which is encircled in a single strand of pearls. As Kelly steps back from the kiss to turn on the lights in the room, the camera stays stationary so that first we see the smart thin patent leather belt, then the exquisite jet-leaf beading descending from the waistband, and finally the expansive white chiffon skirt, which makes Kelly's already-narrow waist look even smaller. Before Stewart can accuse his girl of never wearing the same dress twice because of her profession, we've already been tipped off that she works in fashion by an outfit as chic as it is stark.

When Hitchcock cast Kelly as Francie Stevens, "the restless, thrill-hunting American heiress" (according to the film's trailer) opposite Cary Grant's debonair John Robie, a former cat burglar, in *To Catch a Thief*, he not only decided to shoot the film on location on the French Riviera, but also insisted, in a decision rare for that era in filmmaking, that Head design the movie's extensive array of costumes on location. Hitchcock gave Head carte blanche—as long as she adhered to his notes that Kelly appear like the most impossibly beautiful creature to ever walk the planet—to create a parade of nonstop, scene-stealing luxe for both Kelly's spoiled Francie and her flamboyant, extravagantly bejeweled mother.

An overjoyed Head followed Hitchcock's instructions to the letter. The three gowns she designed for Kelly are not only the film's showpieces but also her career favorites. Kelly wears the first when she's dismayed to discover that her mischief-loving mom has invited John Robie to join them for dinner. To simultaneously convey Francie's discomfort and initial distrust while accentuating her desirability, Head dressed Kelly in a diagonally pleated spaghetti-strapped chiffon gown, with each fold brandishing a different shade of blue, from the deep azure of the Mediterranean to the shade of Kelly's eyes, yet the base color of the dress is a blue as icy as her behavior at the table (see page 169, top). However, when Kelly stands to let Grant walk her to her hotel room, the tightly fitted bodice that mirrored her rigid table conversation gives way to a flirtatious gossamer chiffon panel floating off her right shoulder and the billowing weightless folds of the multitonal blue chiffon skirt. It's no wonder Robie succumbs to Francie's impulsive reversal of a kiss at her door.

The second dress is the one Head sent up against the film's most famous scene. It's not easy to upstage a display of harbor fireworks outside a darkened hotel-room window, but Francie's desire to seduce John Robie is handily achieved by a figure-caressing strapless gown of white crisscrossing pleated chiffon (see page 168). The exaggerated sweetheart neckline accomplished three goals: it deliberately accentuated Kelly's breasts; it allowed ample room to showcase

Francie's bait, an elaborate diamond necklace (which is actually a fake); and its arc allowed just enough fabric to rise into a close-up to appease film censors who at the time forbade close-ups in which a person appeared to be naked. The tight chiffon latticework also extended just below the waist to make Kelly's appear even narrower when contrasted against the highly gathered skirt. Finally, an added panel of chiffon flowed from the top of the back of the gown to give it the illusion of a peignoir when backlit by the fireworks. Of course, Robie succumbs yet again.

Finally, there is Francie's theatrical gown for the costume ball (see page 169, bottom). Combine the fête's theme of Louis XV with Hitchcock's penchant for mocking the wealthy, and you get a party where all the costumes are deliciously ludicrous. But Kelly's dress is the most wonderfully haughty revelation—gold lamé from head to unseen toe. In a gilded wig with a bird trapped in its waves, Kelly sports yet another gown with a breast-enhancing pleated sweetheart neckline, with gold opera glove-like sleeves rising to the same height, and with a corseted bodice you could bounce a quarter off of. A ball-gown skirt explodes from the waist with nearly a dozen diagonal folds of theater-curtain depth spiraling from Kelly's left hip. When she turns, you can see that the gown is tightly laced up the back. At this point, the now-proved-innocent Robie is a goner.

Consistently topping every poll as the favorite Oscar gown of all time, and an inspiration for other designers (Ralph Lauren riffed on it for Gwyneth Paltrow [see page 174], and Escada did the same for Kim Basinger when she won her Oscar in 1997), the aquamarine satin ensemble Helen Rose designed for Kelly (opposite) radiated the precise balance of glamour and reserve that faultlessly suited the idealized image of the screen's most memorable blonde. And what helped to burn this image into our collective consciousness is the fact that Kelly actually wore the gown in public three times. She first wore the gently draped sheath with almost bustle-like drapery in the back at the opening of *The Country Girl* in 1954. Then she wore it again to pick up her Oscar for the film in 1955. But the most common picture of Kelly in the dress was shot by Philippe Halsman for *Life*

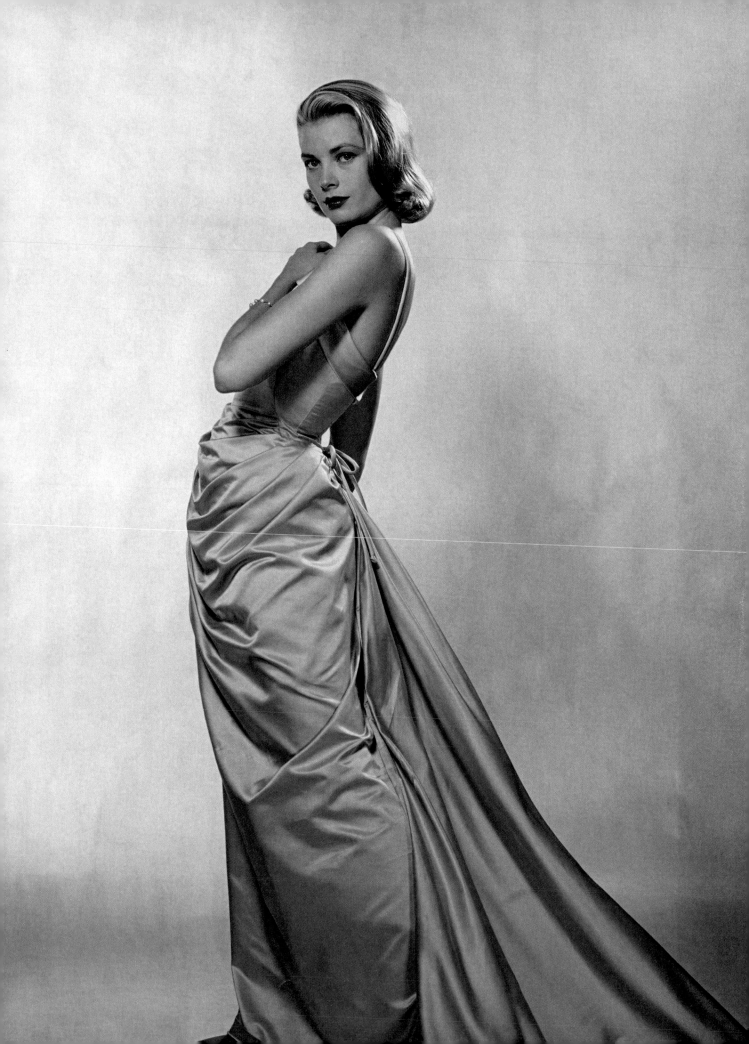

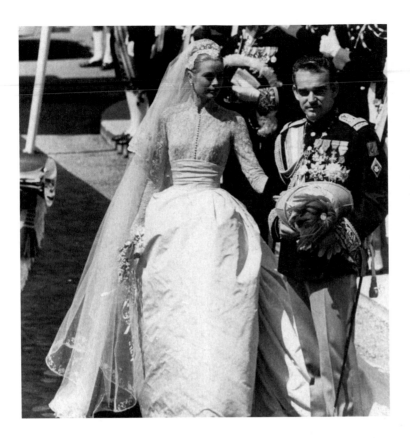

a month after the Academy Awards. This time, the dress had an additional panel going across the bodice but was photographed without the matching floor-length evening coat that Kelly had worn over it previously. The ease of Kelly's hair and makeup, combined with the simplicity and rare color of Head's design, makes the total picture unforgettable. The gown's elegance never challenged Kelly's beauty.

But on her wedding day, the Princess of Monaco's dress (above and opposite) was not designed to make that same claim. A highly disappointed Head did not do the honors, because she was aligned with Paramount Pictures, while Kelly was still in the midst of a seven-year contract with MGM (Hitchcock had borrowed her for his films). In order to get out of that contract and marry Prince Rainier III, she reluctantly had to agree to let MGM film the wedding for worldwide distribution. MGM paid for most of the wedding, including the bride's gown, which was designed by the studio's head costume designer, Helen Rose.

The bodice was made from an antique Valenciennes lace known as rose point, which Rose purchased from a museum, then had both reembroidered to appear seamless and studded with seed pearls and tiny lace petals. No longer Hitchcock's fantasy woman, Kelly was buttoned to the top of her neck and all the way down to the wrist in long, tight-fitting sleeves. The barely visible strapless bodice was wrapped by a silk cummerbund (Kelly had a twenty-one-inch waist at the time) and then opened to twenty-five yards of waist-pleated silk faille with a thin hoop underneath to maintain structure. Three large bows and a lace inset accented the eleven-foot train. Her silk tulle veil was edged in the same seed pearl–accented rose-point lace with a pair of appliquéd lovebirds. Rose claimed that the wedding dress employed thirty-five people at MGM working in secrecy for six weeks.

When she left for her honeymoon, Kelly was dressed in a gray suit by Edith Head. Her trousseau included outfits by James Galanos, Pauline Trigère, Christian Dior, Ceil Chapman, Adele Simpson, and Norman Norell.

Just before Francie seduces Robie in *To Catch a Thief*, Robie faintly tries to thwart her seduction by getting her to admit that her "diamond necklace" is imitation. "But I'm not," she replies. When it comes to timeless stardom and class, Grace Kelly was the real thing.

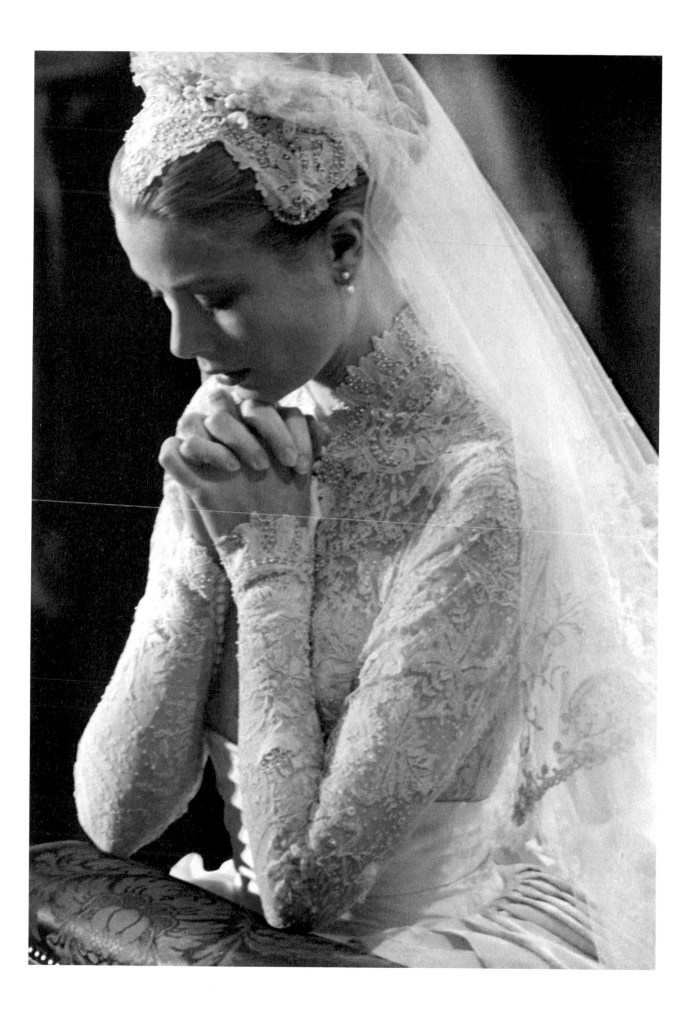

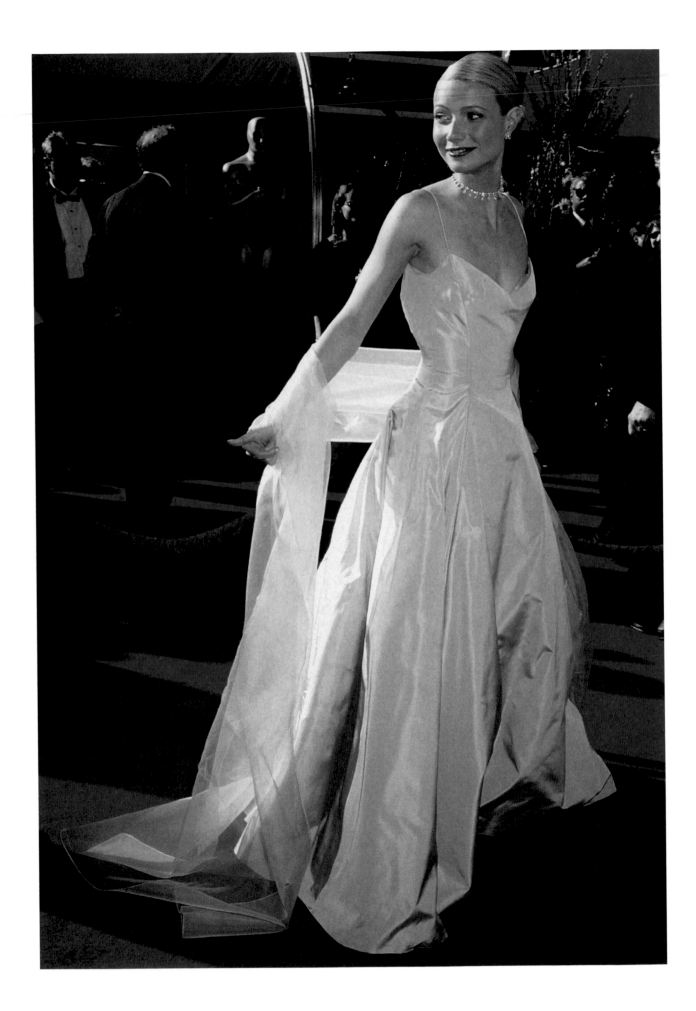

"GRACE KELLY" GOWN

Ralph Lauren · 1998

Hollywood is a perpetually hopeful and sweetly persistent suitor, always on the make for a new best love. After her romance with Brad Pitt was over but before she launched her lifestyle website GOOP, when Hollywood thought that just being an actress might be enough for Gwenyth Paltrow, the town fervently began to woo her. It was as if the industry was resetting the place at the head of a table that had been empty ever since Grace Kelly had excused herself and abandoned her movie-queen throne for a real one. For a moment, Hollywood thought Paltrow might pull up a chair and join them.

Shakespeare in Love was the perfect way to embark on this courtship. A lushly romantic, wonderfully literate period film about the wonders of acting and the power of love, it hit all the industry G-spots. The film went backstage. It went onstage. It entered the royal court, bedrooms, and haylofts. There was passion and lust and loss, but in the end no one really got hurt. And in the center of this blissfully ribald tale was an incandescent Paltrow (abetted by her lovely chemistry with Joseph Fiennes), playing a woman who wasn't a victim or defeated by fate. The film was nominated for thirteen Academy Awards that year, including Best Picture and Best Actress.

Gwyneth responded exactly as hoped. She swept into the Oscars on the arm of her adored dad, producer and director Bruce Paltrow (her mother is actress Blythe Danner), in a made-to-order dress designed specifically to recall the spirit of Grace Kelly by Ralph Lauren, who has always hailed Hitchcock's favorite blonde as one of his career muses.

Accordingly, the spaghetti-strapped satin gown was of a classic princess design, absent any extraneous detail. The big difference was in Lauren's unusual color choice, a buoyant but not bubblegum pink, a color that Kelly had never fancied but Paltrow has often worn to consistently flattering advantage. With her hair color and skin tone, multiple shades of pink looked more romantic than girlish on her. Her hair was pulled back a little tighter than the Princess of Monaco might have worn it, but the delicate Harry Winston necklace—a surprise gift from her father on the occasion—was spot-on.

If anything appeared slightly amiss, it was that the dress seemed a little loose on top. The rumor is that the dress had been constructed with some light padding, but that after the last fitting, Paltrow had called Lauren and told him that she had removed it—and there was no time left for another adjustment. However, no one in either the designer's or actress's camp is willing to corroborate this, so let's just say, for some reason, the weight of the gown pulled the dress a bit lower as the night wore on.

When Paltrow came onstage to tearfully acknowledge all those who had helped make her victory possible, she ended with the admission that she could never have done the role "had [she] not understood a love of tremendous magnitude," then tearfully thanked her family. The town was now hers. In addition to giving her a gold-plated Oscar, it got on bended knee, offering her every brass ring available.

In 2003, Paltrow married Coldplay front man Chris Martin and moved to England. Kelly's seat at the table remains empty.

"HAPPY BIRTHDAY" GOWN

Jean Louis · 1962

Marilyn Monroe was going somewhere very special. And she wanted a dress that would fit the occasion. But she wouldn't tell designer Jean Louis where she was going. "I want you to design a truly historical dress, a dazzling dress that's one of a kind," she told him. "A dress only Marilyn Monroe could wear."

It wasn't the first time Monroe had referred to herself in the third person, as if she were someone she knew but didn't always inhabit. Hearing her do so wasn't as unsettling as realizing that her captivating yet ultimately tragic form of third person indicated that she knew the star persona she had created far better than she knew herself. Monroe wanted her dress to be a surprise, so when event coordinator Richard Adler (composer and producer of *The Pajama Game*) asked her what she was going to wear when she sang "Happy Birthday" to President John F. Kennedy in front of fifteen thousand people at New York City's Madison Square Garden, she showed him a black satin Norman Norell with a high collar. He left happy. And then she went to Jean Louis to see what he had come up with.

Louis proposed creating a gown from flesh-colored soufflé made in France. So that it could be molded to her body, the material required that Monroe stand still for many hours on a chair. Since Monroe didn't want Louis to line the dress and because she didn't plan to wear underwear, he had to place twenty layers of the soufflé over her breasts and two hundred additional elasticized panels that afforded more give than the soufflé mesh, allowing her to move without risking overexposure. (Adlai Stevenson said the dress was made out of "skin and beads.") Then he put in a clear zipper, plus hundreds of tiny hooks, that would tighten the dress once she was in it. Then twenty-five hundred sequins and beads were applied in a careful "random" pattern. The entire process took a month and cost Monroe more than twelve thousand dollars.

But Monroe got what she paid for, as the dress made her appear to be coated in nothing but glitter. Much has been made over the fact that, because she was never on time, the president's brother-in-law Peter Lawford introduced her as "the late Marilyn Monroe." (No doubt Lawford was joking, but she died only a few months after.) But it's doubtful anyone remembered a word he said at the time because when Monroe walked onstage, pandemonium ensued. Then she sang the slowest, breathiest rendition of "Happy Birthday" ever recorded.

It's funny: Jack Benny, Ella Fitzgerald, Peggy Lee, Jimmy Durante, even the great Maria Callas are just some of the stars who also performed at Kennedy's birthday. Not only does no one remember what they wore, no one even mentions them having been onstage. History has declared Monroe the sole attraction that night. In October 1999, the dress was sold at Christie's for $1.2 million.

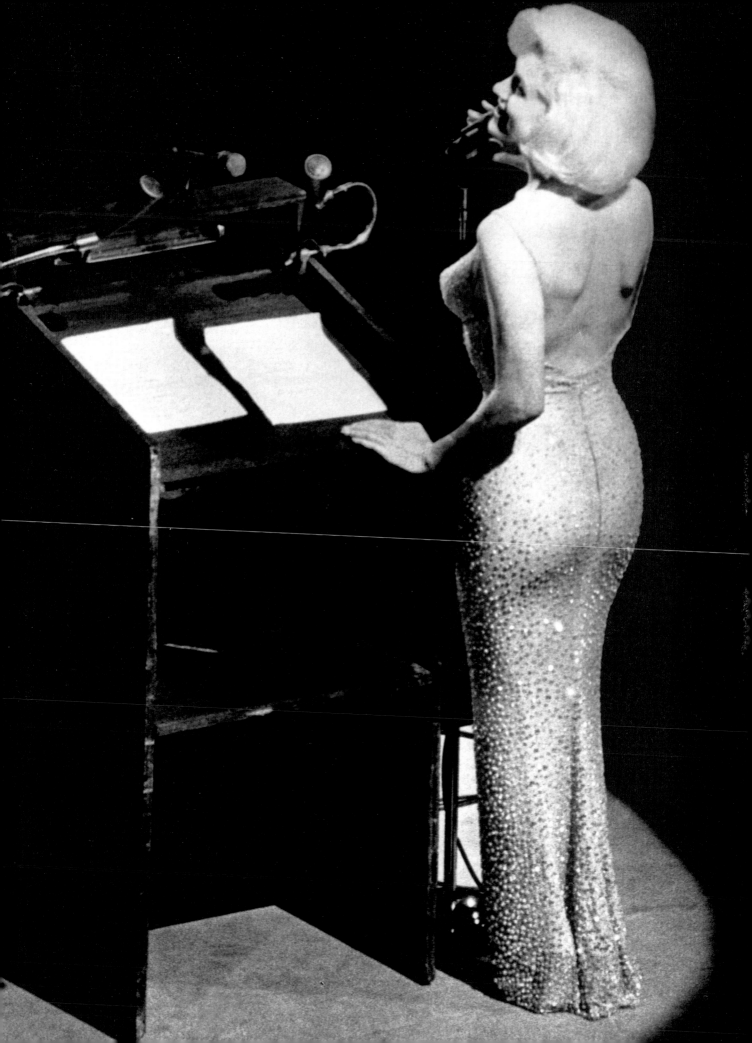

CONCERT TOUR GOWN

Jean Louis · 1967

It's one thing to stitch a curvaceous woman in her thirties wearing no undergarments into a nude beaded gown. But when a woman in her fifties wants the same dress, an alternative approach might be wise. Luckily, Jean Louis had dressed Marlene Dietrich for years. In fact, he had designed a dress for one of her postwar tours that featured yards of chiffon trailing everywhere. But instead of getting more demure as she got older, Dietrich got bolder. The first time she came to him to make a nude gown was actually prior to Monroe. In the early 1950s, Dietrich wanted to play Las Vegas, so she needed something with flash. Using soufflé, Louis created a dress with more layers, with larger beads going way up the torso, above the breasts. Dietrich wore the dress over a thick body suit that helped hold in her figure. For her onstage entrance, she added an oversize white ermine coat that she loosely draped around her shoulders so it could dust about fifteen square feet of stage.

Her conductor in Vegas was a young musician named Burt Bacharach, who told her after he had won her confidence that she needed a better and bigger act. Several years later, she and Bacharach embarked on a national tour including Broadway. Dietrich commissioned two other versions of this dress, with adjustments for her body through her midsixties. When you view the tapes of her performances in her later years—she basically croaks out her classic songs, "La Vie en Rose," "See What the Boys in the Back Room Will Have," and "Where Have All the Flowers Gone?"—bigger beads notwithstanding, how does she look? Like Dietrich, of course.

But when she no longer believed she looked as fans imagined her, she became a recluse, refusing to leave her Paris apartment. In his hypnotic documentary, *Marlene*, Oscar winner and former Dietrich costar Maximilian Schell spends the entire film trying to get her on film. You do hear her, often through her door. But she never relents. Great illusions and screen legends die hard.

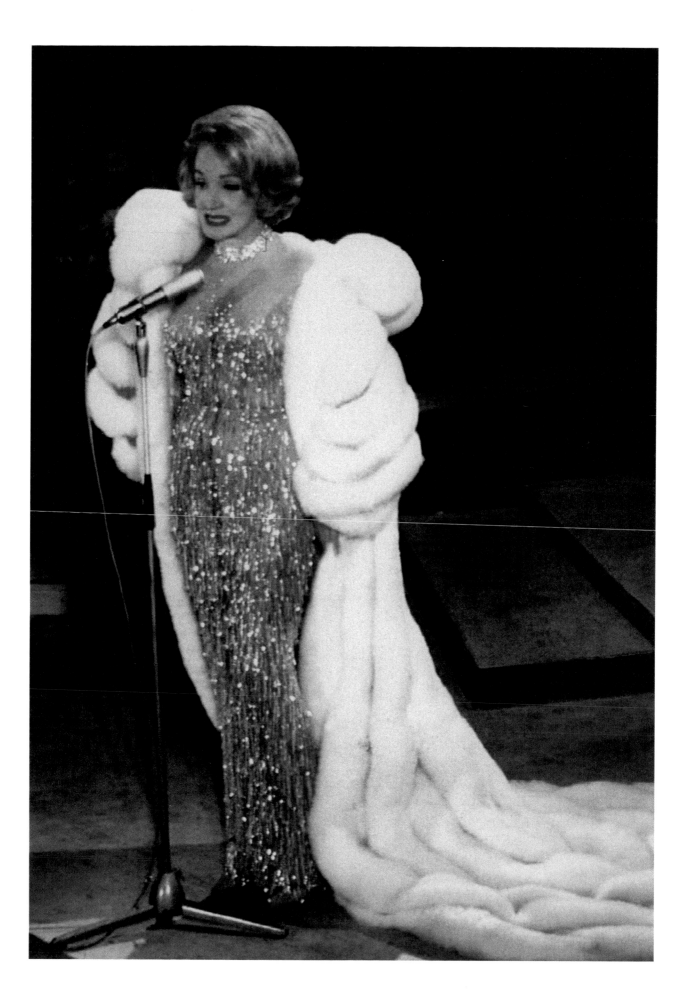

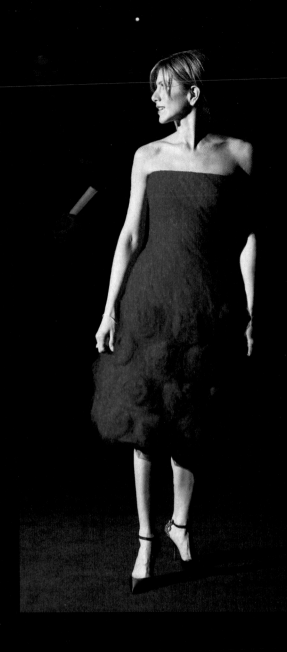

FIESTA DRESS
1959

TAFFETA ROSETTE GOWN
2003

ELEGANT COLUMN GOWN
2007

For more than four decades, Valentino Garavani has consistently dressed more celebrities, aristocrats, royals, socialites, supermodels, and billionaires' wives in haute couture than any other designer in modern times. No matter that the press and retailers put him on a pedestal from the moment his parents mortgaged their home so that he could open his atelier in Rome in 1960, it was specifically for "my ladies," as he called them, that he always designed his clothes.

Not surprisingly, the ladies always responded with unparalleled devotion. The reason for such seamless simpatico: Valentino lives exactly the way they do. From his Château de Wideville—with its fifteen gardeners in residence to tend to its separate formal topiary, rose, English, vegetable, and lavender gardens—which is just down the road from the Versailles Palace, to his chalet in Gstaad; from his villa on Rome's Appian Way to apartments in London and New York City; not to mention a hundred-fifty-foot yacht usually filled with members of his extended family heading toward an exotic port every holiday, Valentino lives a glamorous life. And he has always believed that the glamorous life is the only life worth living.

To that end, the most glamorous color one of his ladies could wear was "Valentino red." The designer discovered this brilliant shade of vermilion while still an apprentice with Jean Dessès in Paris in the late 1950s. He attended

an opera at the famed Gran Teatre del Liceu in Barcelona and was stunned by the color that dominated the opera house's stage costumes. "It was then I realized," said Valentino, "that after black and white, no other color can match its beauty."

There are forty-five years' worth of marvelous Valentino-red dresses, but probably the one that best highlights his controlled yet florid sense of romance is Fiesta, a joyful bell-shaped cocktail dress from one of his very first couture collections, in 1959 (opposite). Surprisingly similar to a Jean Dessès design presented during Valentino's apprenticeship, this dress is a fortuitous melding of Valentino's unabated fondness for roses, layering, and fabrics that seemingly float on the body. The strapless chiffon gown's bodice is covered in diagonally folded layers of tulle, which descend to literally form an inverted bouquet of sizable tulle roses. The garment's Latin-inspired spirit was not only revived in a pink-and-fuchsia gown variation to mark Valentino's thirtieth anniversary in business, but when Valentino celebrated his fortieth, was reproduced almost full-scale as a cake.

Valentino was not a designer normally associated with restraint. Both his ready-to-wear and especially his haute couture collections reveled in ornamentation and embellishment so resplendent that usually only the lucky wearer of these sartorial treasures had the time and the proximity to relish the intricate qualities of such labor-intensive work. A close inspection of a tweed skirt, for example, could reveal a weave composed of multiple strands of twisted silk, leather, raffia, and lamé thread. Yet two aspects of Valentino's career highlight a completely different side of his talent. By the late 1960s, he became the go-to designer for the core members of the jet set, who moved seamlessly from skiing in the Alps to sunning in Acapulco by private plane or yacht—usually packed with steamer trunks full of Valentino's incredibly sleek, streamlined, monochromatic minidresses and pantsuits. Simultaneously, the other aspect of Valentino's canon affected by his desire to explore modernity through simplicity was his seemingly nonstop output of red dresses. Rarely did his red dresses and gowns feature the level of dizzying embroidery

or beadwork that were featured in other parts of his collections, especially in ready-to-wear. Instead, so secure was the designer in the allure of his signature color that he repeatedly tended to start with a columnar silhouette of silk crepe or chiffon, and then personalize each dress through cut and fabric manipulation—a rectangular cutout at the point of décolleté, an asymmetrical hem, intense ruching on the hip, or Grecian-goddess draping.

One of the loveliest examples of this unexpected, yet commanding self-discipline is displayed in the elegant column gown from his last ready-to-wear collection in spring 2007 (see page 181). Save for a deliberately asymmetrical bust line, the gown's individuality is achieved entirely by strategic knotting that turns one seemingly endless shard of chiffon into a diagonal sash that heralds an unequivocal winner.

However, few could match Valentino's exuberant glory. Another red gown isn't exclusively Valentino's classic red, as it also employs crimson and faded pink, but its overall effect is an extraordinary example of haute couture mastery and of his firm belief that creating impossibly luxurious clothing, not trends, is a designer's primary duty. A standout from his spring 2003 haute couture collection, this strapless gown (this page) is a cascading crescendo of artistry, beginning with a horizontally ruched neckline in chiffon that extends to off-the-shoulder short sleeves that are equally ruched. The intense pleating continues as it descends to the designer's use of classic red at the waist. Just below the hip, however, the gown bursts with a plethora of huge pleated, appliquéd crimson taffeta rosettes that emanate from centers of red Strass crystals. But the most remarkable act of extravagance is the hem, which rises and splits just above the knee to reveal the skirt's interior, lined with equally resplendent pleated rosettes in pink and gray taffeta with crystals at their centers.

No matter how dazzling the rose and topiary gardens are at his French château, none are a match for Valentino's lifelong belief that there is no limit to how beautiful you can make a dress, because there is always a woman who deserves it.

WEDDING GOWN FOR CAROLYN BESSETTE-KENNEDY

Narciso Rodriguez · 1996

Some images are so indelible they scar our collective psyche. For years after the wedding of Prince Charles and Lady Diana Spencer, anytime there were rumors of or any plans for a "storybook wedding," all that people could picture was young Diana, buried in bolts of woven buttercream.

To displace one of pop culture's firmly implanted collective impressions requires an equally powerful new icon. It took fifteen years, but the expulsion of Diana *en croûte* was finally achieved by the image of a couple so refreshing and engagingly modern that seeing them together made marriage look cool again. Both American, they were commoners by law. But in the eyes of their fellow citizens, if not the world, these two were royalty.

It was a wedding executed with such secrecy that even the forty guests could only guess why they were being summoned to Cumberland Island off the coast of Georgia. And as the press was banned, a billion people didn't get to watch, nor did they subsequently get hundreds of photographs to gawk at. Yet all we needed was this one now-famous shot—a supremely handsome, enviably maned young man in a one-button navy blue suit, kissing the right hand of his radiant bride, her blond hair smoothly tucked into a simple bun, her left hand holding a small bouquet of lilies of the valley, and her lean, tall, toned form clad in a sinuously flowing, ungilded, pearlescent silk faille crepe gown that fit like a caress and probably didn't weigh much more.

John F. Kennedy, Jr., and Carolyn Bessette garnered second glances even while doing the mundane. He could be eating sashimi at the Nobu Next Door sushi bar, his pant legs still wrapped, as they often were, in bike clips. She could be on Hudson Street in Tribeca in a fitted Prada jacket, slim jeans, and high Calvin Klein boots hailing a cab to visit her close friend designer Narciso Rodriguez, a former Calvin Klein colleague and, at the time, the up-and-coming designer who created her wedding gown. Whispered buzz and camera clicks were always just beyond arm's length.

Genetics had been kind to both of them. "Carolyn was an extraordinary beauty," says Rodriguez. "What made her special is that she was one of the rare few who really did have great personal style. She knew when to take risks, when to play it safe, what worked on her body, and how she wanted others to see her. Because of that I didn't want to make a dress that would be noticed first. I wanted people to see her, not what I do."

Rodriguez is a minimalist, so his work often suffers for lack of hanger appeal. A woman has to try on his clothes to understand and appreciate his talent. "Simplicity is never simple, especially when you want to show off a body, which is what I love to do most," says

CERRUTI 1881
PARIS

Silk Crepe bias gown Silk tulle veil & gloves

Rodriguez. From the famous photograph of the couple leaving the chapel, Bessette's gown could easily be misread as a slip sheath, which it is not. The faille is cut on the bias, and a single seam curves down under the bust on both sides to meet in the back. Then there is another lateral seam at the knee so that the fabric can flow more freely and widely at the bottom. Both seams allow the dress to follow Bessette's every curve with grace and ease.

Because of his relationship with Bessette, Rodriguez says, "Making this dress meant everything to me. I had to be sure it was right. So before I presented it to Carolyn, I flew to Paris to show it to Azzedine [Alaïa]. No one knows more about cutting than Alaïa, so if he hadn't given me his blessing, I might have shredded it." Rodriguez did get thumbs-up, but admits that his idol and mentor was "a little pissed. I came all this way to get his approval for something so special, but I couldn't tell him whom it was for. I had to keep a secret, and Alaïa loves to gossip. He wasn't happy."

The accolades were global when the world saw the photograph of the just-married couple on the church steps. "I was blindsided by the commotion," recalls Rodriguez. "Seeing my dress on millions of kiosks around the world, on the cover of every paper. It changed my life." But not necessarily in the way one might think. Rodriguez was besieged with offers to capitalize on this once-in-a-lifetime opportunity—to reproduce the dress at every price point, to do a bridal line. He turned down all the offers. Instead Rodriguez "wrapped up the pattern, the sketches, even the extra pieces of fabric, and gave them to Carolyn as a gift, so she would know that no one else would ever have that dress. I am still tongue-tied to this day over how much joy and melancholy that one garment could bring into my life. And I would trade all of it, if she could still be here."

John F. Kennedy, Jr., and Carolyn Bessette-Kennedy died in a plane crash on July 16, 1999.

THE "RYAN WHO?" DRESS

Olivier Theyskens for Nina Ricci · 2010

She's a good girl, she is. True, in interviews such as her first cover story for *Vanity Fair,* there are flashes of Tracy Flick, the stop-at-nothing senior running for high school president she played in *Election,* and she did name her production company Type A. Still, when it was time to put on a party dress, Laura Jeanne Reese Witherspoon had been faithful to her Louisiana roots. Below her gentle tumble of blond ringlets, she'd don a black lace-tiered Valentino here; a heavily embroidered vintage tea-length Dior to accept her Oscar there; or she'd pick a pert red Carolina Herrera all tied up at the waist with a big black bow.

However, in 2006, amid public accusations of her husband's infidelity, Witherspoon's marriage to Ryan Phillippe fell apart, generating a perfect storm of publicity. In Hollywood, celebrity humiliation is a spectator sport, so when it came time for the Oscar winner's first public appearance after the separation, anticipation grew over how Witherspoon would handle herself solo.

She arrived at the 2007 Golden Globe Awards all smiles. Never did she utter an unkind word. But Witherspoon's slimmer figure, now snugly zipped into a strapless, bright canary-yellow silk brocade Nina Ricci cocktail dress set off by her blood-red open-toed pumps, screamed, "Screw you, buddy!" so raucously loud, home viewers reached to turn the volume down on their televisions. With nary a ruffle or fillip of lace in sight, the yellow of the dress drawing attention to her newly straightened, blunt-banged cut, Witherspoon's transformation was a blatant strategy for garnering media attention. Did it work! It also served as an effective reminder to young Hollywood actresses that the way to snag more press when you're neither nominated nor venerated is to not pass up any pretense to grande damesmanship and to show off what your elders can't buy or borrow: great skin and youth. And judging from her response to all the attention, sweet revenge is one hell of a blusher. So joyful was Witherspoon's pose and calm was her poise that not a single reporter had the nerve to ask if her marital discord had prompted her to turn the style dial to BABE. But then, is anyone who willingly holds a jeweled microphone any match for a bona fide type A woman on a mission?

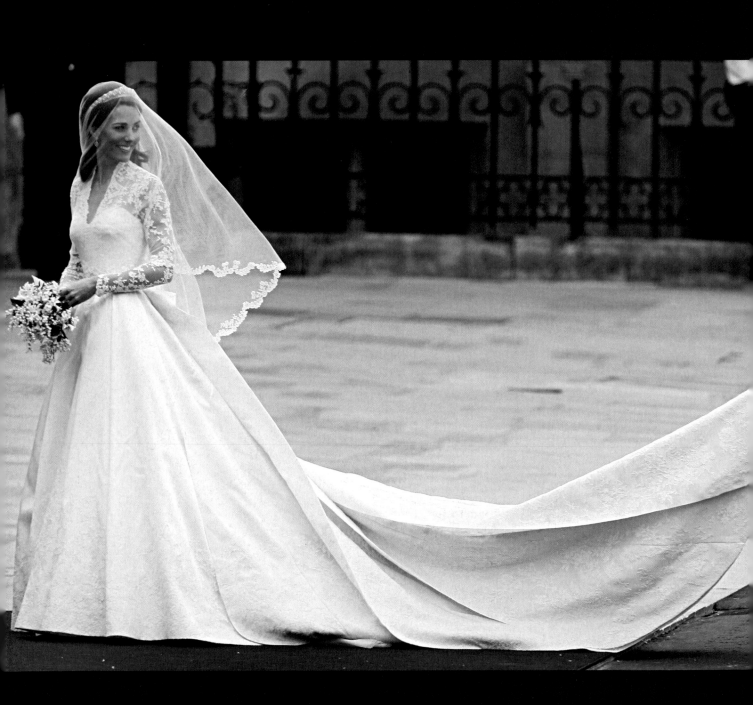

WEDDING GOWN FOR CATHERINE, DUCHESS OF CAMBRIDGE

Sarah Burton for Alexander McQueen · 2011

The impending nuptials of H.R.H Prince William and Catherine Middleton were most notable for inciting more guessing games than the number of broken marriages in the British royal family. When will they marry? Where will they marry? Who'll be invited? And, most importantly, who will design Kate's bridal gown?

The problem with guessing games is that they only remain fun with the addition of clues. But there were none. The legendarily loose-lipped House of Windsor became so close-mouthed it was as if there'd been a run on duct tape. The silence hardly satisfied a public now more fascinated by gossip than hard news. What began as amusing speculation soon grew tiresome, thanks to the media's relentless threadbare theorizing about all minutiae of the wedding.

But on the morning of April 29, 2011, a beautiful, beaming Catherine Middleton stepped out of a Rolls-Royce Phantom VI in front of Westminster Abbey in a serenely stunning wedding gown—streamlined but shrewdly appropriate yet undeniably sensual. Instantly, cynicism vanished as more than two billion viewers worldwide were once again craving another shot at happily ever after.

Sarah Burton—the late Alexander McQueen's right hand, a formidable successor to her mentor's label and genius—had designed a gown so "spit-spot," to quote Mary Poppins, that acclaim was universal.

Burton admitted that Middleton knew what she wanted after eight years of being in the royal spotlight. She was beset by none of the naïveté that had plagued Prince William's late mother, Diana, Princess of Wales, at this crucial point in her life (see page 24).

Reminiscent of Princess Grace of Monaco's wedding gown (see pages 172–173), the dress sheathed the bride's bare arms and shoulders in lace appliqué comprised of roses, thistles, shamrocks, and daffodils, handmade by members of the Royal School of Needlework (who were told they were working on a costume for a film). The lace continued over a form-fitting sweetheart neck bodice, then gracefully blossomed into McQueen's signature slightly-padded-at-the-hip skirt; made of ivory satin gazar, the skirt gloriously extended by a sweeping series of seams that arched from hip to hem of the nine-foot train.

Holding the end of the train was Kate's maid of honor, her sister, Pippa, clad in a clinging ivory cowl-neck satin sheath, also by Burton. An untraditional choice in color as it matched the bride's dress exactly, Pippa's sheath fit her enviable figure so sinuously that a Facebook page devoted to viewing her from behind had 160,000 members before the wedding disco party ended early the next morning.

As the duchess said as she walked onto the Buckingham Palace balcony to face "her public" for the first time, "Oh wow!"

BROWN COCKTAIL DRESS FOR *ALL ABOUT EVE*

Edith Head · 1950

While electrifying on-screen, Bette Davis's reputation was that of an insecure harpy, a vengefully jealous colleague, and a nonstop aggravation to all who worked with her, even those who liked her. That's why she wasn't offered the role of Margo Channing in *All About Eve* until the last minute, after Claudette Colbert dropped out of the film. No one at Twentieth Century-Fox wanted to work with her, including Darryl Zanuck, the head of the studio, and Orry-Kelly, who had done Davis's costumes for years at Warner Brothers.

By chance, Davis met Edith Head and immediately connected with the designer's strength and directness. So when Twentieth Century-Fox offered Davis the role of Margo, she insisted they borrow Head from Paramount to design costumes for the film. But there was a hitch: Charles LeMaire, the wardrobe director at Fox, disliked Head. He didn't appreciate her superior attitude or reputation as a credit thief (see Audrey Hepburn, page 29). So there was a compromise: Head would design Davis's clothes only.

Davis and Head agreed to use the tempestuous Tallulah Bankhead (who had starred on Broadway in *The Little Foxes*, one of Davis's great screen roles) as their blueprint for Margo. Bankhead, who, like Davis, was no beauty, favored sharp, square necklines,

capped shoulders, and a fitted waist—a sartorial geometry that flattered an older woman. For the crucial "Fasten-your-seat-belts" party scene at Channing's house, when she finally lets her conniving secretary-aide, Eve Harrington, know sthat she sees through her aura of innocence, Head suggested re-creating a favorite dress of Bankhead's for Davis to wear.

But because Davis had been hired at the last minute; because Head had been allotted limited time in the costume studio, since LeMaire didn't want her around; and because the script by screenwriter-director Joseph Mankiewicz—considered to be one of the most deliciously acidic ever penned—was being rewritten daily, there had been no time for fittings. Head arrived on set with the dress on the day slated for shooting the scenes, zipped Davis into the costume, and watched as it promptly fell off her shoulders.

The costume designer flipped. She had made the top wider to accommodate Davis's large breasts but never had the chance to see that the actress's shoulders weren't equally broad. She wanted to sew Davis into the dress, but before she could reach for thread, Davis yanked at the top, pulled it down and back, and asked her new friend, "How about this? I like it!" repeatedly lifting and readjusting the neckline. "It will give me something to do."

Davis wasn't known for understating her talent, but in the party scene, she plays her hostess gown like a concertmaster who has been

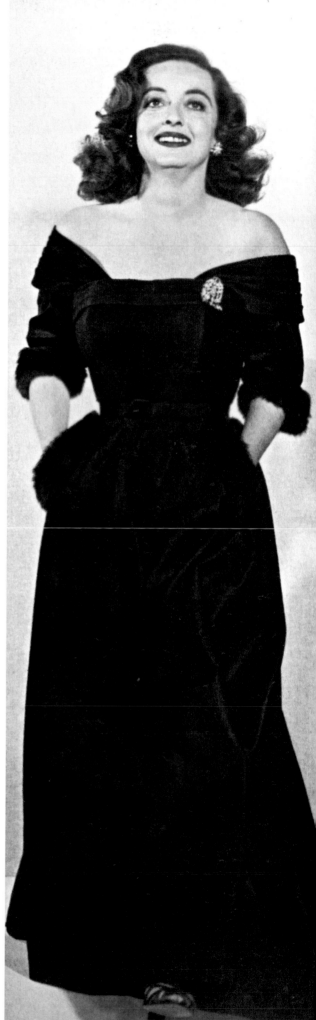

handed a Stradivarius. The chocolate-brown silk grosgrain has a firmly fitted bodice, but there are open panels under the arms. The long sleeves have fur cuffs accented with rhinestone circlets. The skirt also has a fur lining bordering slash pockets, which, when Margo thrusts her hands in her pockets, emphasizes her attempt to ground herself and contain her growing jealousy as she repeatedly confronts her husband, Bill, about his growing infatuation with Eve. (Both Oscar de la Renta and Carolina Herrera frequently show ball gowns with slash pockets in the skirt. It's about the only way to keep the dresses modern and relatable.)

For all of Head's concern about the top, the part of the dress that Davis wields with greatest power is the skirt, which is voluminous, thanks to additional pleating in the back and a thick tulle crinoline. As Margo goes from room to room in her townhouse, she lifts the skirt up, thrusts it back on one side, and leads with her opposite shoulder, making one sweeping grand entrance after another.

All About Eve was nominated for fourteen Academy Awards and won six, with Head and LeMaire sharing the 1951 Oscar for Best Costume Design. But LeMaire couldn't enjoy his win. Although he had outfitted everyone else in the picture, he already knew that when people talked about how much they loved the costumes for *All About Eve*, what they were really talking about was Margo's dress.

Sarah Jessica Parker

DAYTIME STARLIGHT GOWN
Richard Tyler · 2000

———

SOUFFLÉ DRESS
Karl Lagerfeld for Chanel · 2002

———

SHREDDED TULLE GOWN FOR *SEX AND THE CITY* (TELEVISION SERIES)
Donatella Versace · 2005

———

WEDDING GOWN FOR *SEX AND THE CITY: THE MOVIE*
Vivienne Westwood · 2008

———

Even factoring in those who design, cut, sew, sell, edit, buy, shoot, style, and write about it, fashion has no bigger enthusiast than Sarah Jessica Parker. The relish she radiates when she is wearing something expensive, exclusive, or exotic is infectious. You will never see her step on a red carpet as if it's a slippery slope, a chore, or payback for a paycheck. Instead, this woman works a crowd as if she's a prima ballerina performing a new solo fashioned just for her.

Because the HBO original television series *Sex and the City* was a nonstop cheerleading marathon for an industry that keeps her character, Carrie Bradshaw, in a state of constant gush (Prada, Jimmy Choo, Oscar de la Renta, and Manolo Blahnik all owe her big-time), there is no one who will not offer Parker whatever she wants to wear.

In *Sex and the City*, Carrie, costumed by Patricia Field, is dressed to make a statement, get a laugh, tug at a heart. The clothes were tools. But off-screen, Parker would rather make a splash than make a point.

And she usually does. In 2000, Parker attended the Golden Globe Awards in a long gown by Richard Tyler (see page 194). It's a great example of the right dress on the right woman. Lovely, lively, and enthusiastic as she is, Parker is not an ideal model. She is five foot three, which makes wearing a long gown a challenge. She is slim but doesn't have

long legs. Her eyes are dazzling; her nose is prominent; her jaw line long. To look her best in a designer's best, Parker needs to choose carefully.

The Tyler gown reveals a savvy self-awareness. It has a low straight neckline, which doesn't always flatter someone who is vertically challenged, but because the tulle is a shade of blush that nearly matches Parker's skin tone, where she ends and the dress begins is blurred. In addition, the gown's skirting doesn't flare until well below Parker's hips, lengthening her torso. And finally, the ambling vertical paths of the highly reflective brilliants also work to her advantage, affording her the bearable lightness of appearing taller.

The cotton-candy-colored Chanel confection (see page 193) she chose to wear to the 2003 Emmys is another memorable SJP moment. The gathering of all that gossamer organza is cast in a spirit-lifting shade of pink. The slight bell in the skirt exposes both a delicate eyelet hem and her feet, raising her center in a way that no other gown could. The bibbed neckline, which matches the hem, standing slightly away from her breasts, lifts them as well and reflects a flattering shaft of white under her

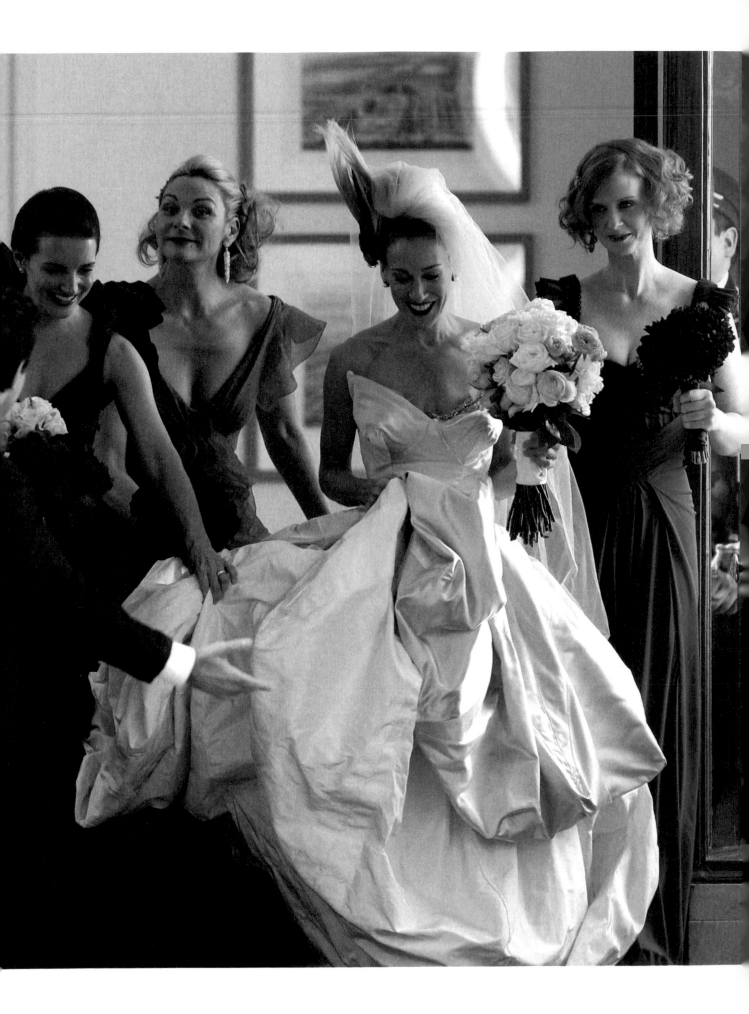

chin. With all those folds, she doesn't need her hair to repeat the pattern, so it is smartly and slickly tucked back. Not only does she look perfect from head to toe, but the overall effect evokes the airiness of cotton candy. Looking at her in this Chanel makes you feel happy. It's a dress you wish was in your closet just so you could begin the day looking at it.

Then there is the dress *Sex and the City* devotees refer to as "the one she got dumped in." But if you're going to be miserable, why not do it engulfed in eighty thousand dollars' worth of Versace haute couture (see page 195)? Having forsaken her beloved trio of friends, as well as her favorite city, all for the sake of love, Carrie puts on this never-ending cascade of tulled tiers to wear in Paris, the most romantic city in the world, to celebrate a new life on the arm of her dashingly suave, worldly, and wildly sexy artist boyfriend (who just happens to look just like Mikhail Baryshnikov). But when Baryshnikov's Aleksandr Petrovsky fails to show, she falls onto her hotel bed in despair, and the hand-torn loden-gray tulle tiers of the dress's skirt seemingly transform into engulfing ripples in a murky lake. That moment in that dress was a sure sign that Carrie's dream was over—which meant that our dream of her and Big together was still alive.

Carrie's wedding ensemble in the first *Sex and the City* film was Patricia Field's ultimate triumph (opposite). The Vivienne Westwood gown, with its asymmetrical tiers and diagonal bodice, is at once romantic and subversive because it aggressively courts tradition while thumbing its nose and neckline at ritual bridal symmetry. And the blue feather on the veil is outrageous. But it's all pure Carrie.

The worldwide success of the *Sex and the City* film sparked a six-month waiting list at the Westwood workrooms for copies of the sixteen-thousand-dollar gown. (Unlike Narciso Rodriguez, who refused to copy Carolyn Bessette-Kennedy's wedding dress (see page 184), Westwood had no problem reproducing something made for a woman who doesn't exist.) It just proves how much women miss the sex columnist who pins all those big flowers to her dresses, and how much the world of fashion owes Parker.

GOWN WITH ILLUSION PANELS

Geoffrey Beene · 1991

Geoffrey Beene never looked over his shoulder at what any other designer was doing. The most radical modernist of American designers, he was driven by a fiercely curious desire to reveal unexpected allure in the most unexpected areas of the human body. As a result, he restlessly searched for new fabrics that would enhance the body without the weight of impeding movement. His cutting techniques were astonishing. He could create, with no fastenings or zippers, a dress that slipped on with the ease of a sweatshirt—one of his most popular gowns was a long sequined football jersey that was put on over the head. He also created a dress that was constructed with one zipper that spiraled diagonally down from the neck, twice around the body, then down to the hem. You could step right into it, although, admittedly, your arms had to be a little limber to do it.

Unlike Alaïa, whose body-conscious techniques are applied to happily broadcast or even boast of sexuality, Beene's approach to designing a dress was more intimate. In his open-back gown, the dress is austerely covered in the front. The large cutout back—Beene's favorite body part to expose—stands in sharp contrast to the long sleeves and long column of black jersey that hits the floor, making a small pool. But it's those strategic triangular cutouts caressing the hips that urge you to come closer, to observe a woman, as if she doesn't know you're there, so you can discover her sensuality without her knowledge. In actuality, nothing overt is revealed. Beene was not an obvious tease like Cavalli or Versace. Beene would also expose a hip or thigh in point d'esprit or slash open the clavicle of a sparely cut day dress. He wasn't out to cause a commotion, just to incite a little mischief.

Though Beene mentored such talents as Alber Elbaz for six years and Doo-Ri Chung, and could claim Narciso Rodriguez and Tom Ford as staunch defenders and admirers, his refusal to modify his emphatic vision for more commercial success ruffled feathers of some key players in the industry, causing Beene to be overlooked at critical points in his career. However, egos fade and true talent never does. Beene's talent has outlasted their pique, retaining all its wit and intrigue, because he found the human form—especially a woman's—so inscrutably fascinating that each season he'd eagerly search for something new to marvel at. Luckily, he was always generous enough to show us what he'd found.

FLORAL GRUNGE DRESS

Marc Jacobs · 1992

The dress isn't what you'd call beautiful. This striped, cropped, long-sleeved T with plaid knickers and a barely buttoned long black-and-yellow floral dress with the capped sleeves, would never get within five miles of a red carpet, doesn't incorporate any couture techniques, and is shown with sneakers because any shoe that has the name Louboutin, Blahnik, or Choo inside it would simply look ridiculous. The fabrics don't even "match."

And yet, for the current generation of designers, the industry they work in, and the citizenry they serve, this is Bunker Hill. Marc Jacobs's march of grunge princesses in 1992 fired the first shot to set off a revolution because whether you loved or hated the look, you couldn't dismiss it. Perry Ellis, the company's founder had built his career on a handsomely crafted, yet frequently mischievous, take on classic American sportswear, yet this aesthetic was not an easy fit for Jacobs. Jacobs had tried second-guessing what the company wanted, "but that didn't do it. I needed to go another way."

Except something in the culture was coming through to Jacobs so loud and clear he found he couldn't pay attention to anything else. "Everywhere I looked there was a shift in beauty. Photographers like David Sims and Juergen Teller were rejecting preconceived ideas of glamour. Models like Stella Tennant, Helena Christensen, and Kate [Moss] were dressing so different from what they were paid to wear. I couldn't stop listening to these bands playing what people were labeling 'alternative' music. Suddenly there was this burning drive toward the awkward and imperfect in the arts—noisy, a bit angst-ridden, but not aggressive." Jacobs decided he had to do a collection that summed up all that he was hearing and seeing.

And from that came grunge. "I remember telling Kevyn Aucoin not to put any makeup on the girls he was being paid a lot of money to make up," he says. "I went over to Oribe and told him to leave the hair alone. I was adjusting these beautiful silk plaids I had had woven at factories near [Lake] Como whose patterns were copied from shirts I had bought for three dollars on Saint Mark's Place. I knew I was asking for it, but I was so happy. I was crazy about what I had done."

The crowd's response ran the gamut from elation to anger, shock to complete but amused bafflement. As for Perry Ellis's response to Jacobs's sidewalk angels? They fired him.

Jacobs wasn't surprised. "I know I made it easy for them. A collection is really based on its ability to stimulate profits from those licensees that take their cue from the ready-to-wear collection, and I gave Perry Ellis nothing to work with. And yet, I had never felt better as a person or as a designer, because I realized that I was at my best when I gave myself over completely to whatever had inspired me."

His former employers felt he hadn't delivered, but somebody got the message. Within less than two years, retail was blanketed with grunge-inspired merchandise at every single price point. As for Jacobs, he added his severance pay to the money his business partner, Robert Duffy, had received from mortgaging his house, and "that was just enough to pay for the lease on a store to start my own label. We were broke. So I took on freelance, and then we went about piecing together my first collection for Marc Jacobs. I remember being surprised to see Gianni and Donatella [Versace] in the audience. I took it as a good sign."

Today, many consider Jacobs the world's most influential designer. "Being told you're influential is flattering. But what matters more is to be able to have the freedom to design what I see. That's the only way to create something a woman wants to wear, and that people will remember her wearing."

“I would rather be loved or hated than accepted.”
—MARC JACOBS

ACKNOWLEDGMENTS

Once they get their rhythms and start typing away, I don't know any writers who don't relish being in self-absorbed heaven. But until they reach that blissful state, I don't know any who won't follow every byway to avoid the act of composition. They will vigilantly research the most cursory minutiae, justify watching all three hours of a movie by claiming that the one scene that merits discussion must be viewed "in context," then spend three days tracking down a source who was on vacation in the jungles of Bahia for a mere ten-minute interview, without the least bit of frustration, simply because the tasks of hunting, watching, and talking are a lot easier than writing. And of course, there's always laundry crying out to be folded—what could be more blissfully mindless than that?

Writers are powerless to alter this process. The best they can do is subvert it by using these unalterable patterns to gather great nuggets of fresh information along the way: discern the right people to talk to, deduce a few clever key observations while ruminating instead of doing, and most important, assemble enviable circles of colleagues, friends, and family as eager and determined to help them achieve their goals as they are forgiving of their methods.

Well, I doubt anyone hoping to celebrate fashion could do better than engage Donna Karan, Vera Wang, Diane von Furstenberg, Donatella Versace, Carolina Herrera, Julianna Margulies, Calvin Klein, Narciso Rodriguez, John Galliano, Jason Wu, Bob Mackie, Alber Elbaz, Roberto Cavalli, Karl Lagerfeld, Valentino Garavani, Elie Saab, and Marc Jacobs, all of whom have powers of recall equal to their talent. What a treat it was to experience their wit, their fortuitous accidents, their whispered asides, and their keen awareness of the rarified world they work in.

For nearly two decades I have worked in one of the most delightful corners of this world. The staff of *InStyle* is as harmonious, uplifting, and intelligent as the magazine it produces. Founding Editor and now Time, Inc. Editorial Director Martha Nelson granted me unlimited access to all the creativity, expertise, willfulness, trivia, and idiosyncrasy that infuses fashion's past, present, and future by allowing me the privilege of being one of *InStyle*'s fashion directors. Her successor, Charla Lawhon, was kind enough to extend the advantage, and its current editor, Ariel Foxman, who has steered the magazine to paramount success, has been equally generous. I'm indebted to all of them, as well as to Time, Inc.'s Editor in Chief John Huey, for the continued opportunity and guidance to now do what comes naturally.

What's more, *InStyle*'s Co–Fashion Director Cindy Weber Cleary has such an infallible eye for clothing that matters and an understanding of its effects on the public and our culture that I profit not only from a delightful collaborator but from a master class every day I'm at work. It's the foolish writer who denigrates a good editor as a necessary evil, because I could not do without one. That's because *InStyle*'s Assistant Managing Editor Donna Bulseco is sensational, not just because she gets my jokes, but because she knows just how many I can get away with in a paragraph. Her respect for language and clarity elevates everything I write. It's why she was the first person to read my first entries in the book, and it's due to her initial enthusiasm that I jumped in with both feet.

But I have never met any editor like the one who brought me to the shoreline of this project. Elizabeth Viscott Sullivan's drive is daunting; her scope of knowledge eerie. She approached me with a slightly different idea

than the book I countered with, but once we agreed on a mission, she signed on with a determination that initially threatened to leave me in the dust. When I received her first revision of my manuscript I didn't know whether to throttle her or be thrilled. Elizabeth's focus is frankly and literally stunning: she never let me get away with anything but never failed to revel in what she loved. A cheerleader with boxing gloves, she beat me up and had my back so completely that I'm still reeling, yet I'm so proud of what we've accomplished together that words can't scale the heights of my gratitude. But putting them atop a few cases of her beloved Diet Sunkist soda might give them just the right boost.

You can go on and on about appliqués and artisanry. You can pinpoint trapunto panels and cite bursting rosettes, or insouciant poses that caught your eye. But without the right visuals to illustrate your insight, it's just "take my word for it" and not a whole lot of fun for anyone else. Hopefully, thanks to Rebecca Karamehmedovic's intrepid photo research, Iris Shih's spirited art direction, and Agnieszka Stachowicz's wonderful design, I won't be the only one relishing these choices.

Despite its virtues and proximity, the Internet has dissuaded upcoming generations from experiencing the rush in the hush—the thrill of uncovering vital information in an actual library. Maybe it's a generational thing, but I've never tired of the sense of self-satisfaction of finally hitting on a juicy fact, quote, or picture that had been hiding in the bookshelves. So thank you to both Ms. Karen Trivette Cannell, head of the Special Collection & FIT Archives, and her staff at the Fashion Institute of Technology, as well as her unfailingly helpful counterparts at the Costume Institute Library at the Metropolitan Museum of Art. However, not to sound like

a hypocrite, but this book would have been much harder and much less fun to do were it not for the more than two hundred videos, interviews, film, and television clips I was able to watch on YouTube.

The spirit of several people no longer here hovered over this project. I cherish the mentoring, curiosity, and company of Carrie Donovan and Malcolm Forbes. Even now, I am in awe whenever I encounter the diamond-cut radiance of my friend Amy Spindler's fashion commentary. I will forever miss Gianni Versace's friendship, brilliant talent, and insatiable quest for innovation and mischief, as well as his limitless capacity to discover beauty. And I would be nothing without all that my father and mother did for me. Acknowledgment is a feeble term for the ultimate blessing of being their son.

My sister and I are dissimilar in so many ways—she's as pensive as I am effusive, as constant as I chase a dream a day—and yet no one understands me better. The marvel is that she still stays close. Tapping into her strength is better than a shot of B_{12}; having her love reminds me that nothing else matters nearly as much; and if this book makes her smile, I'll melt the way I always do each time we watch *E.T.*

But the person I owe most to was neither born family nor lives for fashion. He couldn't care less whether a dress is by Dolce & Gabbana or Dior. He rolls his eyes at an industry that spends a half million dollars on a show that lasts fifteen minutes. I doubt whether he even imagines any dress can be memorable. But because of David Nickle's unshakable embrace, unconditional support, and sentiment-free, no-excuses-accepted insistence on my giving my best, I start each day by counting my blessings—and he's the first one on my list.

—Hal Rubenstein

SELECTED BIBLIOGRAPHY

Books

Biskind, Peter. *Easy Riders, Raging Bulls.* New York: Simon & Schuster, 1999.

Brooks, Tim, and Earle Marsh. *The Complete Directory of Prime Time Television Network Shows: 1946–Present.* New York: Ballantine, 1988.

Carter, Graydon, David Friend, and the editors of *Vanity Fair. Oscar Night: 75 Years of Hollywood Parties.* New York: Knopf, 2004.

Cassini, Oleg. *A Thousand Days of Magic: Dressing Jacqueline Kennedy for the White House.* New York: Rizzoli, 1995.

Charles-Roux, Edmonde. *Chanel and Her World: Friends, Fashion, and Fame.* New York: Vendome Press, 2005.

Emanuel, David, and Elizabeth Emanuel. *A Dress for Diana.* New York: Collins Design, 2006.

Ford, Tom, and Bridget Foley. *Tom Ford.* New York: Rizzoli, 2004.

Foundation Pierre Bergé and Yves Saint Laurent. *Yves Saint Laurent Style.* New York: Harry N. Abrams, 2008.

Galella, Ron. *Disco Years.* New York: powerHouse Books, 2006.

Golbin, Pamela, and Valentino. *Valentino: Themes and Variations.* New York: Rizzoli, 2008.

Green, Stanley. *Starring Fred Astaire.* New York: Doubleday, 1977.

Gross, Elaine, and Fred Rottman. *Halston: An American Original.* New York: HarperCollins, 1999.

Guillen, Pierre-Yves, and Jacqueline Claude. *The Golden Thimble, French Haute Couture.* Paris: Editions J.M.G., 1990.

Gutner, Howard. *Gowns by Adrian: The MGM Years 1928–1941.* New York: Harry N. Abrams, 2001.

Hastreiter, Kim. *Geoffrey Beene: An American Fashion Rebel.* New York: Assouline, 2008.

Haugland, Kristina, Jenny Lister, and Samantha Erin Safer. *Grace Kelly Style: Fashion for Hollywood's Princess.* London: V&A Publishing, 2010.

Head, Edith. *The Dress Doctor: Prescriptions for Style, From A to Z.* New York: Collins Design, 2008.

——, and Paddy Calistro. *Edith Head's Hollywood.* New York: Random House, 1966.

Jorgensen, Jay. *Edith Head: The Fifty-Year Career of Hollywood's Greatest Costume Designer.* Philadelphia: Running Press, 2010.

Lacroix, Christian, Patrick Mauriès, and Oliver Saillard. *Christian Lacroix on Fashion.* London: Thames & Hudson, 2008.

Landis, Deborah Nadoolman. *Dressed: A Century of Hollywood Costume Design.* New York: Collins Design, 2007.

Lee, Sarah Tomerlin, ed., for the Fashion Institute of Technology, and Eleni Sakes Epstein, Sally Kirkland, Dale McConathy, Bernardine Morris, and Robert Riley. *American Fashion: The Life and Lines of Adrian, Mainbocher, McCardell, Norell, and Trigère.* New York: Quadrangle/ New York Times Book Co., 1975. (NY) Metropolitan Museum of Art, Hamish Bowles,

Arthur M. Schlesinger, and Rachael Lambert Mellon. *Jacqueline Kennedy: The White House Years.* New York: Bulfinch, 2001.

Padilha, Roger, and Mauricio Padilha. *The Stephen Sprouse Book.* New York: Rizzoli, 2009.

Paris-Musées. *Givenchy: 40 Years of Creation.* Paris: Blanchard au Plessis-Robinson, 1991.

Reeder, Jan Glier. *High Style: Masterworks from the Brooklyn Museum Costume Collection at The Metropolitan Museum of Art.* New York: Metropolitan Museum of Art, 2010.

Rose, Helen. *Just Make Them Beautiful: The Many Worlds of a Designing Woman.* Santa Monica: Dennis-Landman, 1976.

Steele, Valerie. *Encyclopedia of Clothing and Fashion.* 3 vols. New York: Charles Scribner's Sons, 2005.

Tierney, Tom. *Great Movie Dance Couples: Paper Dolls.* Mineola: Dover Press, 2004.

Versace, Gianni, and Omar Calabrese. *Versace Signatures.* Rome: Leonardo DeLuca, 1992.

Vickers, Hugo. *Cecil Beaton.* Boston: Little, Brown & Co., 1985.

Articles

Akbar, Arifa. "Roland Mouret, Designer of the 'Galaxy' Dress, Quits Job." *Independent* (UK). Last modified October 27, 2005. http://www.independent.co.uk.

American Film Institute. "Notes for *Sabrina*." Turner Classic Movies. Accessed October 30, 2010. http://www.tcm.com.

Basye, Ali. "Cinemode: All About Eve: A Bumpy Ride." On This Day in Fashion (blog). Last modified October 13, 2010. http://www.onthisdayinfashion.com.

Brant, Stephanie Seymour. "Azzedine Alaïa." *Interview* (March 2009).

Buchwald, Art, and Tim Dirks. "Europe's Lighter Side: The Cat Prowls Again?" AMC filmsite. Accessed December 28, 2010. http://www.filmsite.org.

Callahan, Maureen. "Keira's 'Atonement' Dress Is One for the Ages." *New York Post*. Last modified December 10, 2007. http://www.nypost.com.

Campbell, Jennifer. "Is Joan Rivers to Blame for Boring Red Carpet Style?" *Fashion Magazine*. Last modified August 31, 2010. http://www.fashionmagazine.com.

Chozick, Amy. "Some Fashion Critics Sniff at First Lady's Gown." Washington Wire (blog), *Wall Street Journal*. Last modified January 20, 2009. http://www.wsj.com/washwire.

Clemons, Leila. Costume review: "To Catch a Thief."

Christian Filmmakers (blog). Last modified April 26, 2010. http://www.christianfilmmakers.com.

Corliss, Richard. "Anna May Wong Did It Right." *Time*. Last modified January 29, 2005. http://www.time.com.

Cox, Johanna. "Happy Birthday, Pretty Woman." *Elle*. Last modified March 23, 2010. http://www.elle.com.

"Episode List for *That Girl*." IMDb, Internet Movie Database. Accessed August 31, 2010. http://www.imdb.com.

Feinberg, Scott. "Iconic Movie Dresses: Ginger Rogers' Feather Dress in 'Top Hat' (1935)." Feinberg Files (blog), *Los Angeles Times*. Last modified January 11, 2009. http://latimesblogs.latimes.com/files/

"Fontana Sisters." Clothing and Fashion Encyclopedia. Last modified June 11, 2010. http://angelasancartier.net.

Freeman, Hadley. "How Not to Wear That Dress." *Guardian* (UK). Last modified December 15, 2005. http://www.guardian.co.uk.

Givhan, Robin. "Obama's Inaugural Gown Conveys a Nation's Optimism." *Washington Post*. Last modified March 9, 2010. http://www.washingtonpost.com.

"Green Dress from *Atonement*." Sunday Couture (blog). Accessed October 2, 2010. http://www.kartanonrouva.net.

H., Sarah. "Top Hat: Ginger Rogers' Ostrich Feather Dress." Clothes on Film (blog). Accessed August 11, 2010. http://clothesonfilm.com.

"Hubert de Givenchy and Audrey Hepburn. Alliance and Friendship." Famous Women-and-Beauty (blog). Accessed August 15, 2010. http://www.famous-women-and-beauty.com.

Hume, Marion. "Going Lightly." *Independent* (UK). Last modified February 14, 1993. http://www.independent.co.uk.

"The Inside Scoop on *Bye Bye Birdie*." TCM Essentials, Jr. Accessed September 2, 2010. http://www.tcm.com.

Jackson, Denny. "Mini Biography of Anna May Wong." IMDb, Internet Movie Database. Accessed January 1, 2011. http://www.imdb.com.

Jones, Stephanie. "*Letty Lynton* (1932)." The Best of Everything (blog). Accessed September 4, 2010. http://www.joancrawfordbest.com.

"Kate Moss Hologram, Alexander McQueen, March '06." *FashioNZ*. Accessed September 4, 2010. http://www.fashionz.co.nz.

Khan, Urmee. "Liz Hurley 'Safety Pin' Dress Voted the Greatest Dress." *Telegraph* (UK). Last modified October 9, 2008. http://www.telegraph.co.uk.

King, Larry, and Hamish Bowles, Oleg Cassini, Elsa Klensch, Pamela Clarke Keogh, Dina Merrill, and Lee Radziwill. "Transcript of CNN Larry King Live: What Jacqueline Kennedy Wore During the White House Years and Why." CNN. Aired July 5, 2001. http://www.cnn.com.

Kuczynski, Alex. "Shopping with: Marlo Thomas: That Girl, All Grown Up." *New York Times*. Last modified February 22, 1998. http://www.nytimes.com.

"Lacroix A–Z." *Wonderland Magazine*. Accessed September 27, 2010. http://www.wonderlandmagazine.com.

Laverty, Chris. "Clothes on Film." Clothes on Film (blog). Accessed October 2, 2010. http://clothesonfilm.com.

Lee, Edith C., updated by Denise Delorey. "Irene Sharaff." Film Reference. Accessed October 15, 2010. http://www.filmreference.com.

"Legendary Burnett Costume to Go on View Dec. 1 at the Smithsonian." Smithsonian National Museum of American History. Last modified November 24, 2009. http://americanhistory.si.edu.

"Legendary Joan Crawford." Legendary Joan Crawford (blog). Accessed September 4, 2010. http://www.legendaryjoancrawford.com.

Martin, Richard. "Fontana Sisters." The Fashion Encyclopedia. Accessed July 27, 2010. http://www.thefashionencyclopedia.com.

"Memorable Quotes for *Absolutely Fabulous*." IMDb, Internet Movie Database. Accessed September 27, 2010. http://www.imdb.com.

Miller, Frank, comp. "Trivia & Fun Facts About *My Fair Lady*." Turner Classic Movies. Accessed October 30, 2010. http://www.tcm.com.

"'Mondrian' Day Dress." Heilbrunn Timeline of Art History, Metropolitan Museum of Art. Accessed October 31, 2010. http://www.metmuseum.org.

Mower, Sarah. "Alexander McQueen: Fall 2006 Ready-to-Wear Collection." Style.com. Last modified March 3, 2006. http://www.style.com.

———. "Gucci: Fall 2004 Ready-to-Wear Collection." Style.com. Last modified February 25, 2004. http://www.style.com.

———. "Prada: Spring 2004 Ready-to-Wear Collection." Style.com. Last modified October 1, 2003. http://www.style.com.

Nicks, Stevie. "Stevie Nicks in Her Own Words." In Her Own Words (blog). Accessed October 19, 2010. http://www.inherownwords.com.

"Phyllis Diller." IMDb, Internet Movie Database. Accessed August 8, 2010. http://www.imdb.com.

Reighley, Kurt B. "Mary Wilson's 'Reflections' on the Glamorous Gowns of the Supremes." Q Scoop (blog), Logo. Last modified June 23, 2010. http://www.logo.com.

Rubenstein, Hal. "The Cold Shoulder." *New York Times*. Last modified February 7, 1993. http://www.thenytimes.com.

Sanderson, Lisa. "James Galanos, One of America's Most Famous Designers." suite101.com. Accessed September 1, 2010. http://www.suite101.com.

Sanderson, Lisa-Anne. "Sorelle Fontana: Couturiers to the Stars." Life in Italy. Accessed July 27, 2010. http://www.lifeinitaly.com.

Sayers, Robin. "Send in the Gowns." *Los Angeles Times Magazine*. Last modified February 8, 2010. http://www.latimesmagazine.com.

Sherwood, Deborah. "Secrets of Di's Revenge Dress." *Sunday Mirror* (UK), CBS Interactive Business Network. Last modified May 3, 1998. http://findarticles.com.

"Shirtwaist Dress." Heilbrunn Timeline of Art History, Metropolitan Museum of Art. Accessed October 31, 2010. http://www.metmuseum.org.

Silver, Cameron. "Daryl Hannah, Eat Your Heart Out!" Decades Inc. (blog). Last modified March 17, 2009. http://www.decadesinc.com.

———. "Pouf Daddy." Decades Inc. (blog). Last modified April 2, 2010. http://www.decadesinc.com.

Singh, Anita. "Valentino Pays Tribute to Julia Roberts at Venice Film Festival." *Telegraph* (UK). Last modified August 28, 2008. http://www.telegraph.co.uk.

Snead, Elizabeth. "'Atonement': The Past Made New." The Envelope: The Awards Insider (blog), *Los Angeles Times*. Last modified December 12, 2007. http://theenvelope.latimes.com.

Snowdown, Katie. "Julia Roberts in Pretty Woman: Elegant Opera Dress." Clothes on Film (blog). Accessed October 5, 2010. http://www.clothesonfilm.com.

"Sorelle Fontana—The History of Italian Haute Couture." Italica. Accessed July 27, 2010. http://www.italica.rai.it.

Spindler, Amy M. "Alaïa and Leger Loosen Up a Bit." *New York Times*. Last modified March 20, 1993. http://www.nytimes.com.

Stafford, Jeff. "Spotlight: *Bye Bye Birdie*." Turner Classic Movies. Accessed September 2, 2010. http://www.tcm.com.

"Travis Banton c. 1934." Defunct Fashion (blog). Last modified August 3, 2010. http://www.defunctfashion.tumblr.com.

Ward, Renee. "Jean Louis." Film Reference. Accessed October 30, 2010. www.filmreference.com.

Watt, Melinda L. "James Galanos." Fashion Encyclopedia. Accessed September 1, 2010. http://www.fashionencyclopedia.com.

Weston, Pauline Thomas. "1956 Grace Kelly Wedding Dress." Fashion Era (blog). Last modified September 15, 2006. http://www.fashion-era.com.

PHOTOGRAPHY CREDITS

Page 14: Dave Benett/Hulton Archive/Getty, 1994. **17**: Kevin Mazur/WireImage, 2005. **19**: Steve Granitz/WireImage, 2001. **20**: Chris Weeks/Getty, 2001. **21**: Steve Granitz/WireImage, 2001. **23**: Loomis Dean/Camera Press Digital/Retna, 1956. **24**: Quadrillion/Corbis, 1981. **26 and 28**: Paramount Pictures/Courtesy Neal Peters Collection, 1954. **29**: Paramount Pictures/Courtesy Neal Peters Collection, 1961. **30, top**: Warner Bros./Courtesy Neal Peters Collection, 1964. **30, bottom**: 20th Century Fox/Courtesy Neal Peters Collection, 1967. **31**: Warner Bros./Courtesy Neal Peters Collection, 1964. **33, left**: Courtesy Everett Collection, 1976. **33, right**: MGM/Courtesy Neal Peters Collection, 1939. **35**: Paramount Pictures/Courtesy Neal Peters Collection, 1951. **36**: Randy Brooke/WireImage, 2006. **39**: Kevin Mazur/WireImage, 1997. **40**: Scott Downie/Celebrity Photo, 1997. **41–43**: Maria Chandoha Valentino/MCV Photo, 1996. **45**: Kevin Mazur/WireImage, 2010. **47**: B.D.V./Corbis, 1997. **48**: Matty Zimmerman/AP Photo, 1954. **51**: Courtesy Everett Collection, 1972. **53**: Rose Prouser/Reuters/Landov, 2000. **54**: Gilbert Flores/Celebrity Photo, 2000. **56 and 57**: Motown/Courtesy Neal Peters Collection, 1968. **59**: Sam Levi/WireImage, 2000. **60**: Ron Galella/WireImage, 1974. **62**: Jim Smeal/WireImage, 1986. **63**: Courtesy Everett Collection, 1988. **65**: Bettmann/Corbis, 1963. **66**: Columbia Pictures/Courtesy Neal Peters Collection, 1975. **67, left**: Ron Galella/Wireimage, 1995. **67, right**: Sean Roberts/Everett Collection, 1995. **69**: © 1973 Condé Nast Publications, Courtesy of Halston, 1972. **71**: Courtesy Gilles Bensimon, 2010. **72**: Columbia Pictures/Courtesy Neal Peters Collection, 1963. **74**: David Longendyke/Everett Collection, 2008. **77**: Chris Moore/Catwalking/Getty, 2010. **79**: Condé Nast Archive/Corbis, 1926. **80**: Douglas Kirkland/Corbis, 1962. **83**: Courtesy Diane von Furstenberg, 1978. **85**: Art Rickerby/Time Life Pictures/Getty, 1962. **86, left**: © John F. Kennedy Library Foundation. **86, right**: Bettmann/Corbis, 1961. **88**: Robert Knudsen, White House/John F. Kennedy Library Foundation, Boston, MA, 1962. **89**: Bettman/Corbis, 1968. **90**: Frank Trapper/Corbis Sygma, 2003. **93**: Scott Downie/Celebrity Photo, 1996. **94**: RKO/The Kobal Collection, 1935. **95**: RKO/Courtesy Neal Peters Collection, 1935. **97**: John Paschal/Celebrity Photo, 1995. **99**: Keystone/Getty, 1949. **101**: Maria Chandoha Valentino/MCV Photo, 1992. **102**: Wilfredo Lee/AP Photo, 1993. **104, top**: Courtesy Everett Collection, 1958–1966. **104, center**: Courtesy Everett Collection, 1957–1963. **104, bottom**: John Springer Collection/Corbis, 1954. **105**: Genevieve Naylor/Corbis, 1946. **106**: Maria Chandoha Valentino/MCV Photo,

2004. **108–109**: Steve Granitz/WireImage, 2002. **111, left**: John Kobal Foundation/Getty, 1934. **111, right**: © The Metropolitan Museum of Art/Art Resource. **112**: AP Images, 1969. **114**: Maria Chandoha Valentino/MCV Photo, 2005. **117**: © Buena Vista Pictures/Courtesy Everett Collection, 1990. **118**: Frank Trapper/Corbis Sygma, 1999. **120**: MGM/Courtesy Neal Peters Collection, 1932. **123**: Courtesy Everett Collection, 1960s. **124**: Maria Chandoha Valentino/MCV Photo, 1988. **126**: Ron Galella/WireImage, 1987. **129**: Thierry Orban/Corbis, 2002. **131**: Jayne Fincher/Getty, 1994. **132**: Dominique Charriau/WireImage, 2010. **134**: Marissa Roth/Retna, 1999. **135**: Kevin Mazur/WireImage, 1999. **136**: Dan MacMedan/WireImage, 2007. **137, left**: Steve Granitz/WireImage, 2007. **137, right**: Lester Cohen/WireImage, 2008. **138**: Focus Features/Courtesy Neal Peters Collection, 2007. **140–142**: Maria Chandoha Valentino/MCV Photo, 1992. **143**: MGM/Courtesy Neal Peters Collection, 1960. **145**: Neal Preston/Corbis, 1987. **146**: Steve Granitz/WireImage, 2003. **148**: Maria Chandoha Valentino/MCV Photo, 1989. **151, left**: Frank Trapper/Corbis Sygma, 2000. **151, right**: Gilbert Flores/Celebrity Photo, 2000. **153, top left**: ABC Photo Arhives/Getty, 1969; **bottom left**: Courtesy Everett Collection, 1969; **top and bottom right**: ABC Photo Arhives/Getty, 1969. **155**: Maria Chandoha Valentino/MCV Photo, 1984. **157**: Lucas Jackson/Retures/Landov, 2009. **158**: Mark Wilson/Pool/Corbis, 2009. **160–161**: Columbia Pictures/Courtesy Neal Peters Collection, 1946. **163, left**: Mike Blake/Reuters/Landov, 2004. **163, right**: Steve Granitz/WireImage, 2004. **165**: Eric Robert, Stephane Cardinale & Thierry Orban/Corbis Sygma, 1997. **167**: Paramount Pictures/Courtesy Neal Peters Collection, 1954. **168**: Paramount Pictures/Courtesy Neal Peters Collection, 1955. **Page 169 (both)**: Paramount Pictures/Courtesy Neal Peters Collection, 1955. **171**: Philippe Halsman/Magnum Photos, 1954. **172**: Joseph McKeown/Getty, 1956. **173**: Bettmann/Corbis, 1956. **174**: Scott Downie/Celebrity Photo, 1999. **177**: Bettman/Corbis, 1962. **179**: Lili Eijsten/AFP/Getty, 1963. **180**: Dave Hogan/Getty, 2004. **181**: Karl Prouse/Catwalking/Getty, 2007. **182**: Maria Chandoha Valentino/MCV Photo, 2003. **184**: Cerruti 1881/AP Photo, 1996. **185**: Denis Reggie, 1996. **186**: Steve Granitz/WireImage, 2010. **188–189**: Pascal Le Segretain/Getty, 2011. **191 (both)**: 20th Century Fox/Courtesy Neal Peters Collection, 1950. **193**: Lester Cohen/WireImage, 2002. **194**: Jim Smeal/WireImage, 2000. **195**: © HBO/Courtesy Everett Collection, 2004. **196**: James Devaney/WireImage, 2007. **198**: Courtesy Andrew Eccles/Geoffrey Beene Foundation, 1991. **201**: Maria Chandoha Valentino/MCV Photo, 1993.